sounds
your of
name

2006, 2007

sounds of your name

nate powell

MICROCOSM

PORTLAND OR

copyright © Nate Powell 2006, 2007

book design by David Janik and Joe Biel

published by:
Microcosm Publishing
www.microcosmpublishing.com

proudly distributed by:
AK Press & Distribution
www.akpress.org

Available in the trade and from Ingram, Baker & Taylor at standard discounts

First Edition - September 2006, 4,000 copies (misprinted)

Second Edition - February 2007, 3,000 copies (hopefully not misprinted)

ISBN 0-9770557-9-5

Microcosm #76045

Contents

About the Author:

Nate Powell was born in 1978 in Little Rock, Arkansas. He spontaneously began reading out of a Fantastic Four activity book in Montana in 1981. Nate began selfpublishing his own zines and comics in 1992 including Walkie Talkie, Conditions, The Schwa Sound, and Please Release. Soft Skull later published It Disappears and Tiny Giants. In 2000 he grad-uated from the School of Visual Arts, NYC.
Nate lives in Bloomington, IN where he eats many breakfasts and sighs a lot. Since 1999 he has worked full-time for adults with developmental disabilities. Nate also sings in pizza theatre band Soophie Nun Squad and manages DIY punk label Harlan Records.
Stress, real and imagined, builds in his neck and shoulders. Nate does not eat meat but does drive way too much.

Acknowledgements:

thank you for the full hearts and honesty, the support and the calling me out:
maralie a-milholland, rachel bormann, brendan burford, al burian, mary chamberlain, chris clavin, aaron cometbus, michael cox, farel dalrymple, jan davis, jim drain, rick driskill (RIP), travis fristoe, alex frixione, the ghost in massachusetts, mara golubovich, rachael hall, emil heiple, michael hoerger, klaus janson, samantha jones, tennessee jones, ben katchor, niki kelce, natalja kent, mike kirsch, kevin lafond, mike lierly, syd long, josh macphee, keith mayerson, lisa merva, art middleton, eli monster, mr. peepers (wherever you are) and miami, christina nickel, melissa number one, dan pastrana, betty brown, mike and peyton powell, ryan quinney, cristy road, rim scott, ryan seaton, ketti snead, chris staros, mike taylor, sparky taylor, craig thompson, erin tobey, matt tobey, brett warnock, nathan wilson, sarah zeidan (RIP), marea noel zimmerman, and andrea zollo, to name a few.

thanks to adventures had with and by soophie nun squad, abe froman, tem eyos ki, boomfancy, gioteens, the reason we all hate each other, the good good, and booyah grandma.

dedicated to jewel elaine powell and john horton powell, jr. (1922-2004)

Nate Powell
PO Box 3382
Bloomington,IN 47402 USA
seemybrotherdance@yahoo.com
www.harlanrecords.org

SHORT STORIES

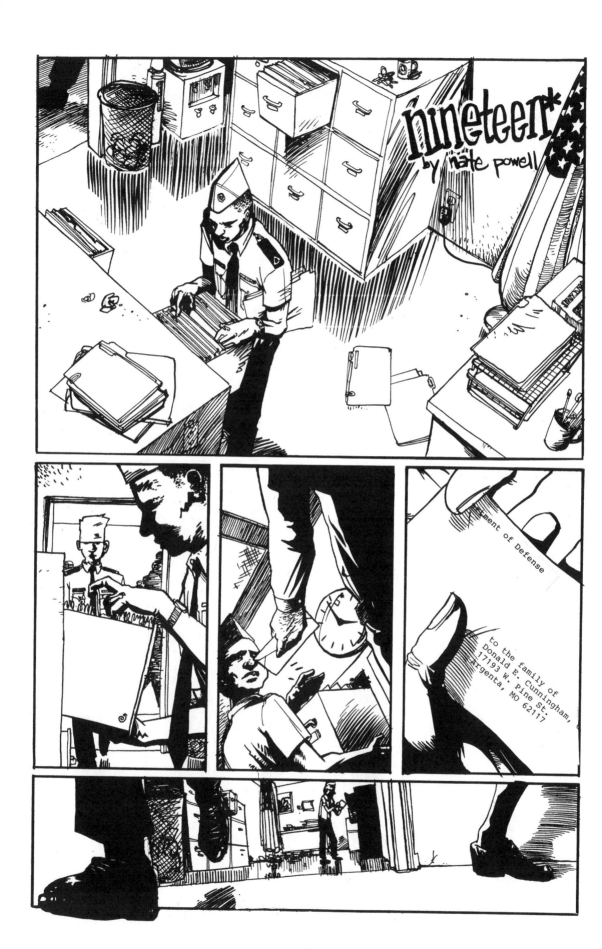

nineteen*
by nate powell

ment of Defense

to the family of
Donald E. Cunningham,
17193 W. Pine St.
Argenta, MO 62117

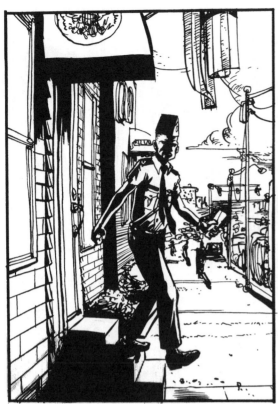

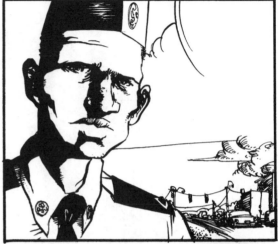

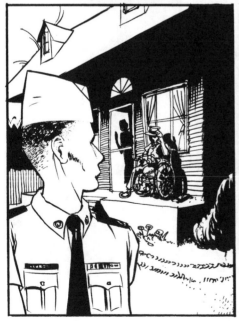
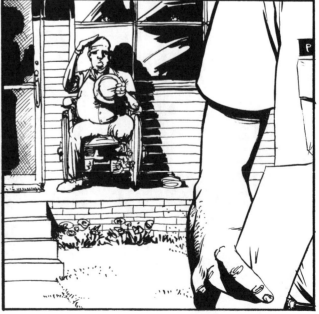

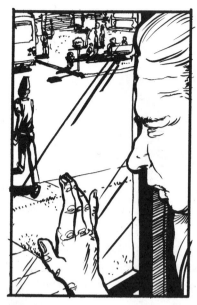

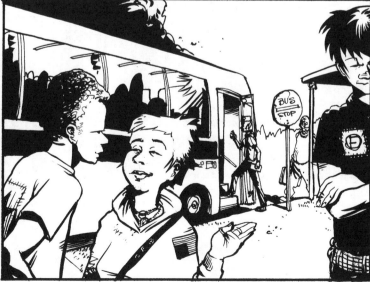

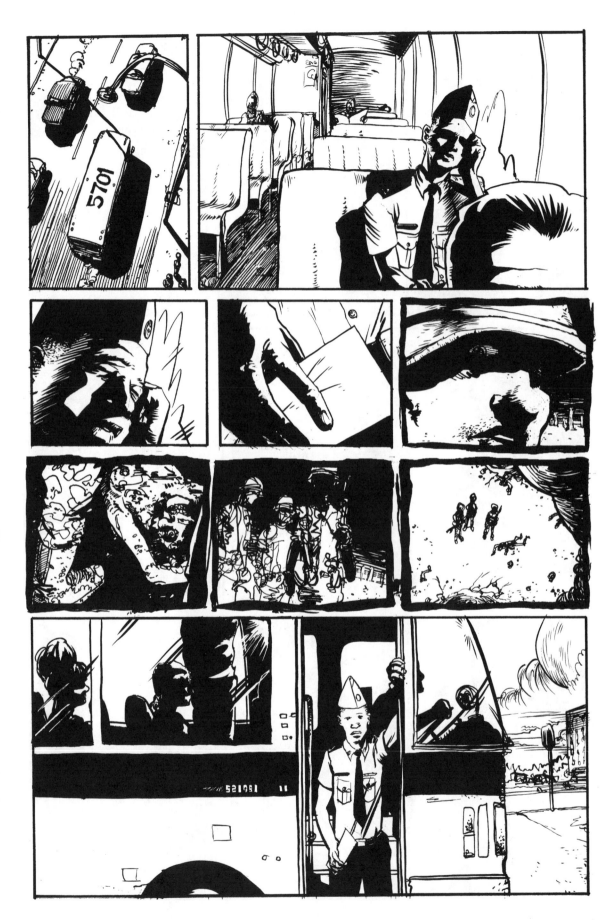

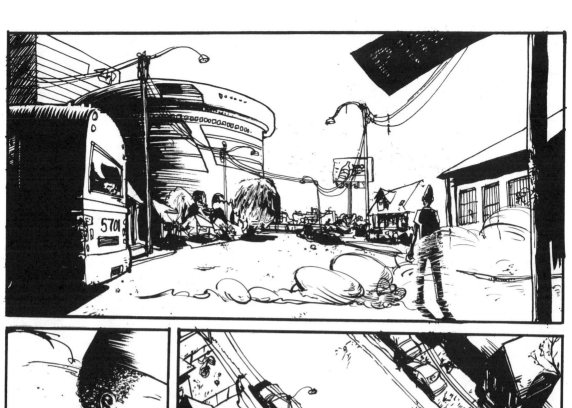

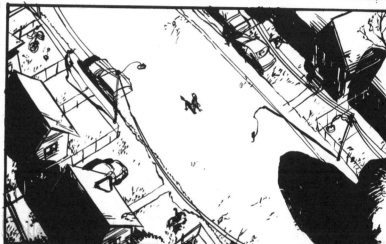

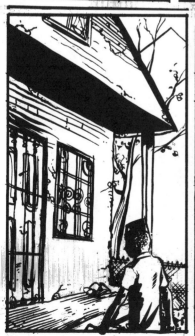

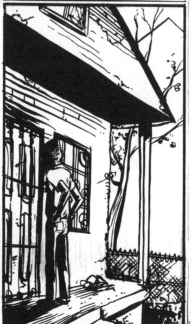

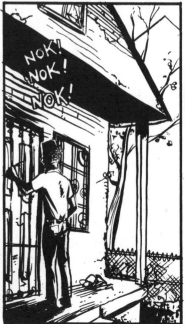

to the family of
Donald E. Cunningham, CPL
17193 W. Pine St.
Argenta, MO 62117

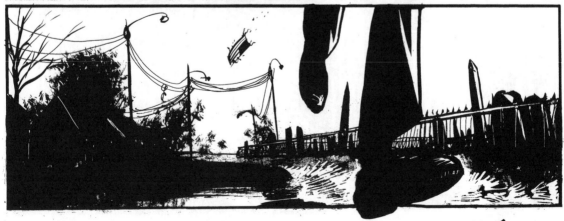

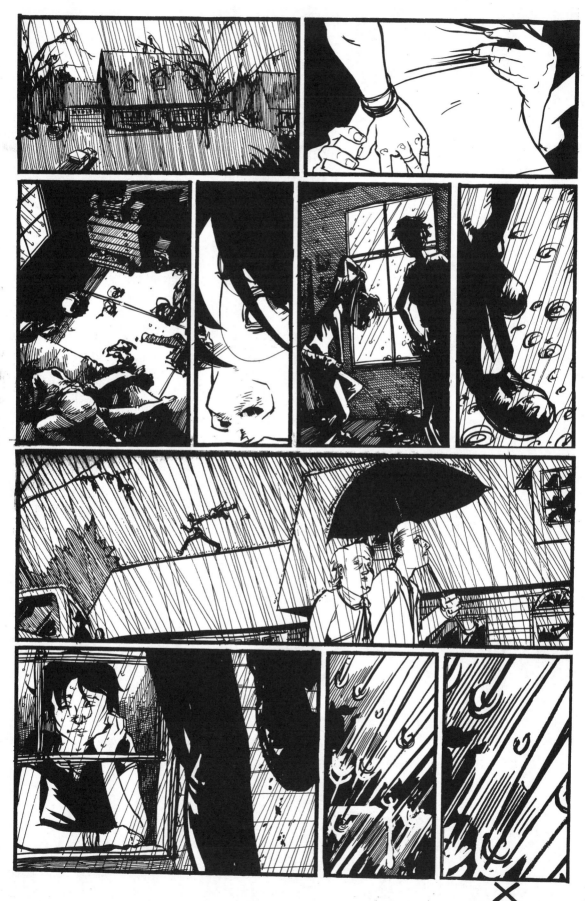

the astronomer's club*

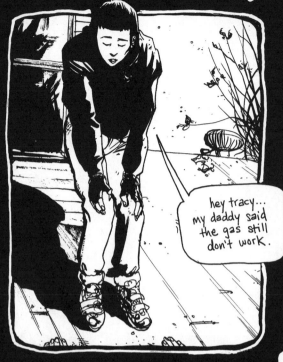

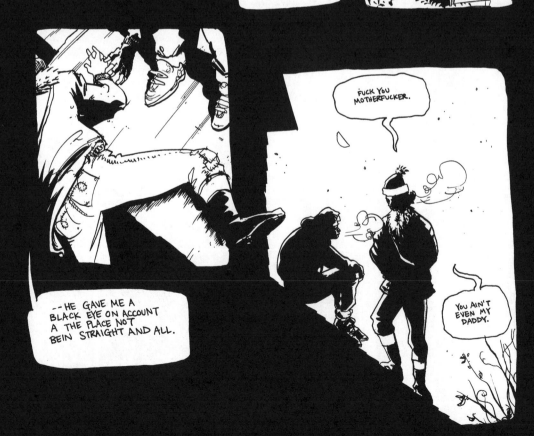

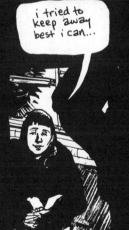

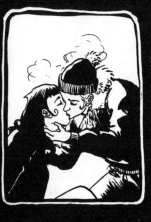
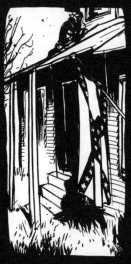

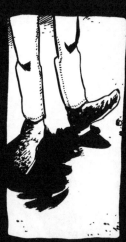
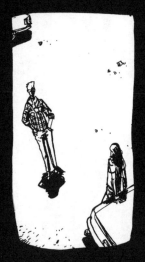
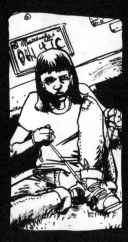

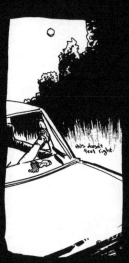
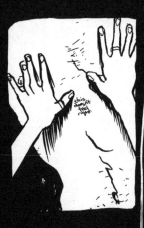

I SHOULDN'T
BE HERE,
YOU KNOW.

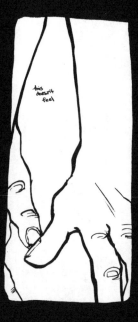

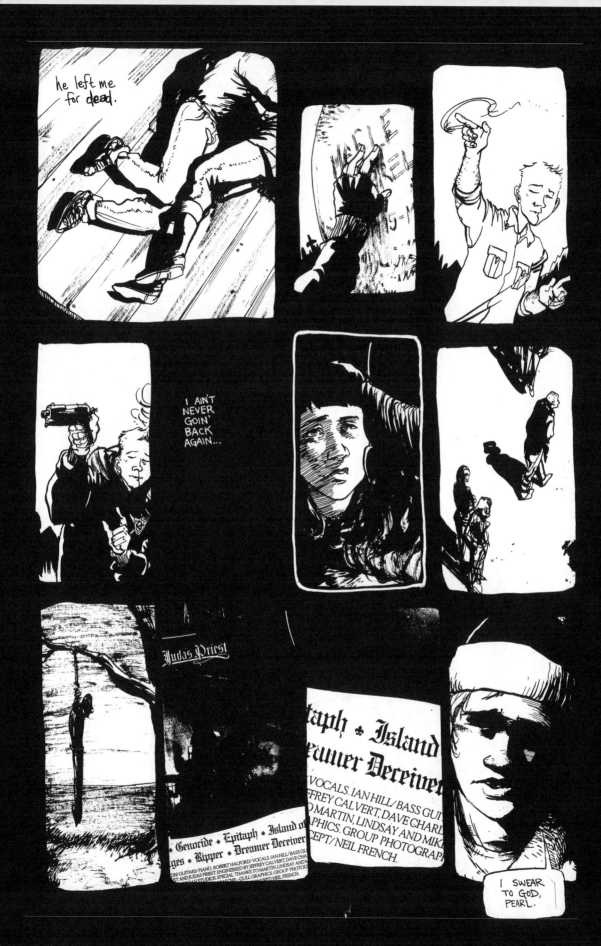

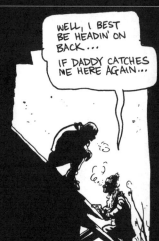

WELL, I BEST BE HEADIN' ON BACK...

IF DADDY CATCHES ME HERE AGAIN...

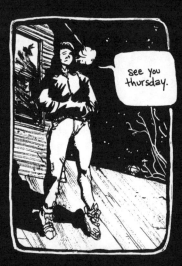

see you thursday.

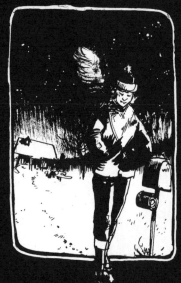

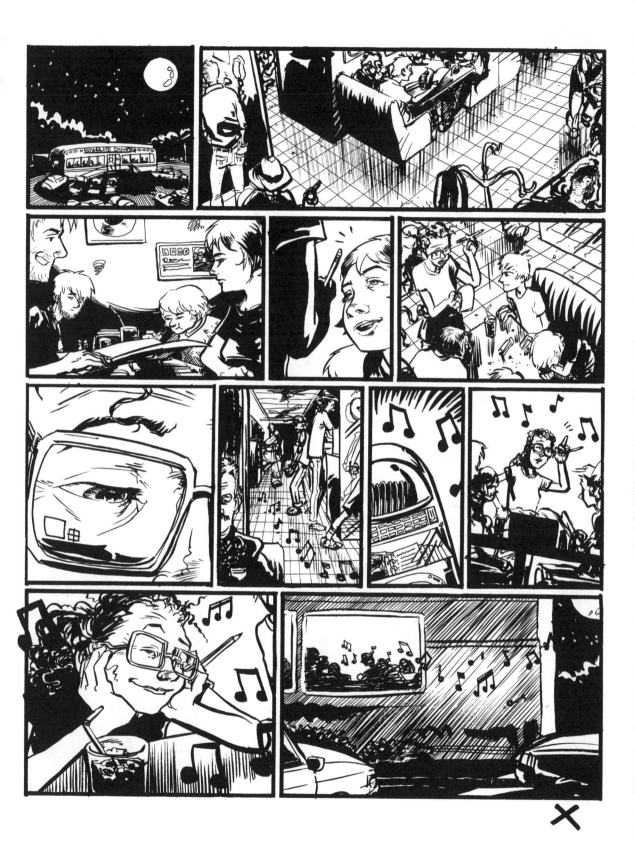

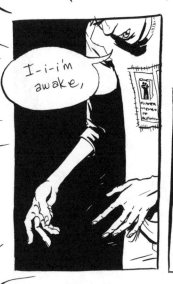

I-i-i'm awake,

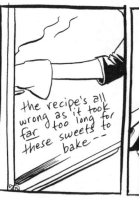

the recipe's all wrong as it took far too long for these sweets to bake--

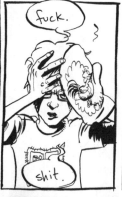

fuck.

shit.

my face f-f-flakes,

i've got a cut on my brow and a pink pink face!

how will you like me now?!

and what if i wear my sweetest browns and baby blues

and swagger with a certain swoop, a-shhh, a-shoo.?

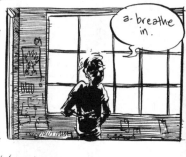

a-breathe in.

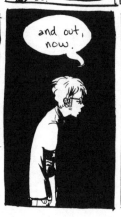

and out, now.

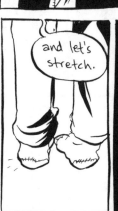

and let's stretch.

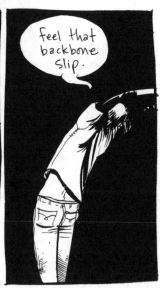

feel that backbone slip.

≡ whew ≡

N° 12·04

14

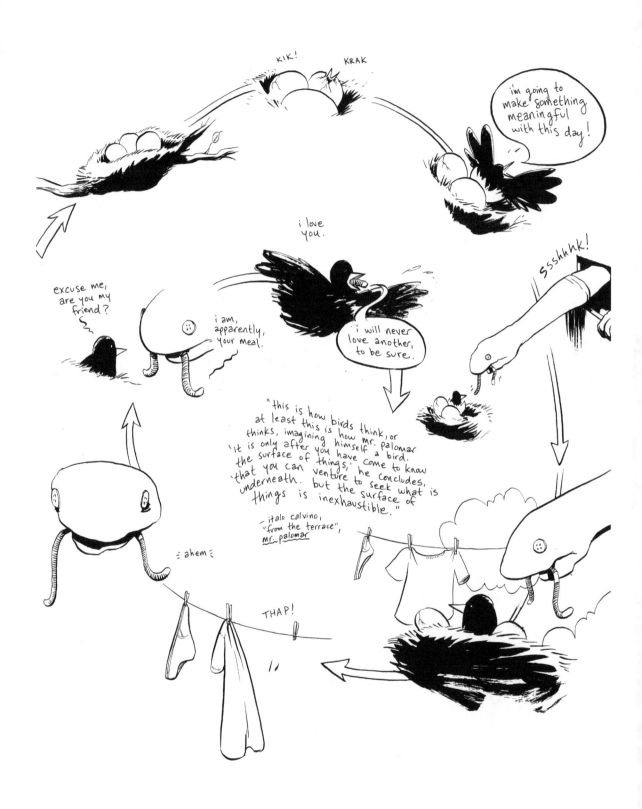

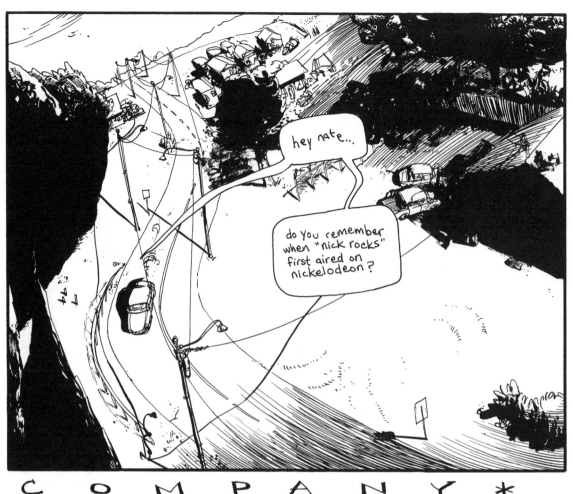

COMPANY *
← by nate powell →

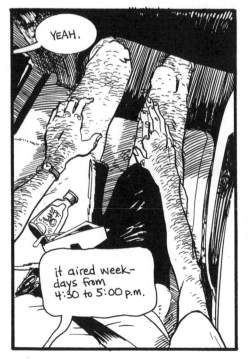

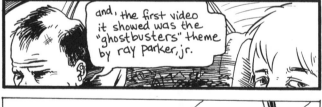

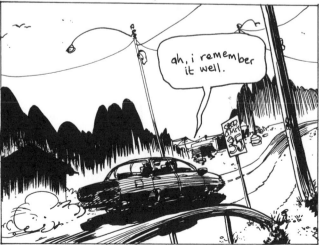

16

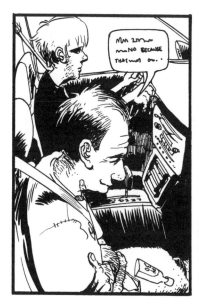

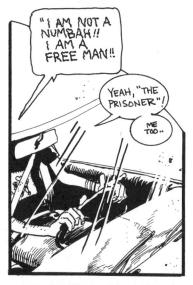

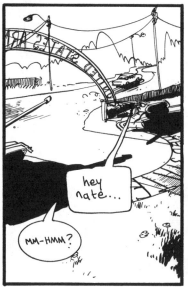

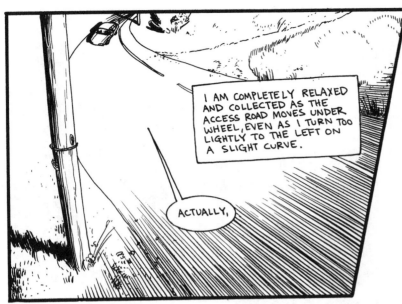

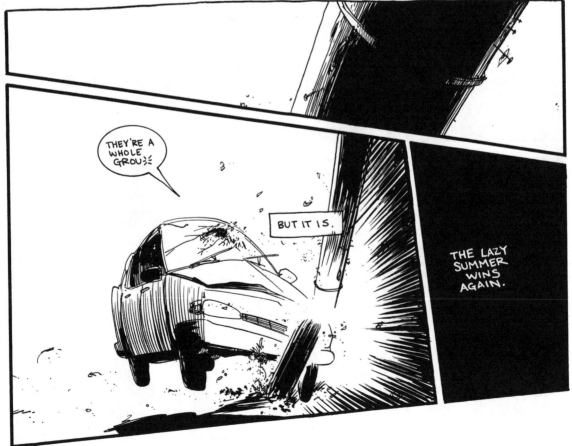

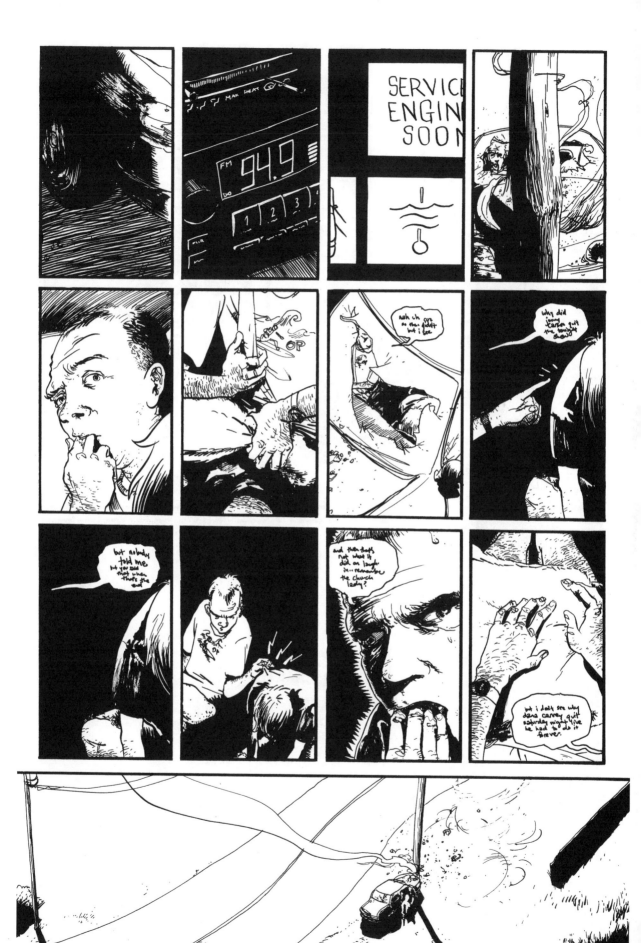

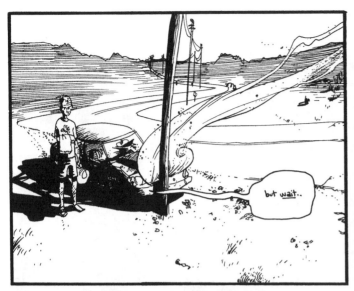

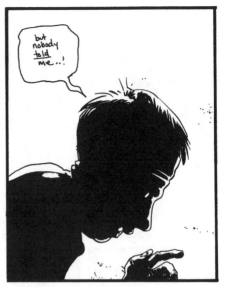

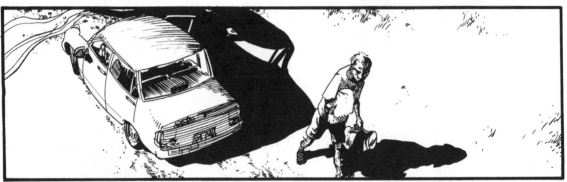

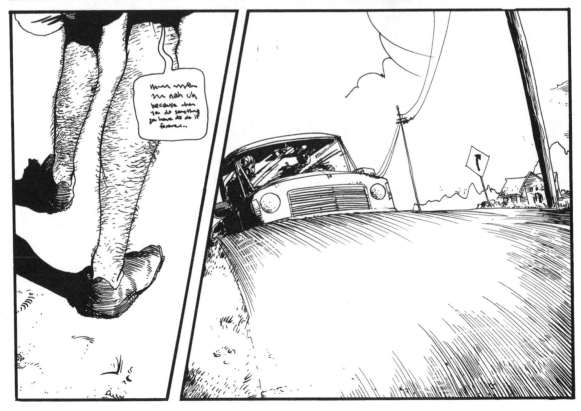

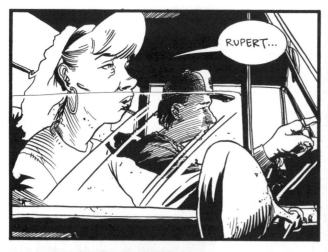
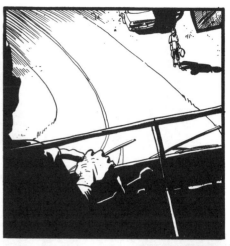

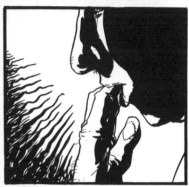
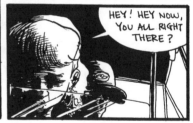
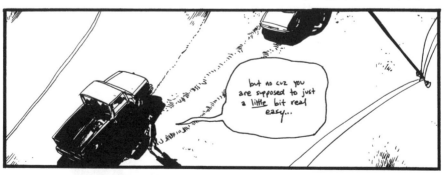

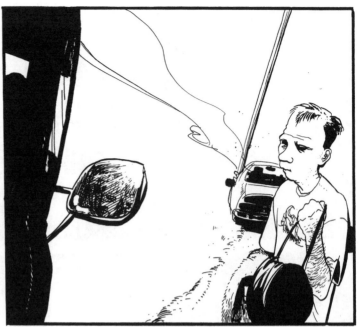
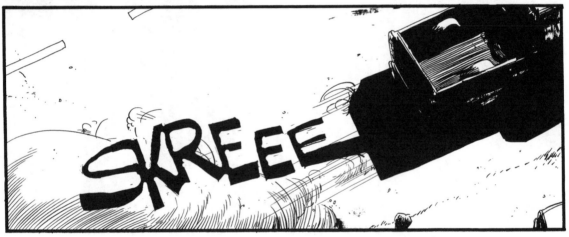

SKREEE

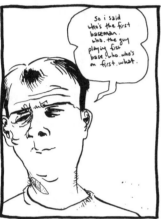
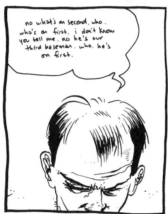
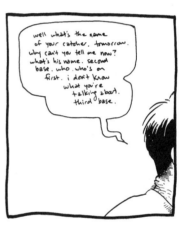
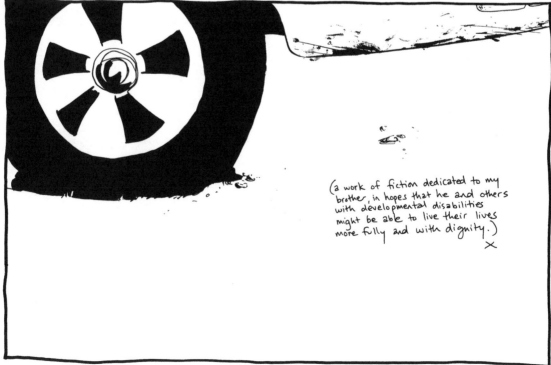

(a work of fiction dedicated to my brother, in hopes that he and others with developmental disabilities might be able to live their lives more fully and with dignity.)

X

NP 10/01.

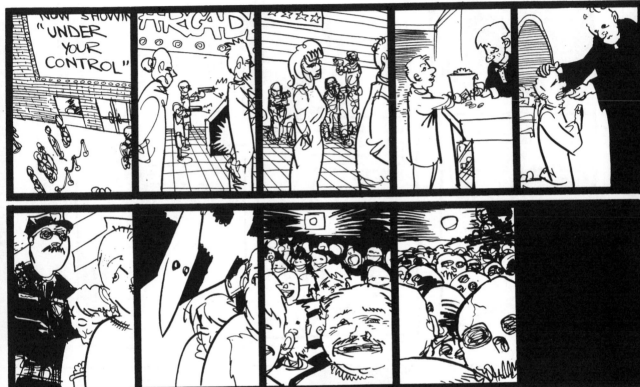

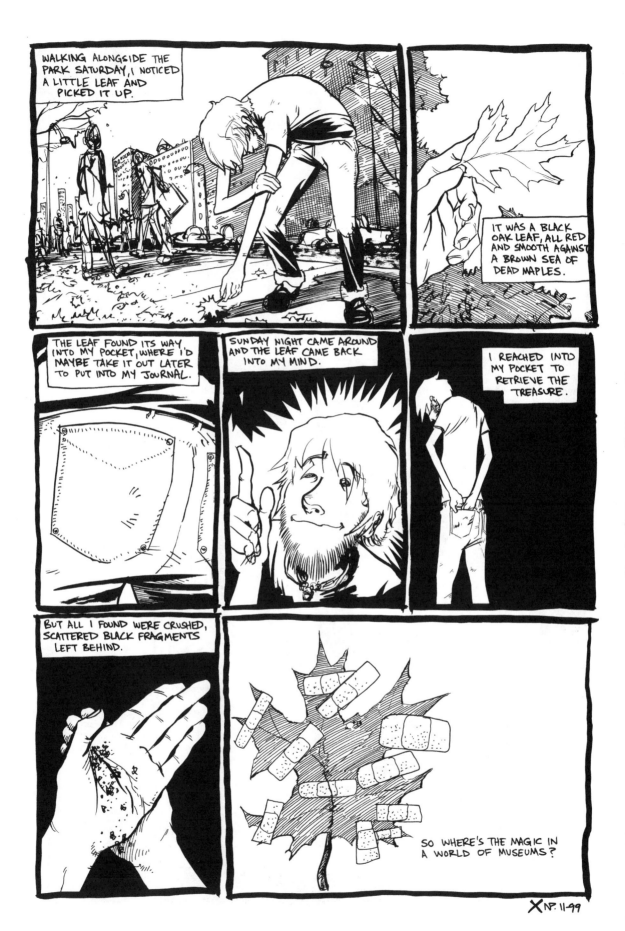

WALKING ALONGSIDE THE PARK SATURDAY, I NOTICED A LITTLE LEAF AND PICKED IT UP.

IT WAS A BLACK OAK LEAF, ALL RED AND SMOOTH AGAINST A BROWN SEA OF DEAD MAPLES.

THE LEAF FOUND ITS WAY INTO MY POCKET, WHERE I'D MAYBE TAKE IT OUT LATER TO PUT INTO MY JOURNAL.

SUNDAY NIGHT CAME AROUND AND THE LEAF CAME BACK INTO MY MIND.

I REACHED INTO MY POCKET TO RETRIEVE THE TREASURE.

BUT ALL I FOUND WERE CRUSHED, SCATTERED BLACK FRAGMENTS LEFT BEHIND.

SO WHERE'S THE MAGIC IN A WORLD OF MUSEUMS?

X NP. 11-99

25

THE PRIME DIRECTIVE

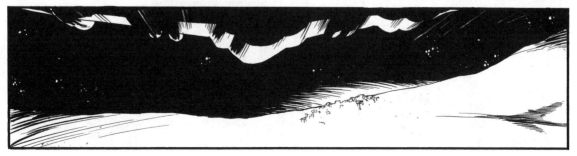

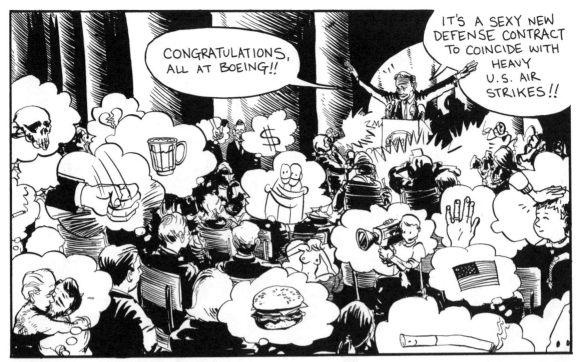

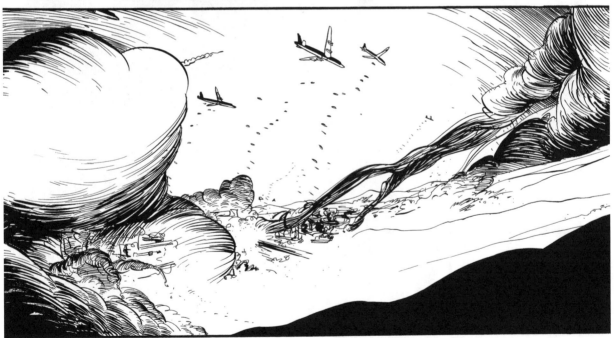

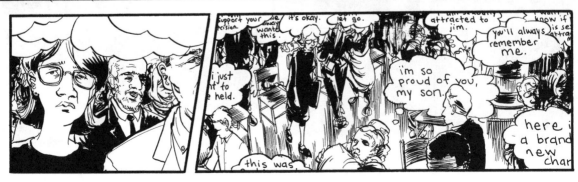

28

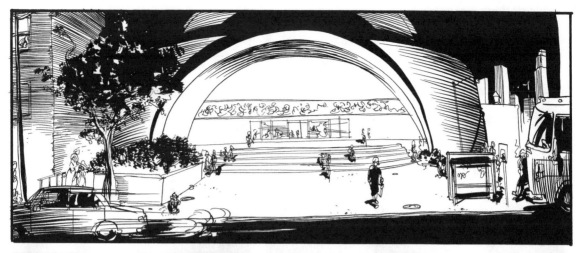

HA HAA!

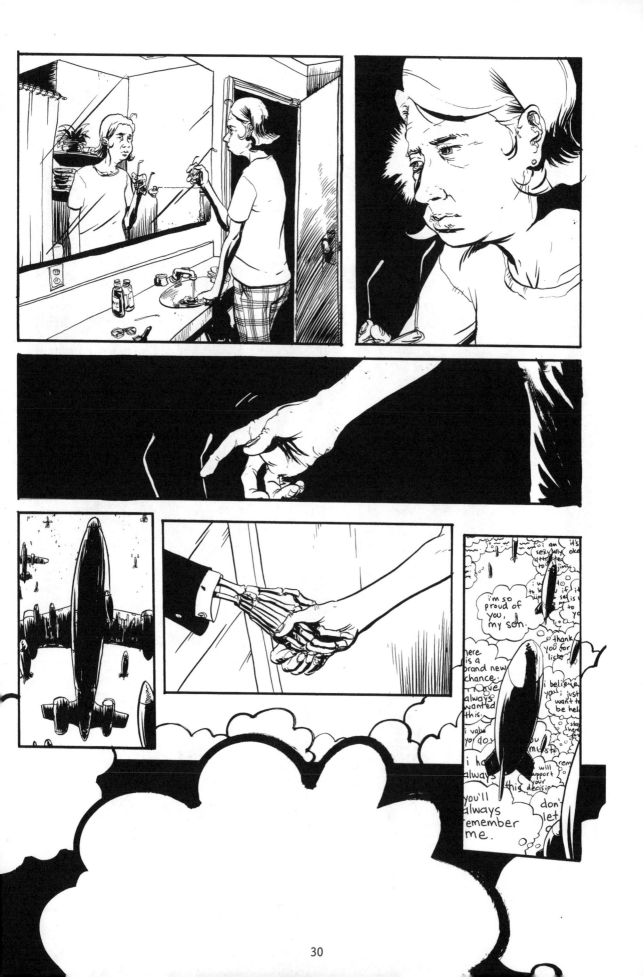

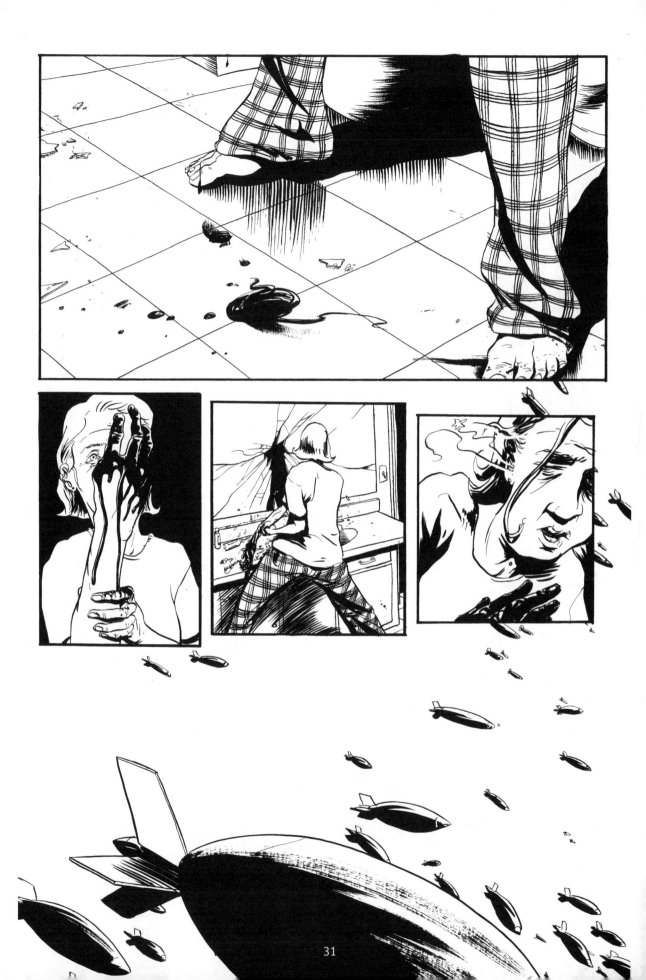

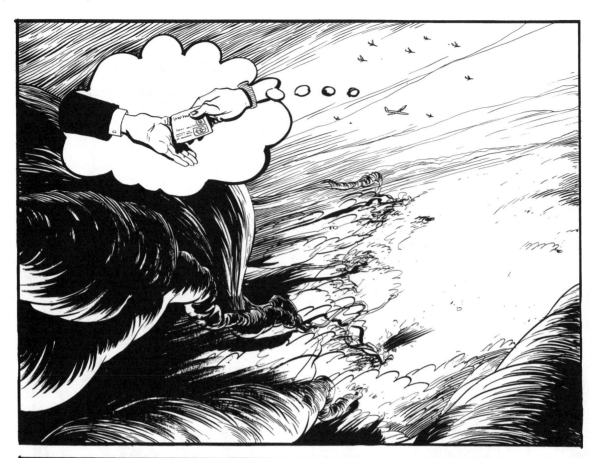

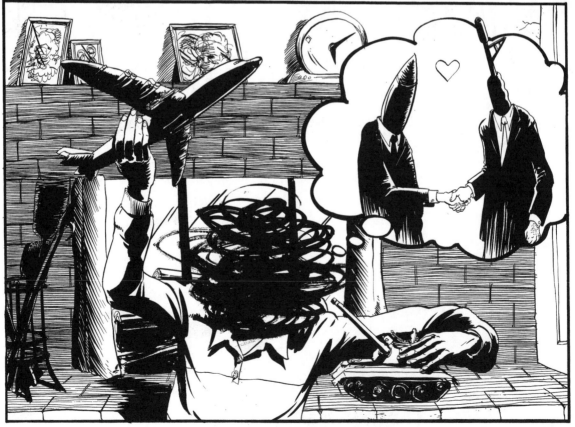

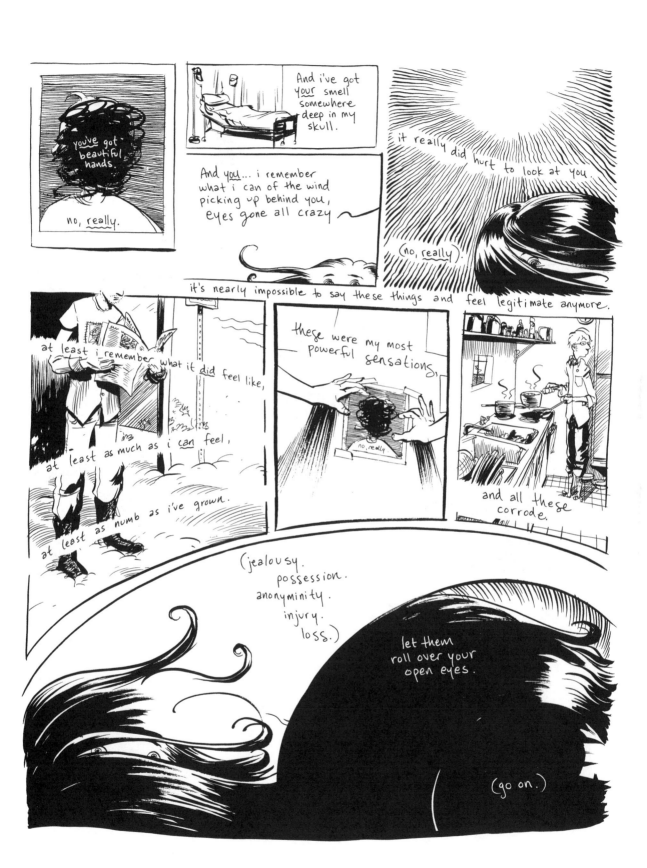

you've got beautiful hands.

no, really.

And i've got your smell somewhere deep in my skull.

And you... i remember what i can of the wind picking up behind you, eyes gone all crazy

it really did hurt to look at you.

(no, really).

it's nearly impossible to say these things and feel legitimate anymore.

at least i remember what it did feel like,

at least as much as i can feel,

at least as numb as i've grown.

these were my most powerful sensations,

no, really

and all these corrode.

(jealousy.
possession.
anonyminity.
injury.
loss.)

let them roll over your open eyes.

(go on.)

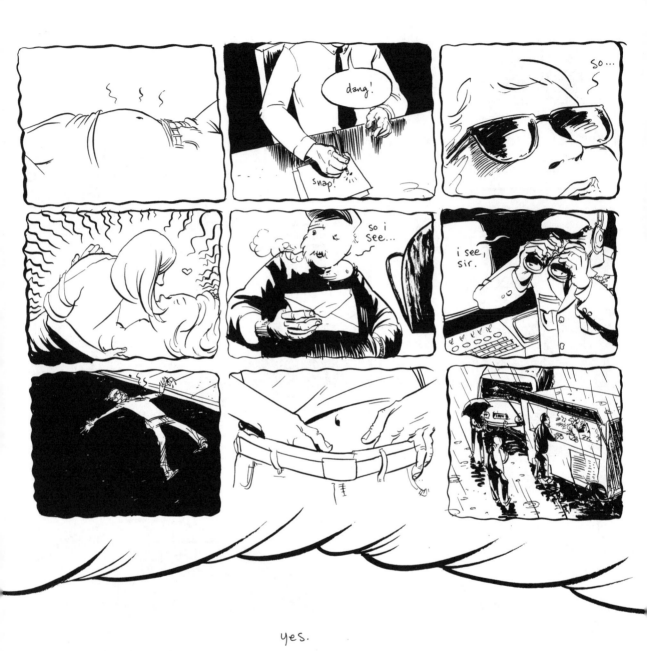

yes.
feel your neck heat up again,
just like it did.

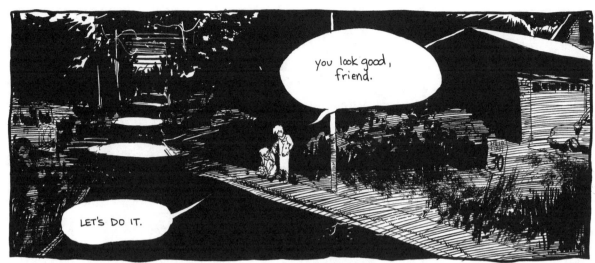

INVISIBILITIES ♆

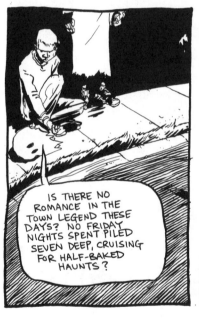

IS THERE NO ROMANCE IN THE TOWN LEGEND THESE DAYS? NO FRIDAY NIGHTS SPENT PILED SEVEN DEEP, CRUISING FOR HALF-BAKED HAUNTS?

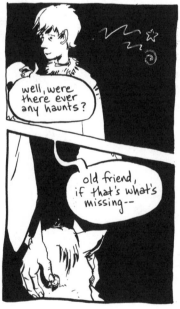

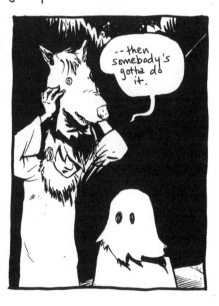

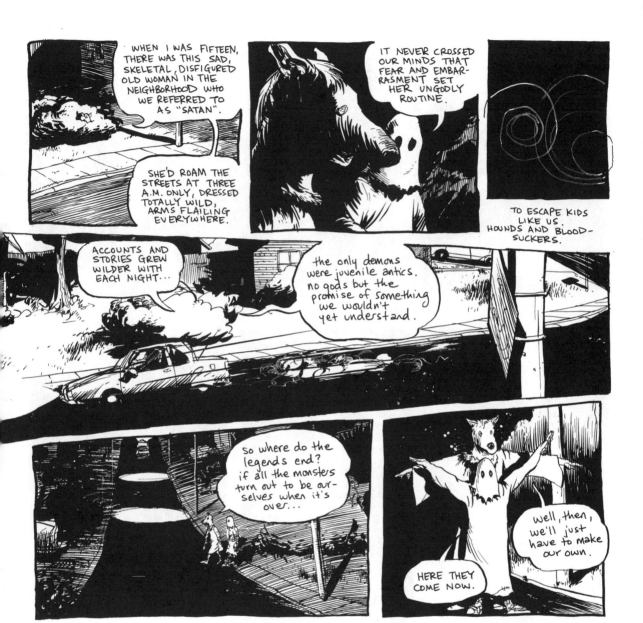

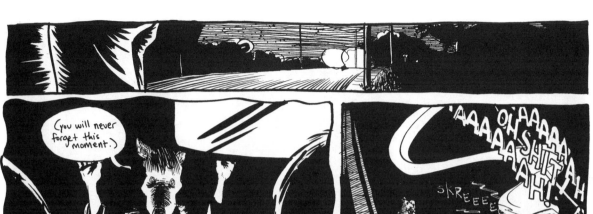

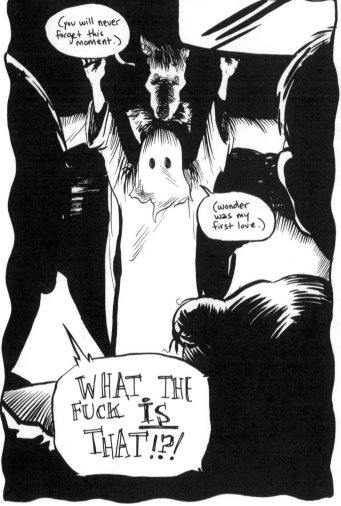

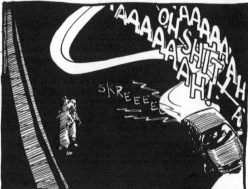

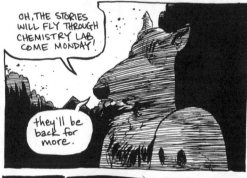

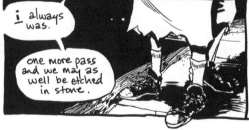

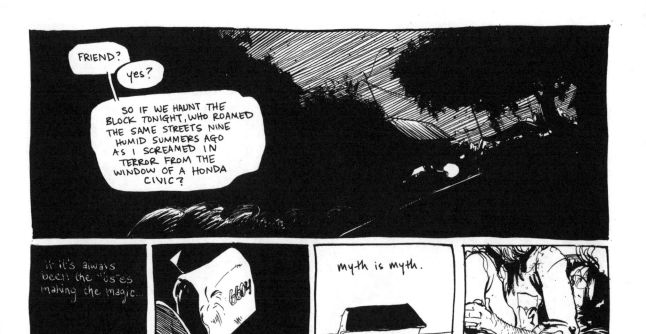

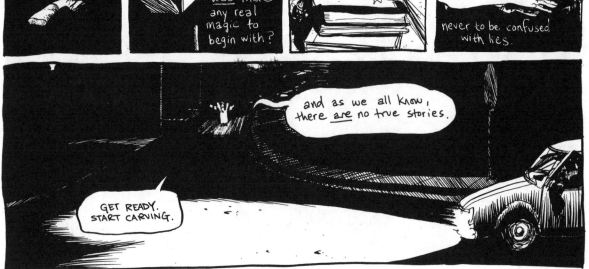

nate powell / seemybrotherdance@lycos.com

X 7-02

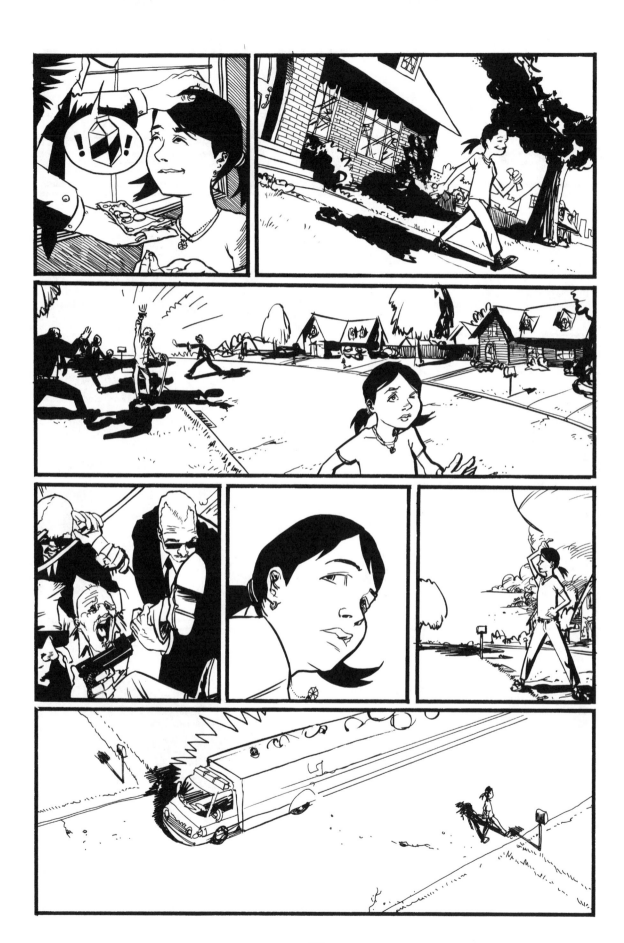

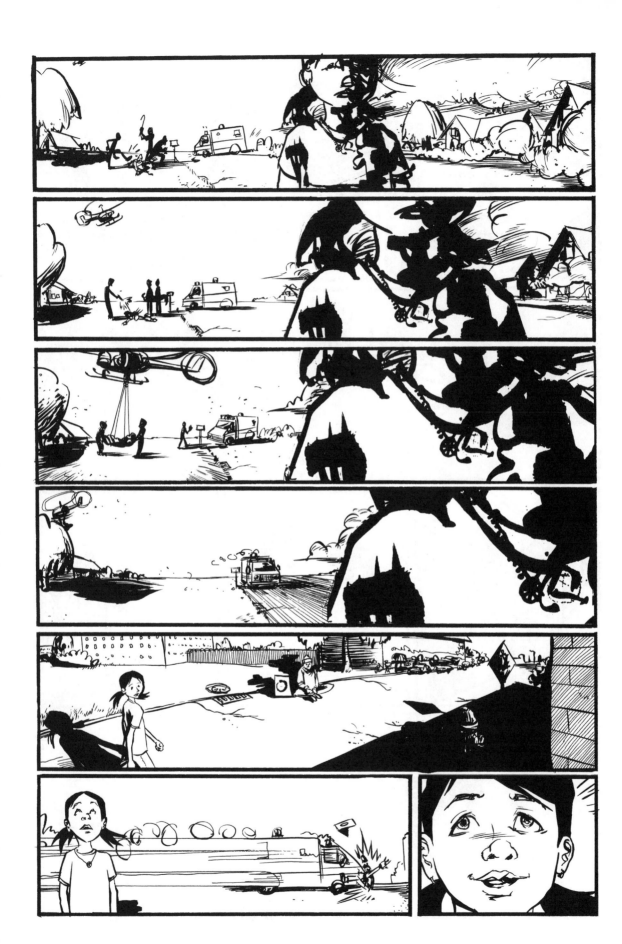

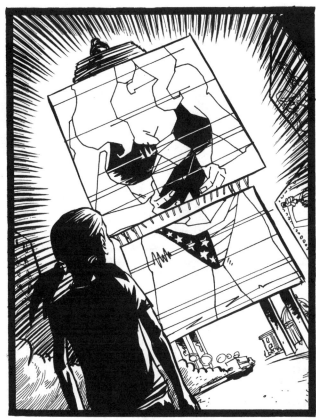
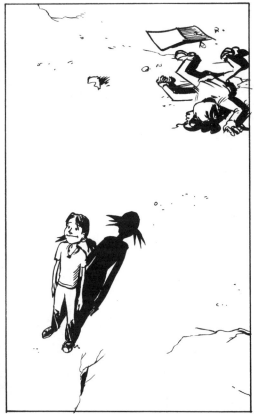
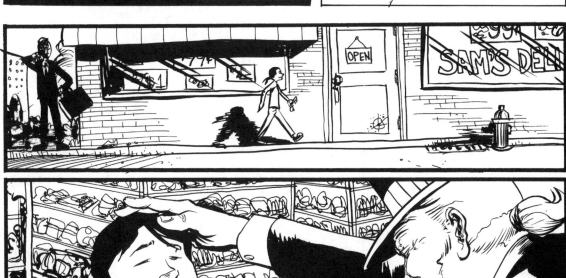

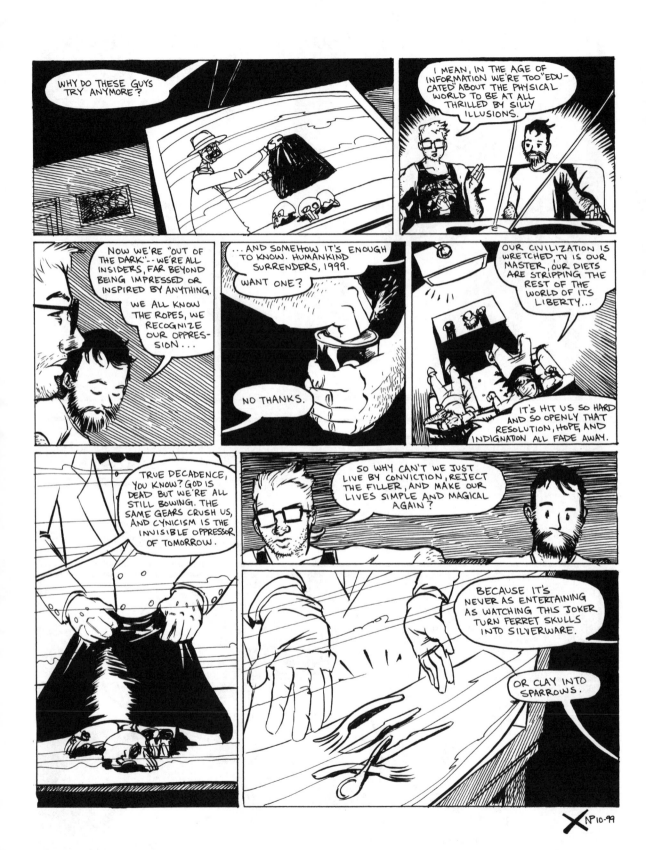

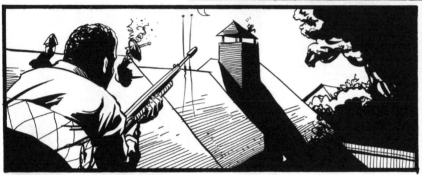

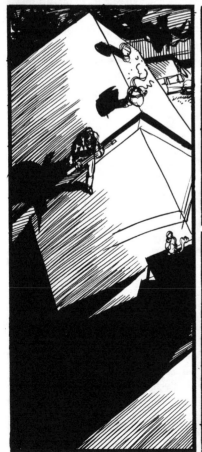

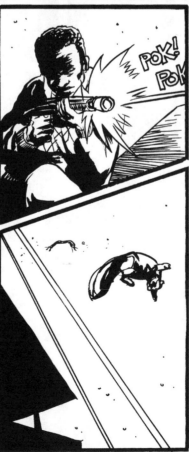

POK!
POK

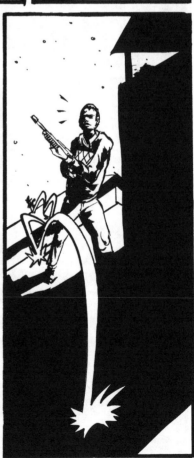

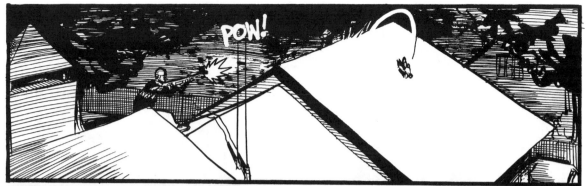

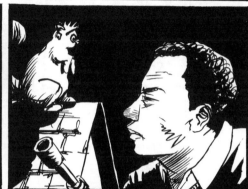

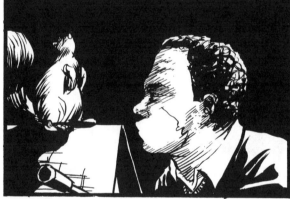

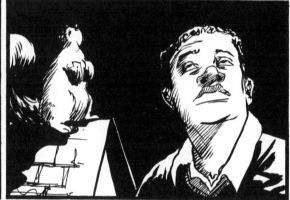

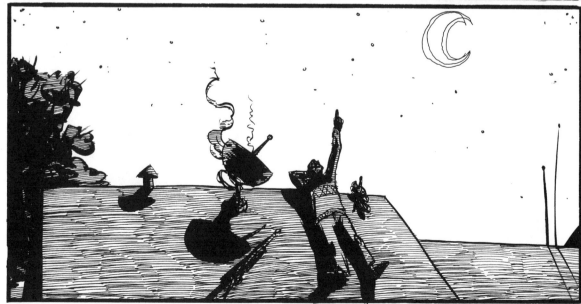

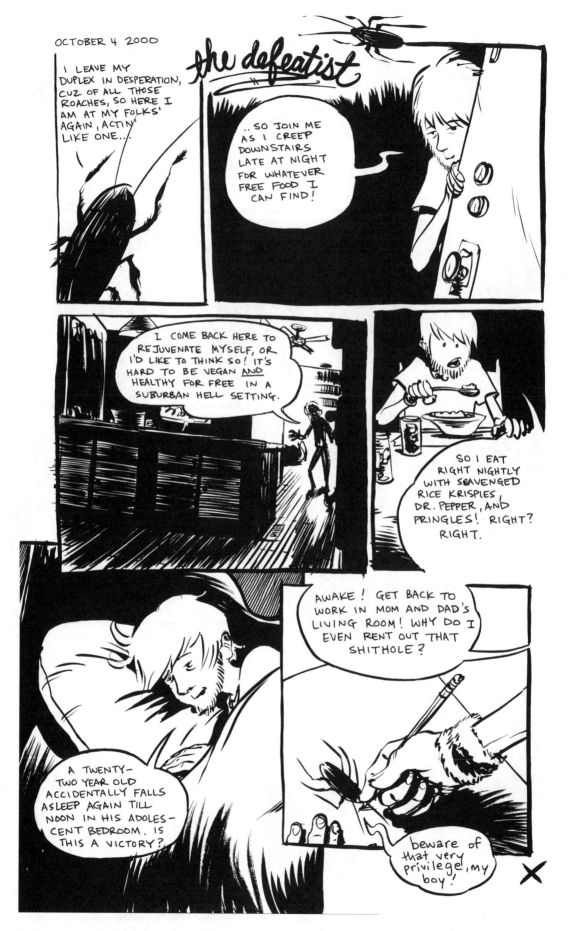

46

IT WAS ONE OF THOSE DAYS YOU NEVER IMAGINE YOU'D REMEMBER, RIGHT? IT WAS FALL OF 1986 AND I WAS IN MONTGOMERY, ALABAMA. A THIRD-GRADER IN MS. MATHERS' ADVANCED READING CLASS (ACTUALLY, A BUNCH OF FOURTH GRADERS)...

(camouflage and rude dog sweats)

WOW! THIS VOCABULARY TEST IS WAY EASIER IF I TAKE IT IN MY OPEN NOTEBOOK WITH THE ANSWERS RIGHT THERE!

YOU DID WHAT!?! NATHAN, THAT'S...

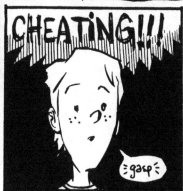

CHEATING!!!

gasp

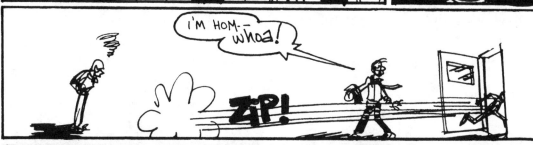

I'M HOM--WHOA!

ZIP!

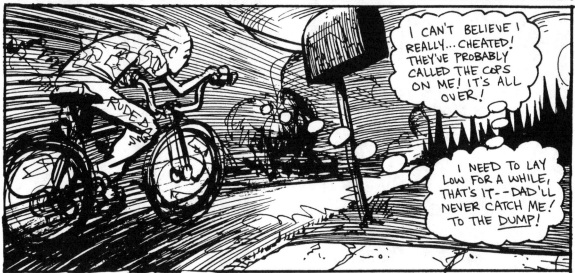

I CAN'T BELIEVE I REALLY...CHEATED! THEY'VE PROBABLY CALLED THE COPS ON ME! IT'S ALL OVER!

I NEED TO LAY LOW FOR A WHILE, THAT'S IT--DAD'LL NEVER CATCH ME! TO THE DUMP!

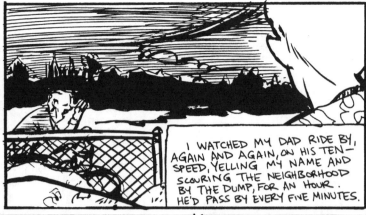

I WATCHED MY DAD RIDE BY, AGAIN AND AGAIN, ON HIS TEN-SPEED, YELLING MY NAME AND SCOURING THE NEIGHBORHOOD BY THE DUMP, FOR AN HOUR. HE'D PASS BY EVERY FIVE MINUTES.

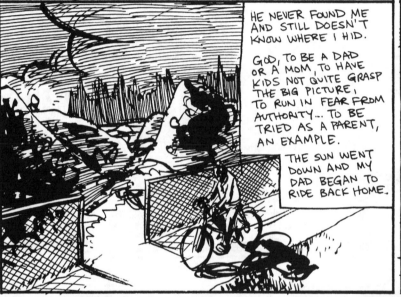

HE NEVER FOUND ME AND STILL DOESN'T KNOW WHERE I HID.

GOD, TO BE A DAD OR A MOM, TO HAVE KIDS NOT QUITE GRASP THE BIG PICTURE, TO RUN IN FEAR FROM AUTHORITY... TO BE TRIED AS A PARENT, AN EXAMPLE.

THE SUN WENT DOWN AND MY DAD BEGAN TO RIDE BACK HOME.

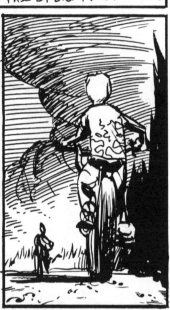

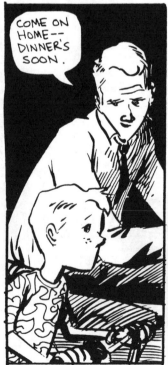

COME ON HOME-- DINNER'S SOON.

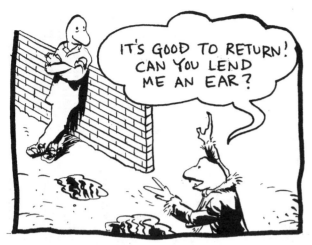

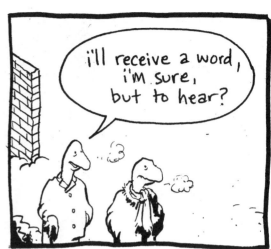

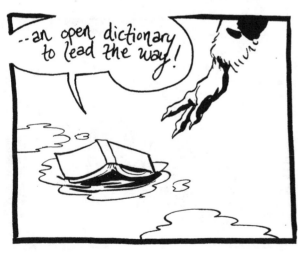

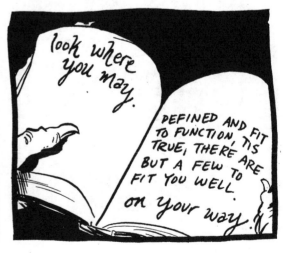

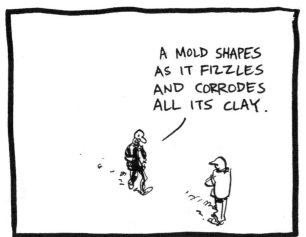

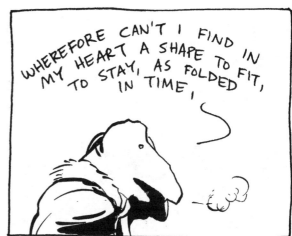

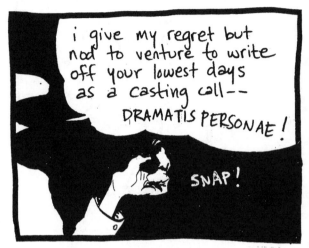

i give my regret but nod to venture to write off your lowest days as a casting call—— DRAMATIS PERSONAE!

SNAP!

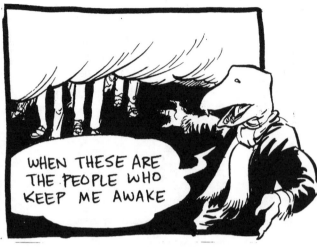

WHEN THESE ARE THE PEOPLE WHO KEEP ME AWAKE

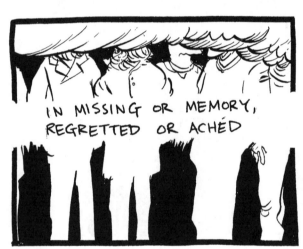

IN MISSING OR MEMORY, REGRETTED OR ACHÉD

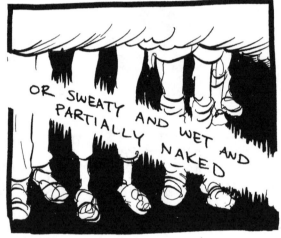

OR SWEATY AND WET AND PARTIALLY NAKED

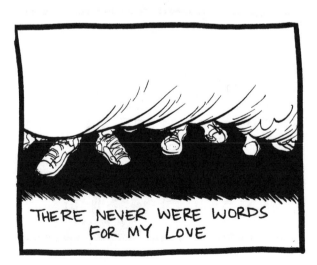

THERE NEVER WERE WORDS FOR MY LOVE

YET I DO

I TAKE AS IT SHIFTS
SHAPES BUT SHAN'T
EVER NAME IT.

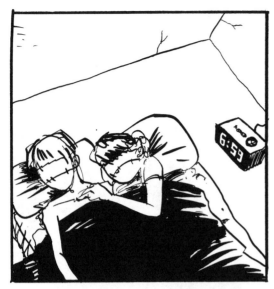
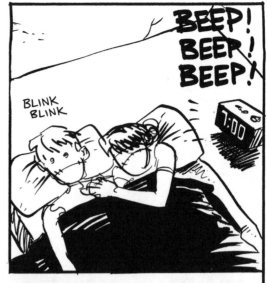
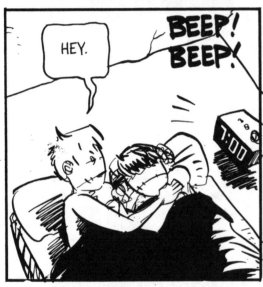
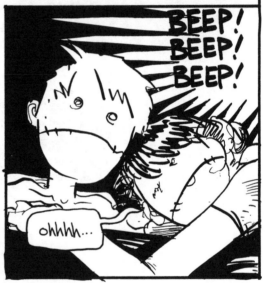
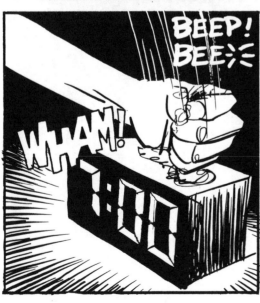
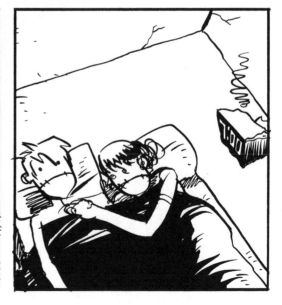

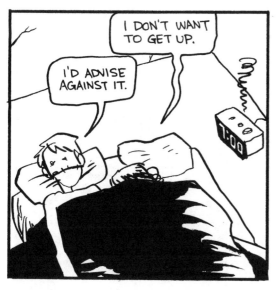

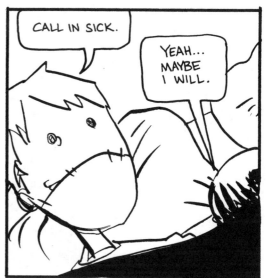

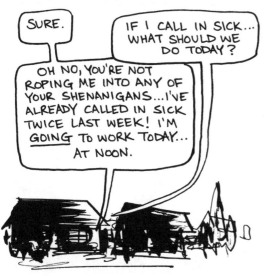

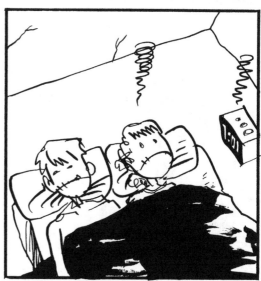

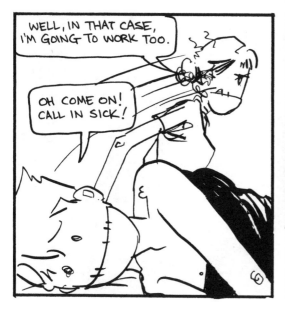

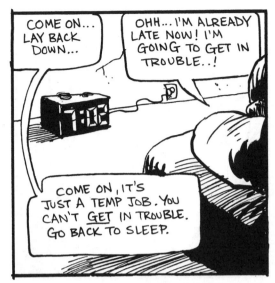

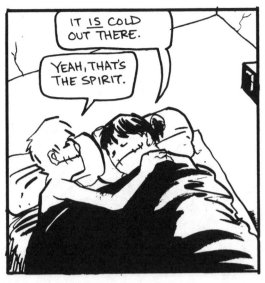

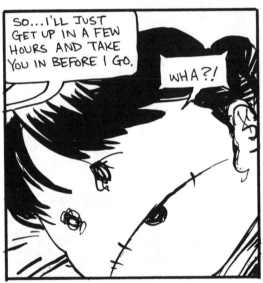

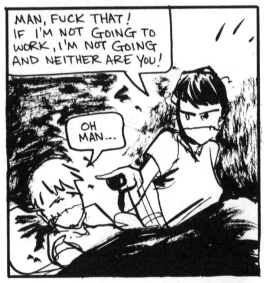

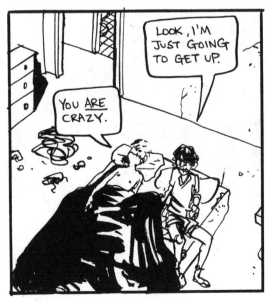

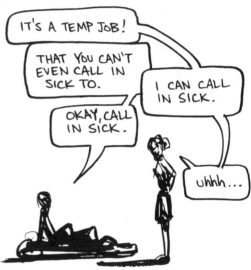

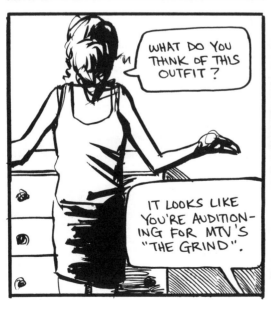

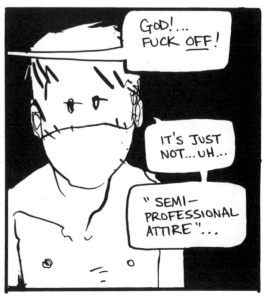

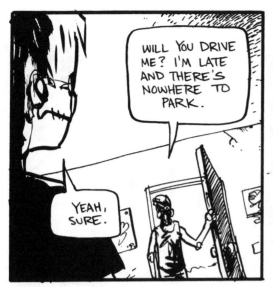

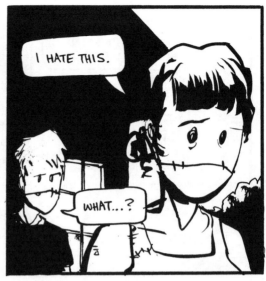

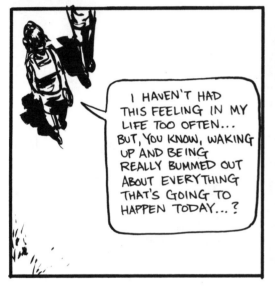

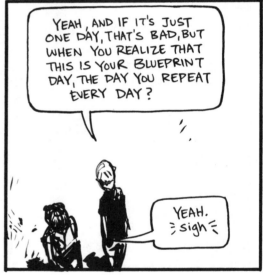

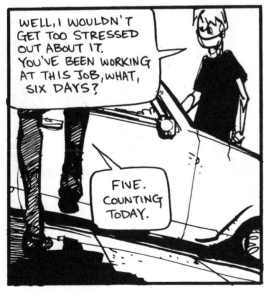

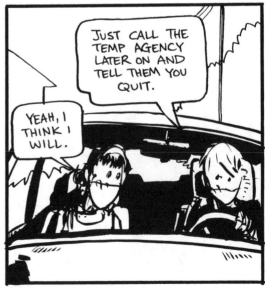

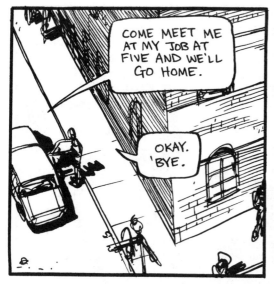

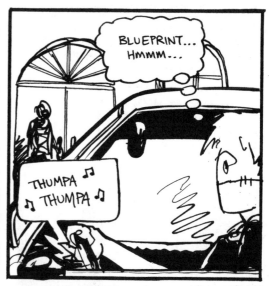

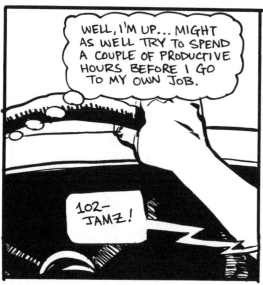

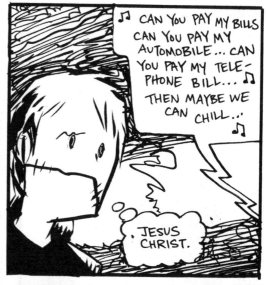

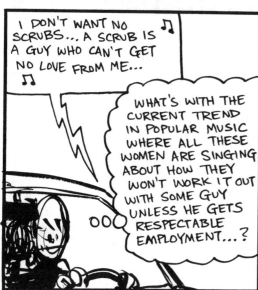

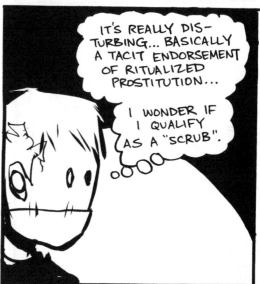

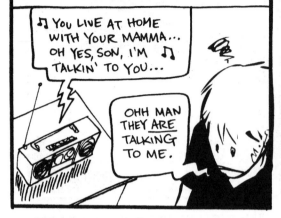

I REMEMBER, THIS SUMMER I WAS STAYING WITH MY MOM IN ROME... IN ITALY THE TLC SONG "NO SCRUBS" WAS HUGE... AND IT REALLY BURNED ME--ESPECIALLY THE ONE LINE --

♪ YOU LIVE AT HOME WITH YOUR MAMMA... OH YES, SON, I'M ♪ TALKIN' TO YOU...

OHH MAN THEY ARE TALKING TO ME.

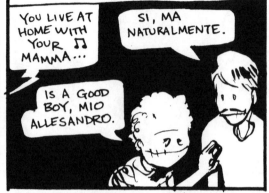

BUT THEN, AFTER A FEW WEEKS I HADN'T MET A SINGLE ITALIAN MALE WHO DIDN'T LIVE WITH HIS MOTHER... IT'S JUST THE WAY THEY DO IT OVER THERE. MAYBE THEY DON'T TAKE THE LINE AS DEROGATORY.

YOU LIVE AT HOME WITH YOUR ♪ MAMMA...

SI, MA NATURALMENTE.

IS A GOOD BOY, MIO ALLESANDRO.

WELL, HOME.

COFFEE.

THERE'S SOME HALF-AND-HALF IN THE FRIDGE SOMEWHERE...

≷SIGH≷

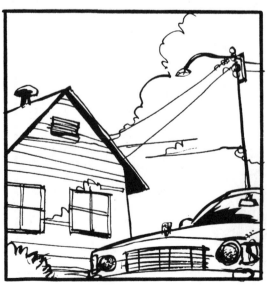

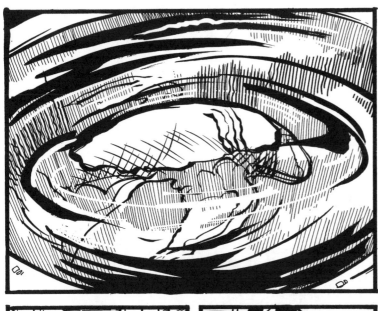
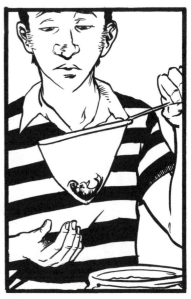
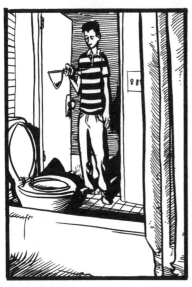
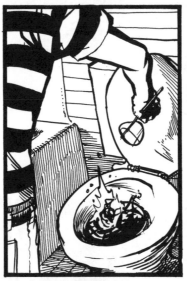

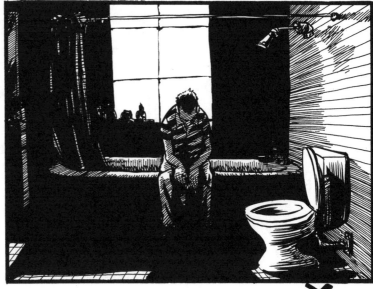

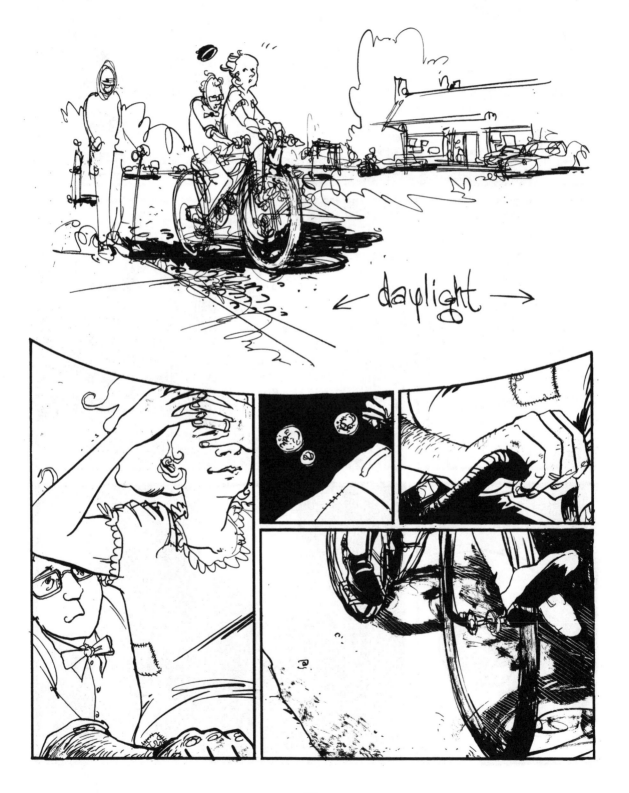

← daylight →

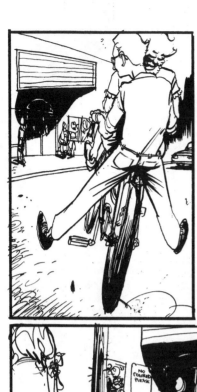
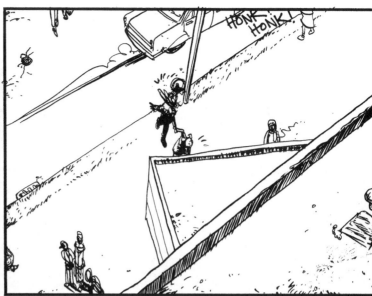
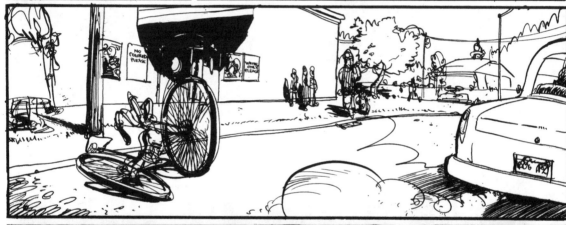
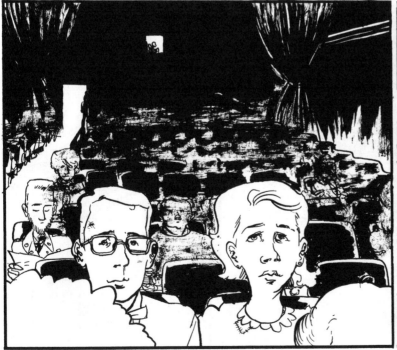

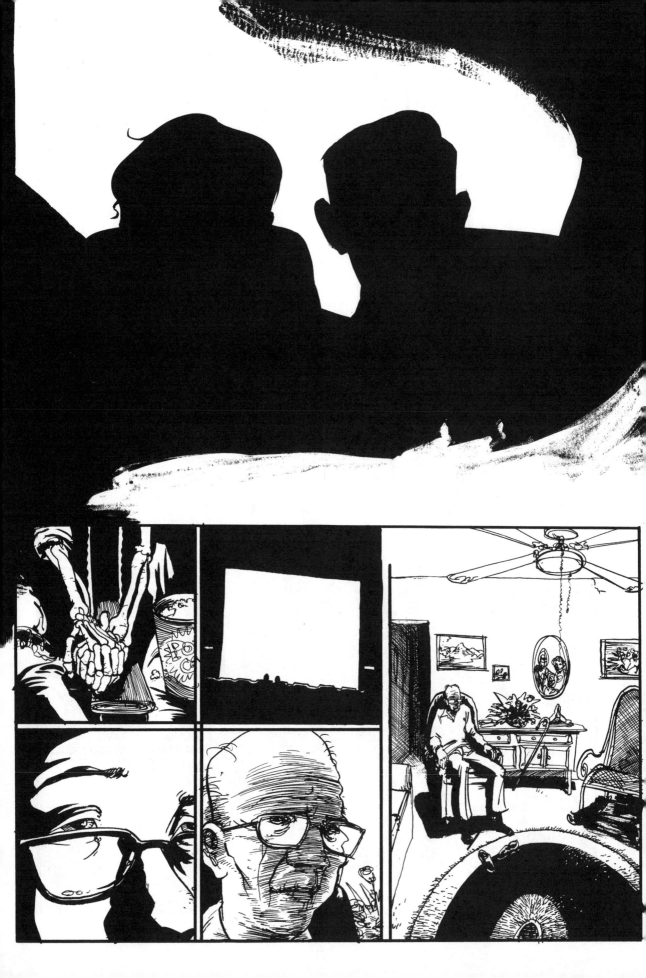

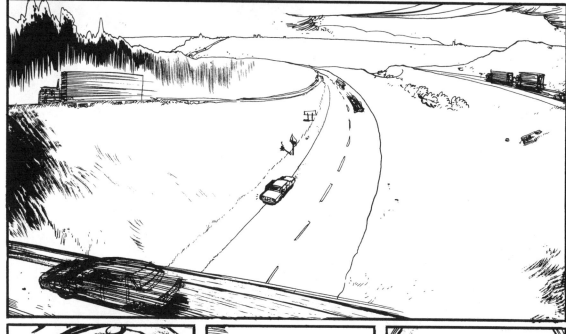

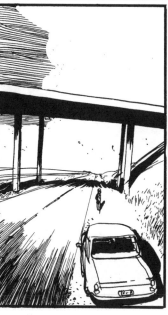
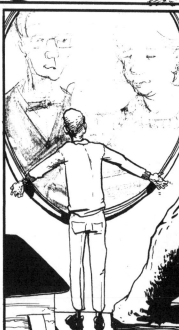

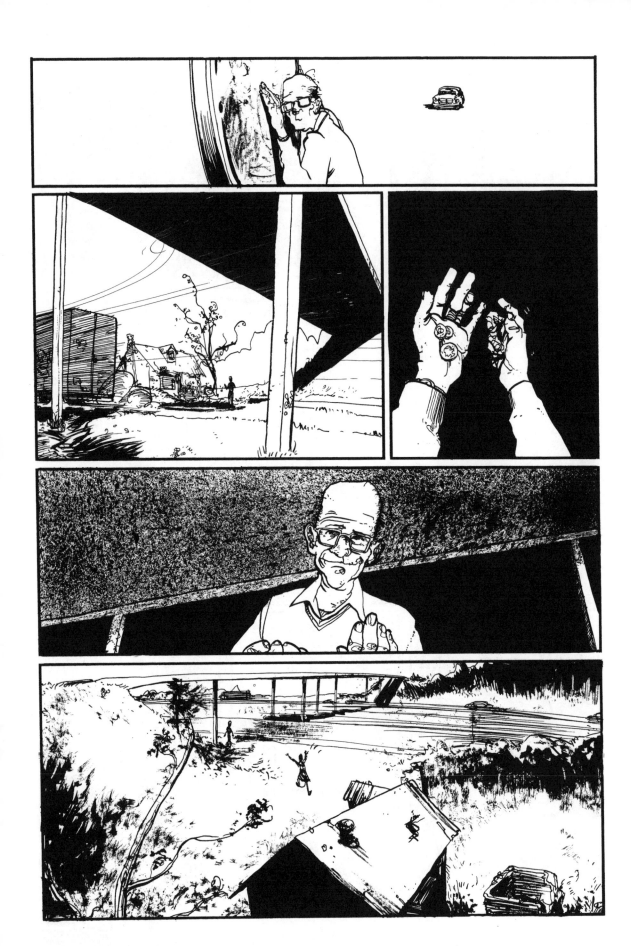

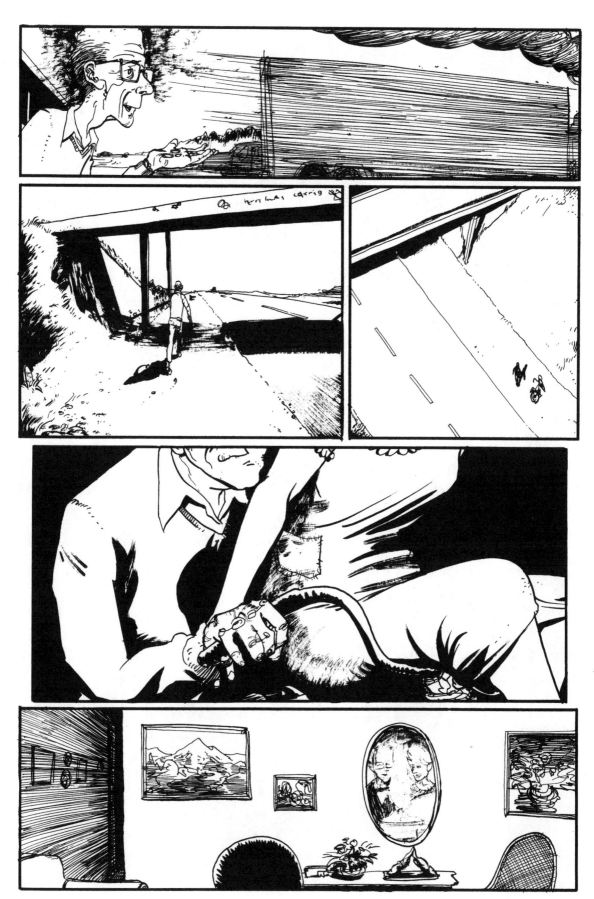

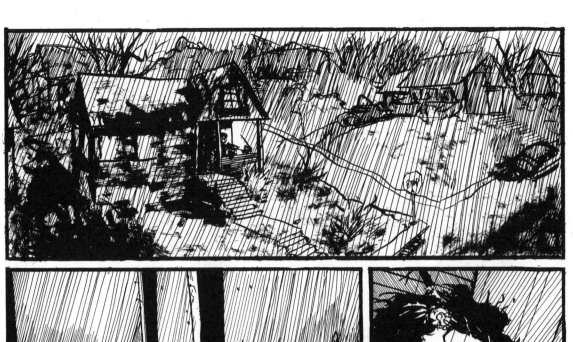

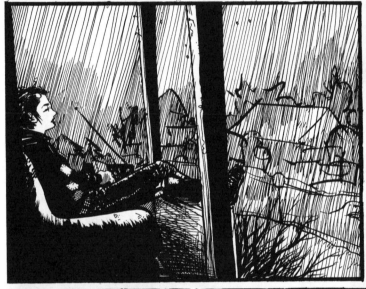

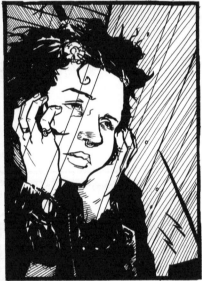

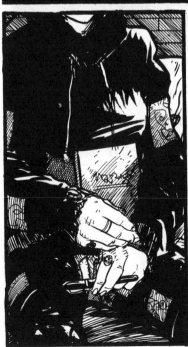

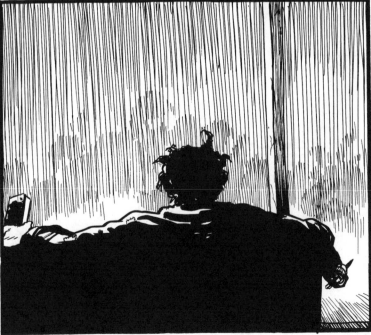

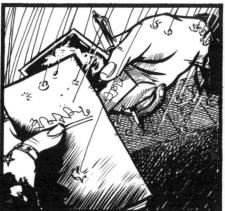
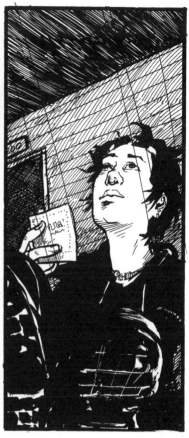
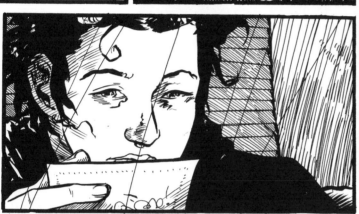

STORIES NOT AS SHORT

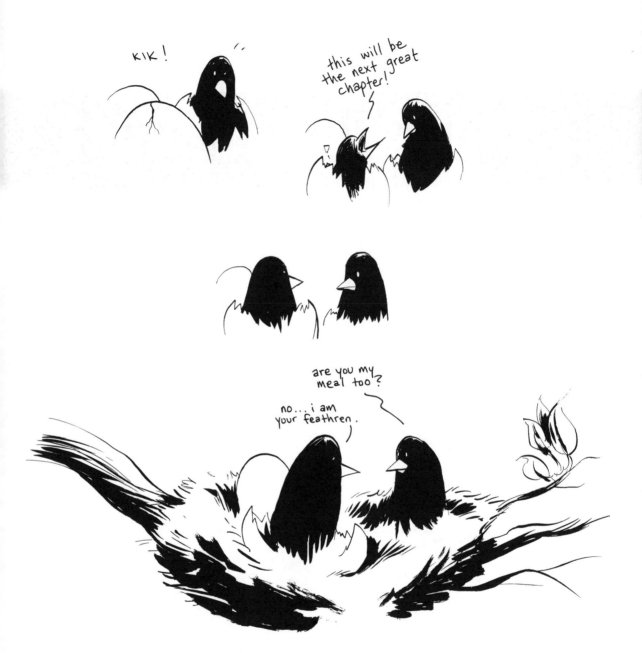

CONDITIONS

1. mercury

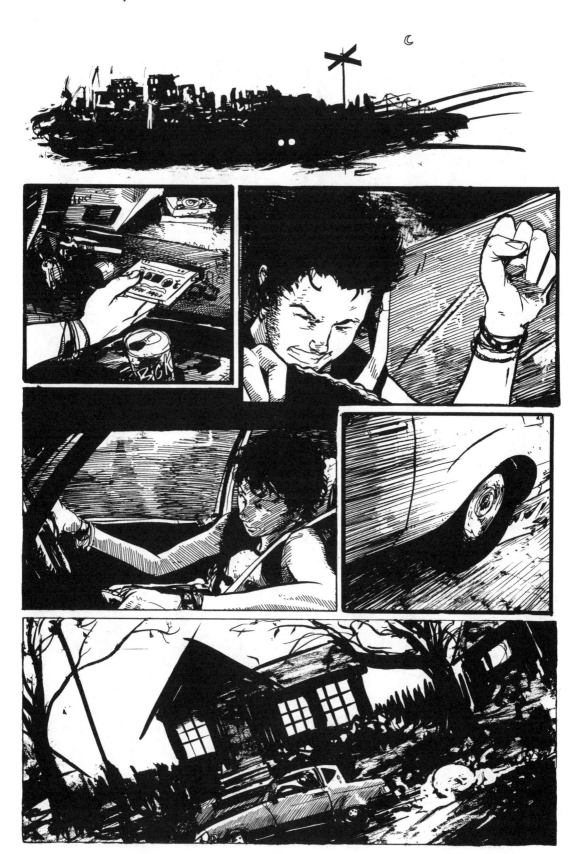

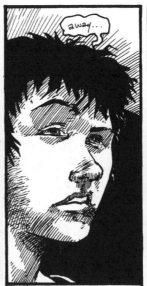
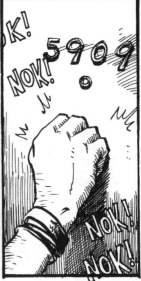

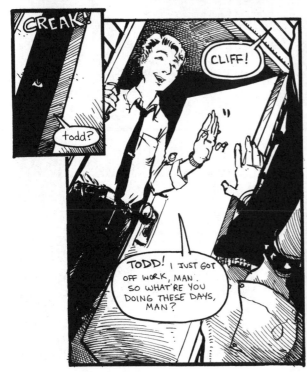
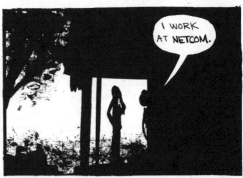
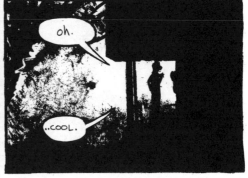

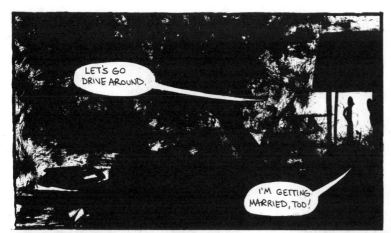

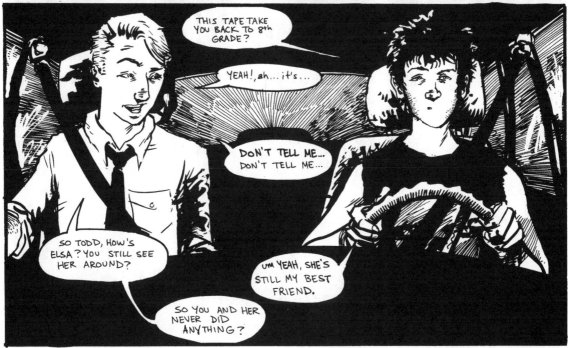

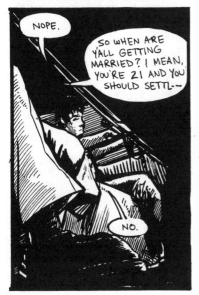

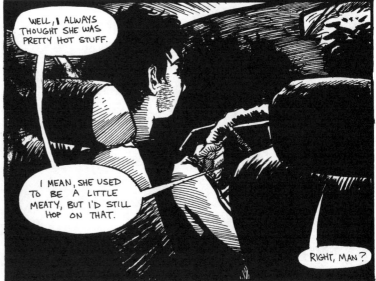

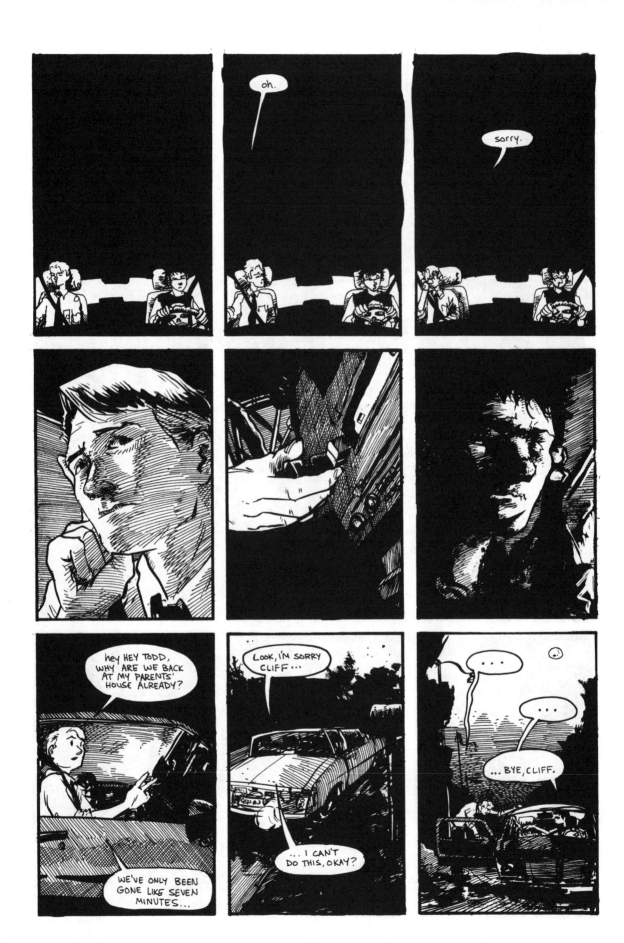

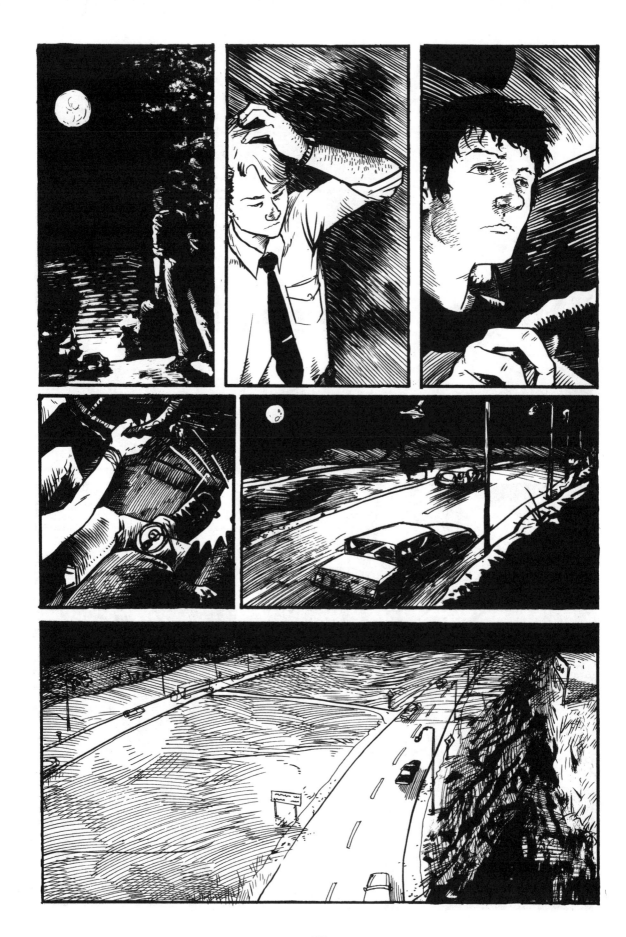

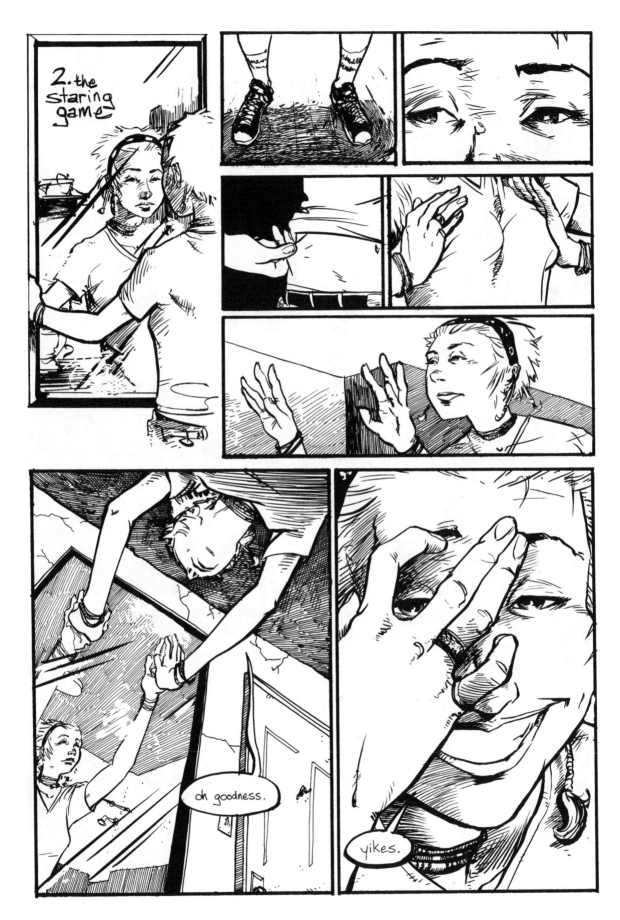

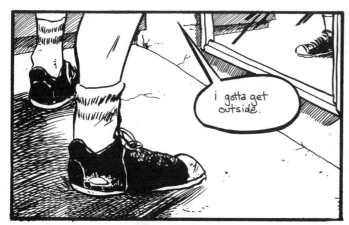

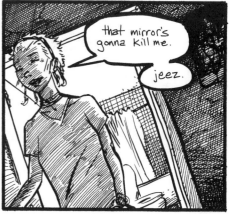

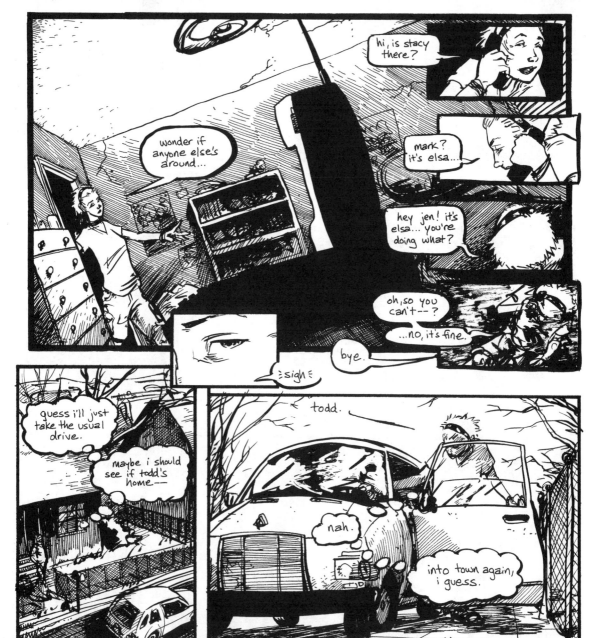

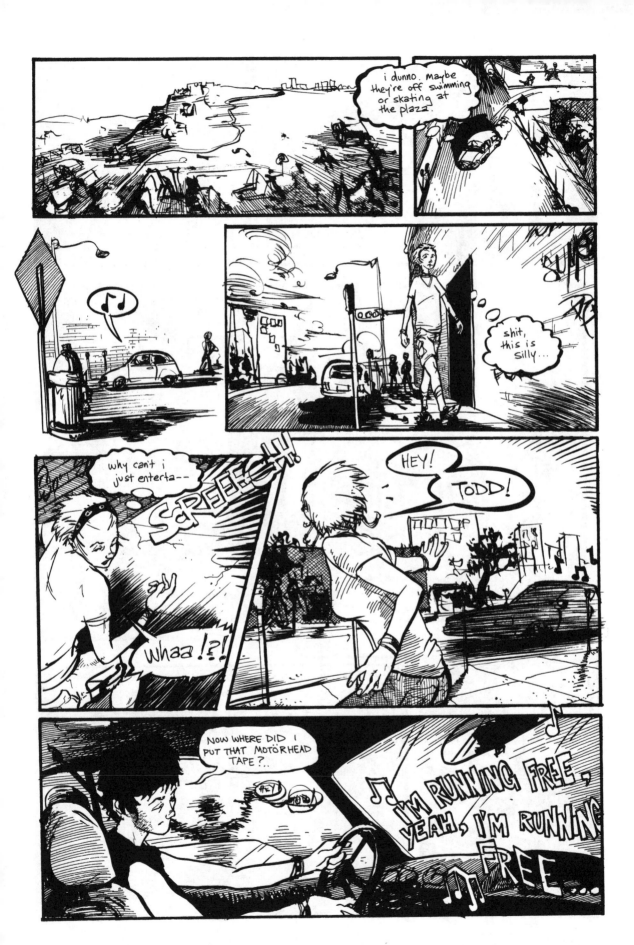

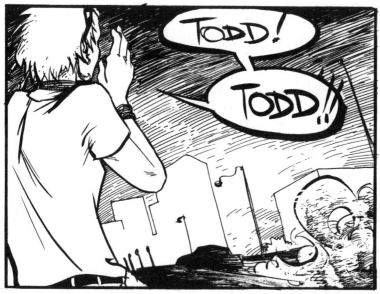

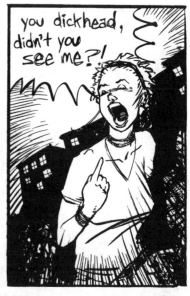

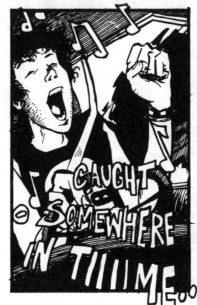

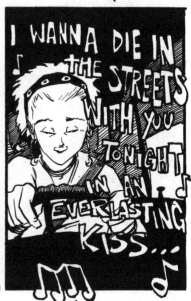

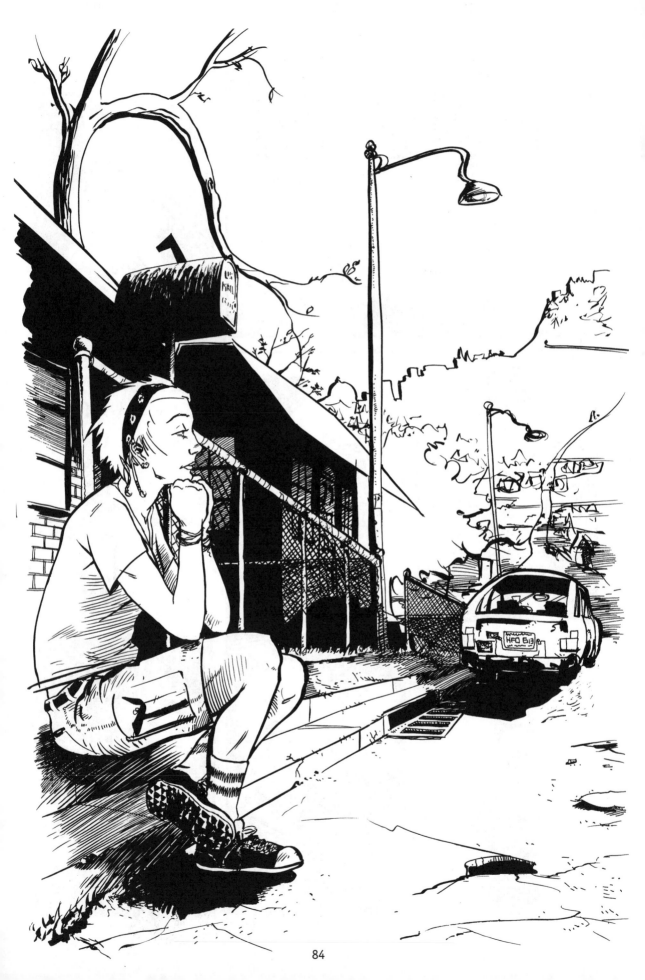

3. the mission

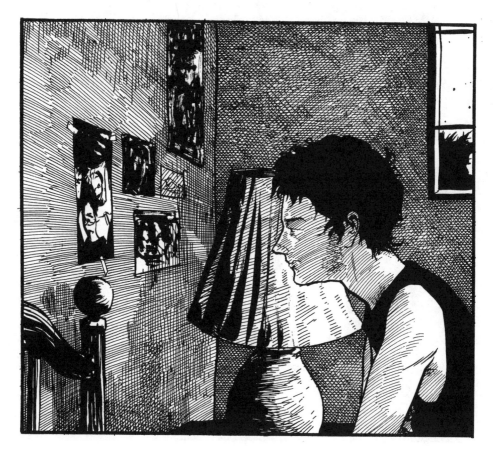

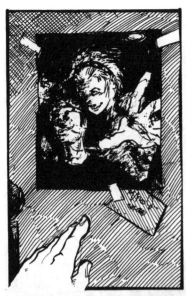
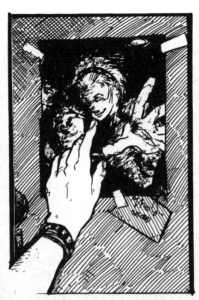
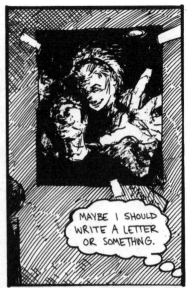

MAYBE I SHOULD WRITE A LETTER OR SOMETHING.

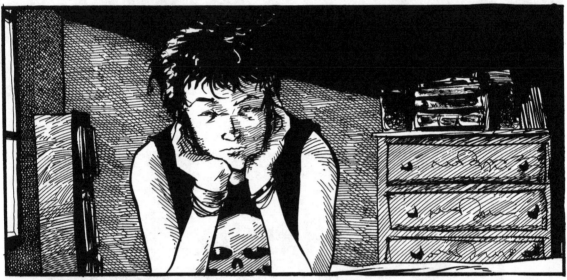

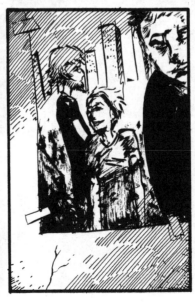

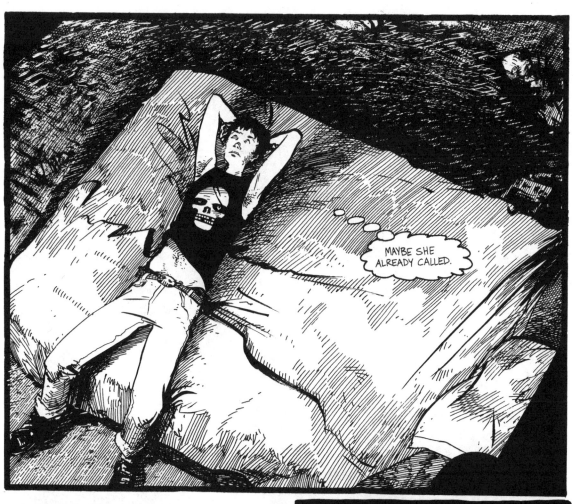

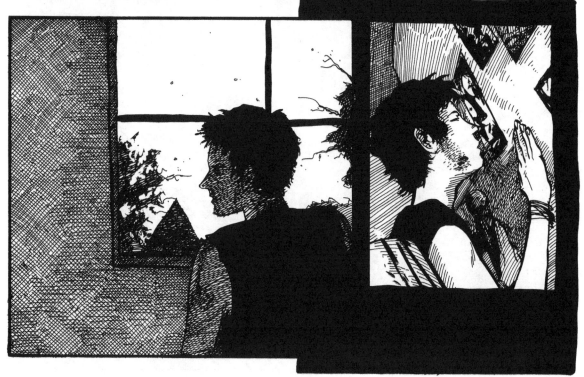

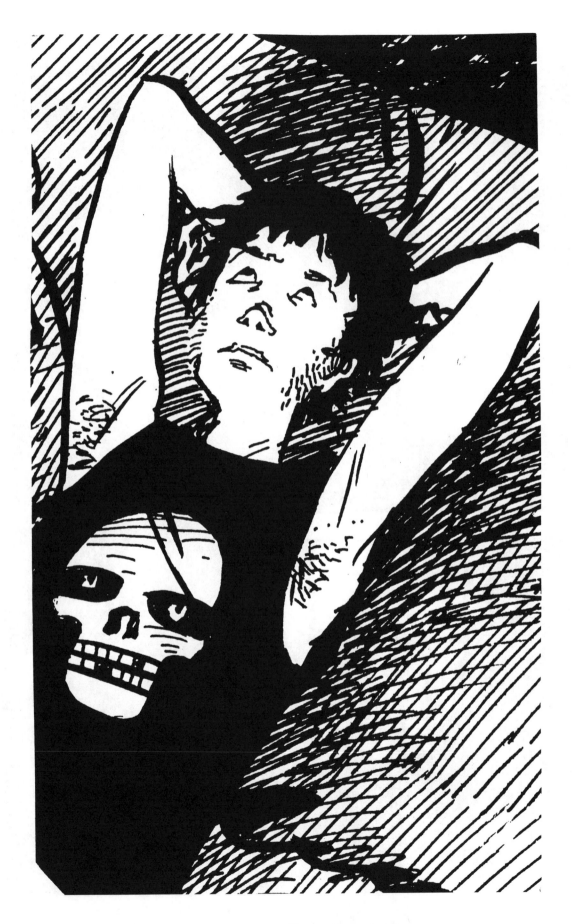

4. CLOCKS

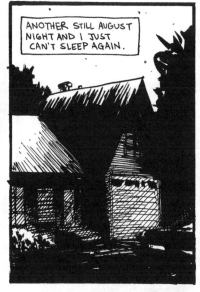

ANOTHER STILL AUGUST NIGHT AND I JUST CAN'T SLEEP AGAIN.

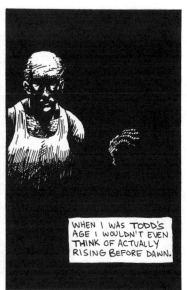

WHEN I WAS TODD'S AGE I WOULDN'T EVEN THINK OF ACTUALLY RISING BEFORE DAWN.

..UNLESS I WAS SNEAKING OUT AGAIN, THAT IS.

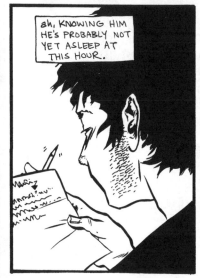

ah, KNOWING HIM HE'S PROBABLY NOT YET ASLEEP AT THIS HOUR.

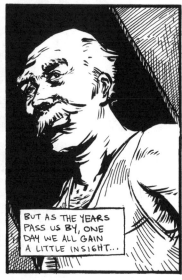

BUT AS THE YEARS PASS US BY, ONE DAY WE ALL GAIN A LITTLE INSIGHT...

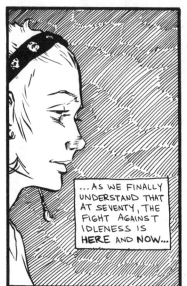

...AS WE FINALLY UNDERSTAND THAT AT SEVENTY, THE FIGHT AGAINST IDLENESS IS HERE AND NOW...

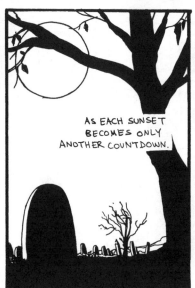

AS EACH SUNSET BECOMES ONLY ANOTHER COUNTDOWN.

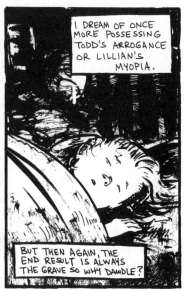

I DREAM OF ONCE MORE POSSESSING TODD'S ARROGANCE OR LILLIAN'S MYOPIA.

BUT THEN AGAIN, THE END RESULT IS ALWAYS THE GRAVE SO WHY DAWDLE?

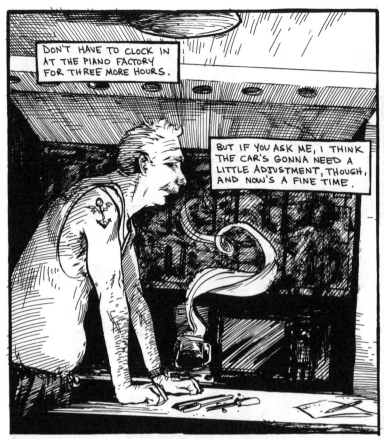

DON'T HAVE TO CLOCK IN AT THE PIANO FACTORY FOR THREE MORE HOURS.

BUT IF YOU ASK ME, I THINK THE CAR'S GONNA NEED A LITTLE ADJUSTMENT, THOUGH, AND NOW'S A FINE TIME.

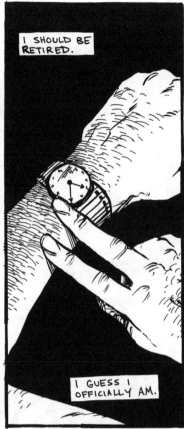

I SHOULD BE RETIRED.

I GUESS I OFFICIALLY AM.

BUT WE'VE ALL GOT TO KEEP OUR HAND'S FULL SOMEHOW...

EVEN IF WE KNOW WE'RE ONLY FOOLING OURSELVES.

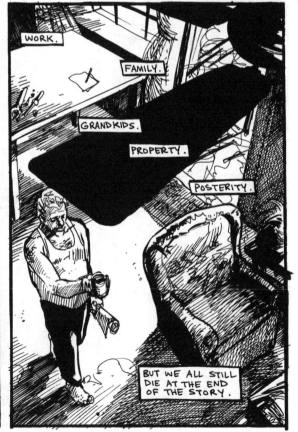

WORK.

FAMILY.

GRANDKIDS.

PROPERTY.

POSTERITY.

BUT WE ALL STILL DIE AT THE END OF THE STORY.

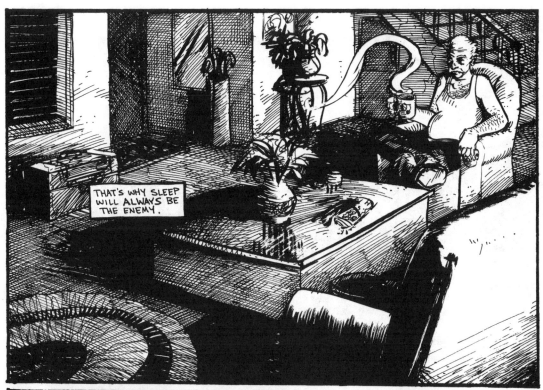

THAT'S WHY SLEEP WILL ALWAYS BE THE ENEMY.

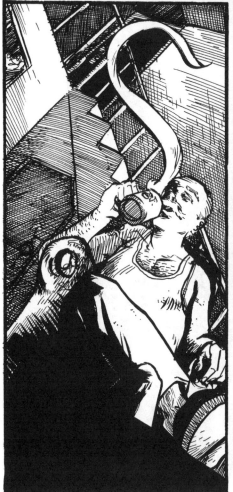

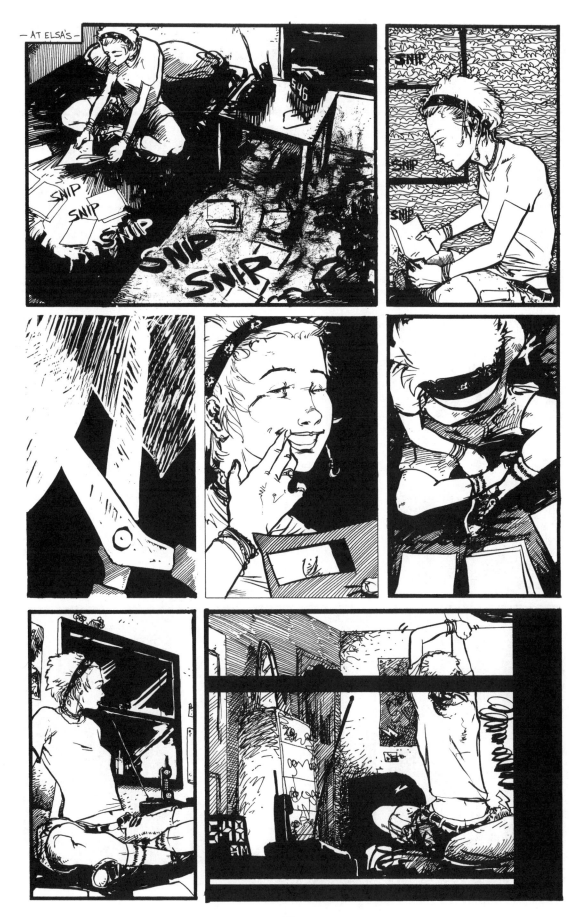

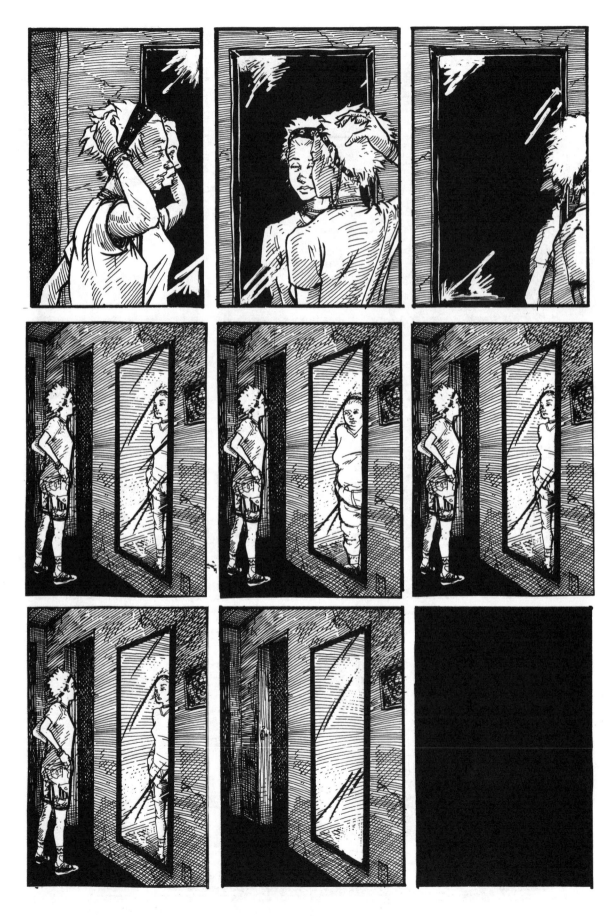

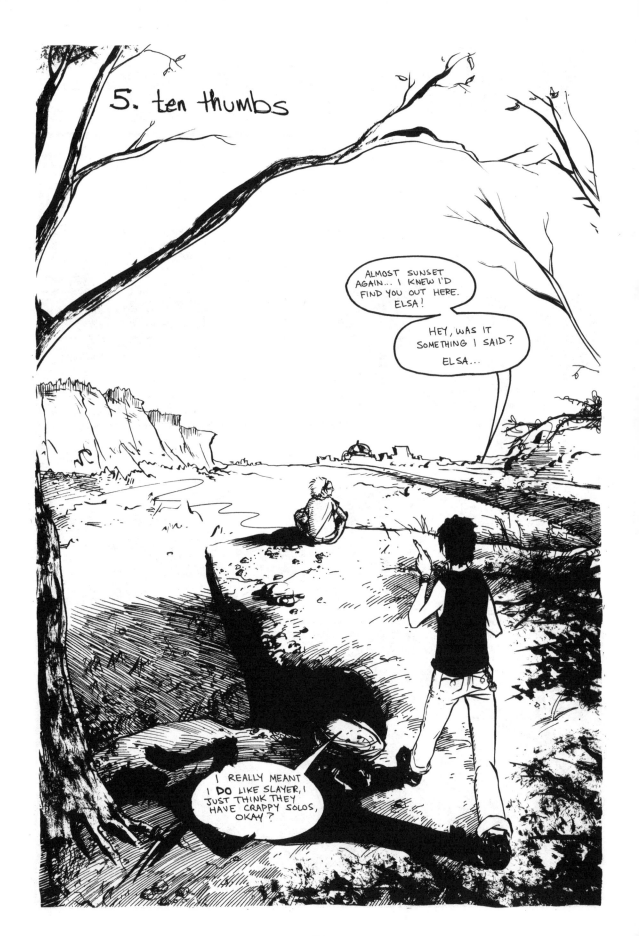

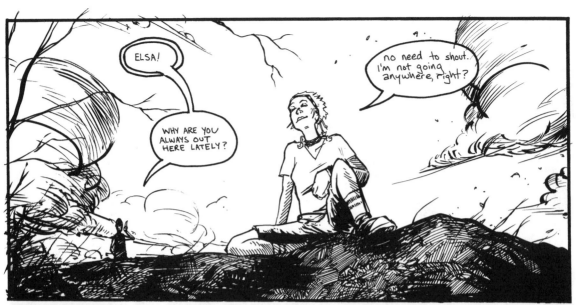

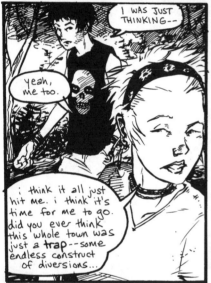

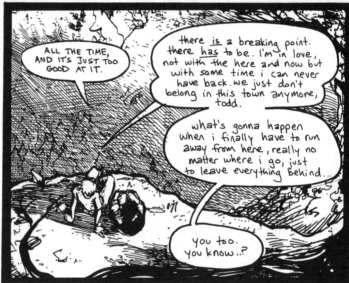

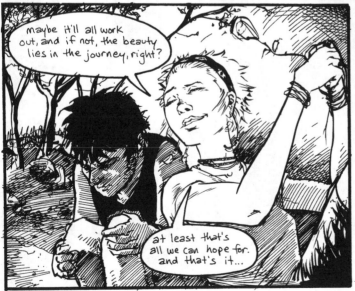

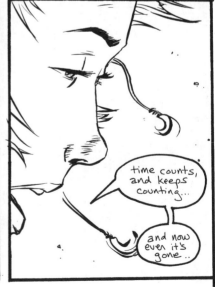

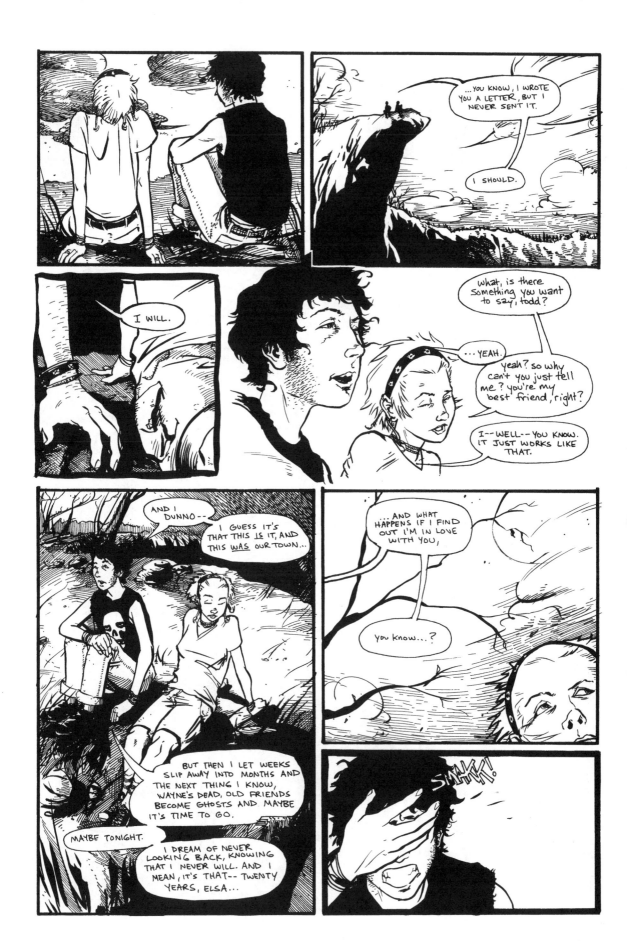

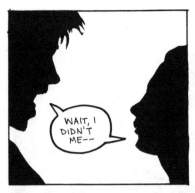

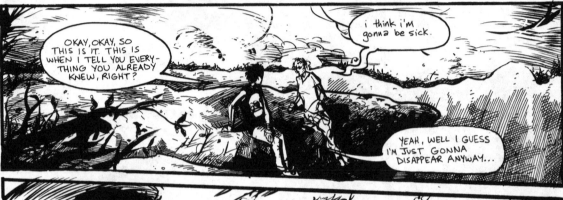
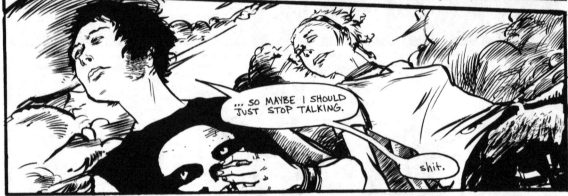
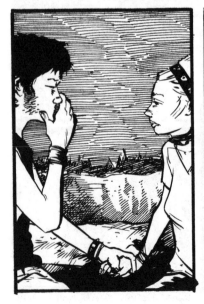
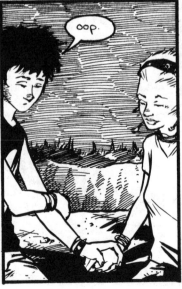
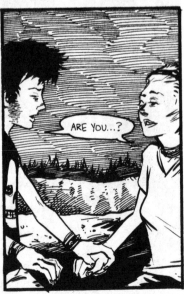

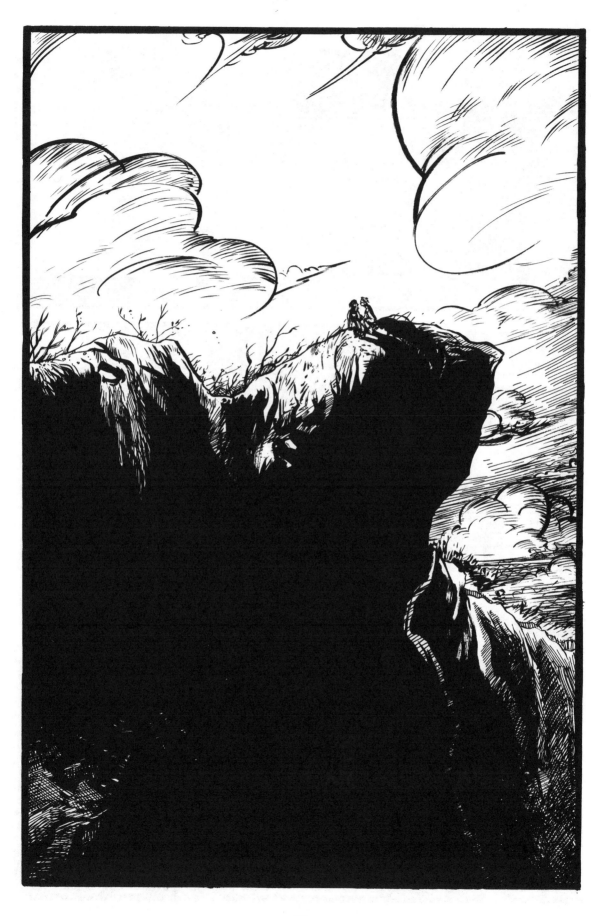

6. NEVER ENDER

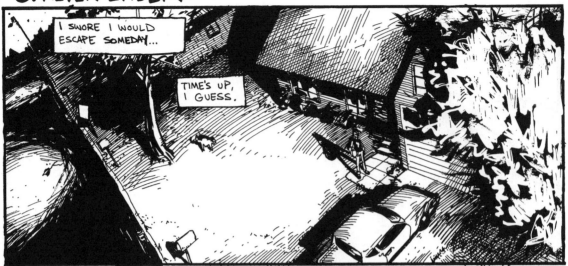

I SWORE I WOULD ESCAPE SOMEDAY...

TIME'S UP, I GUESS.

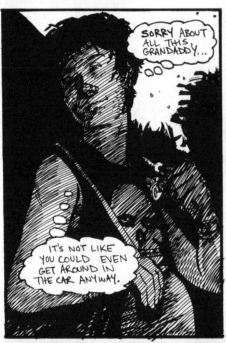

SORRY ABOUT ALL THIS GRANDADDY...

IT'S NOT LIKE YOU COULD EVEN GET AROUND IN THE CAR ANYWAY.

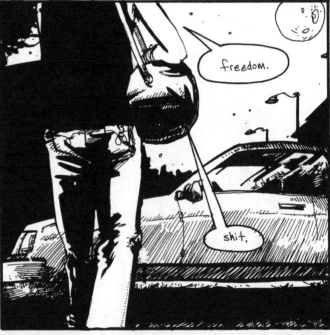

freedom.

shit.

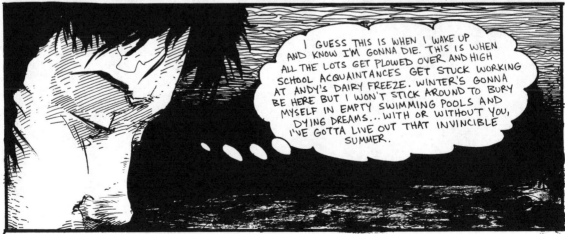

I GUESS THIS IS WHEN I WAKE UP AND KNOW I'M GONNA DIE. THIS IS WHEN ALL THE LOTS GET PLOWED OVER AND HIGH SCHOOL ACQUAINTANCES GET STUCK WORKING AT ANDY'S DAIRY FREEZE. WINTER'S GONNA BE HERE BUT I WON'T STICK AROUND TO BURY MYSELF IN EMPTY SWIMMING POOLS AND DYING DREAMS... WITH OR WITHOUT YOU, I'VE GOTTA LIVE OUT THAT INVINCIBLE SUMMER.

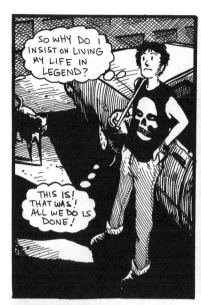

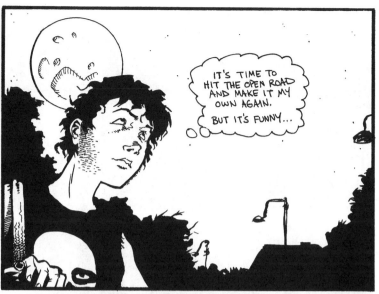

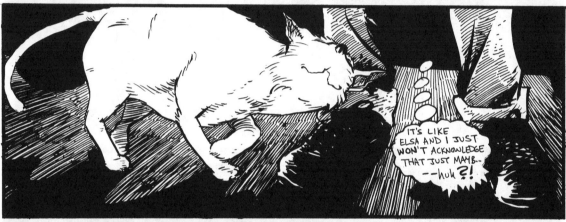

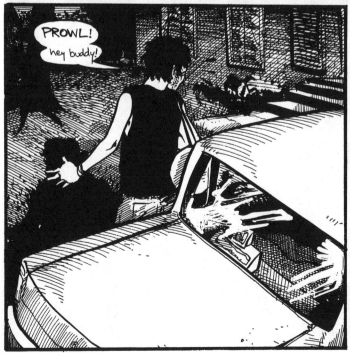

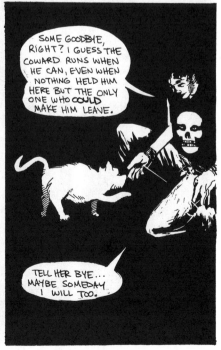

101

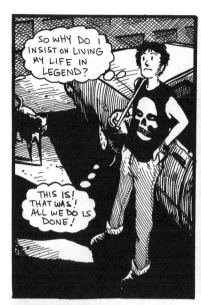

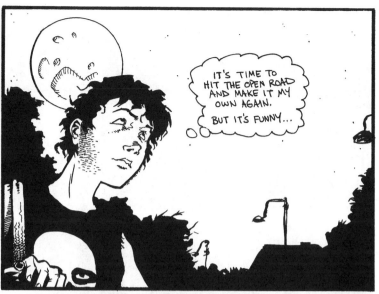

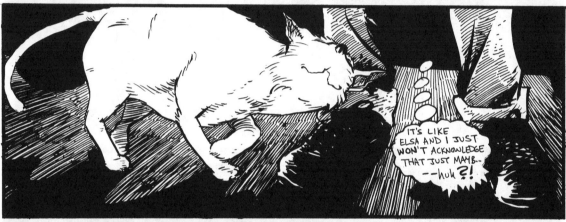

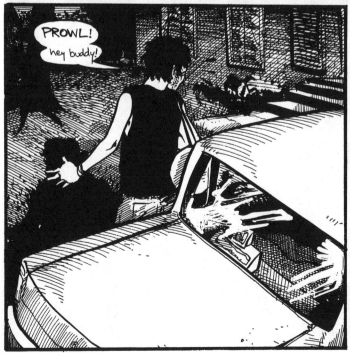

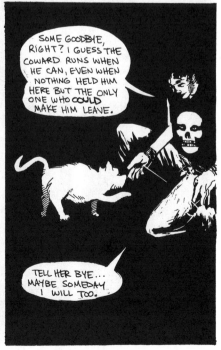

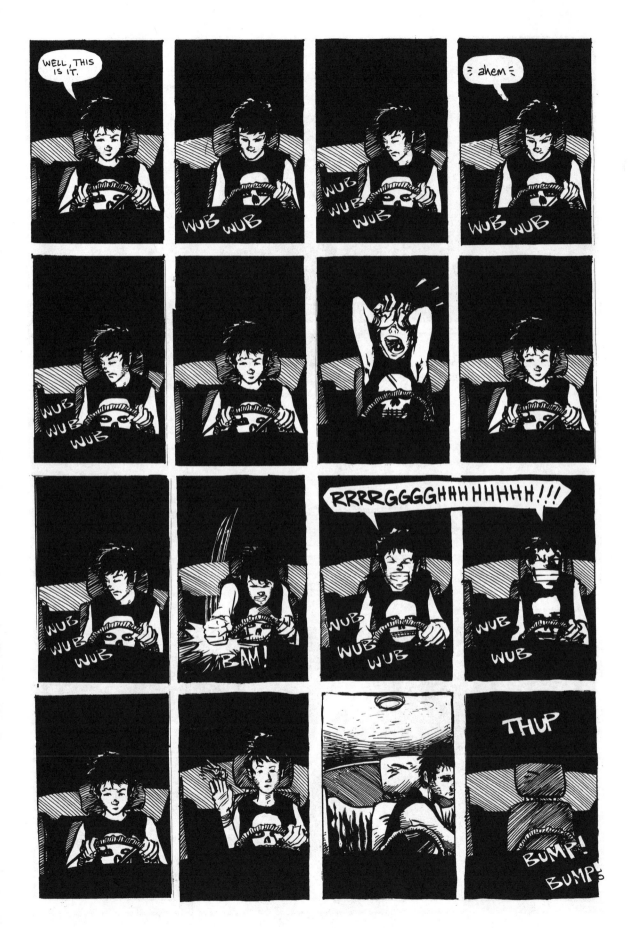

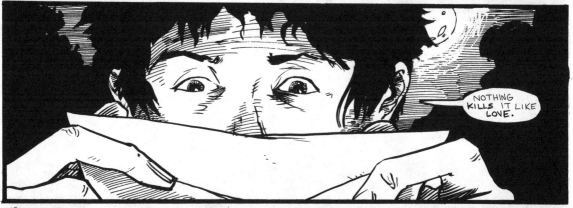

NOTHING KILLS IT LIKE LOVE.

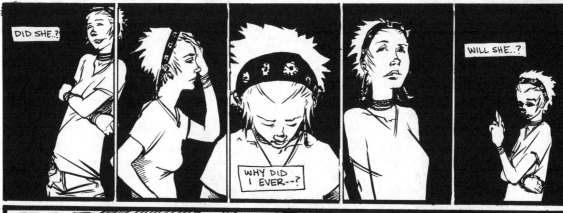

DID SHE..?

WHY DID I EVER--?

WILL SHE..?

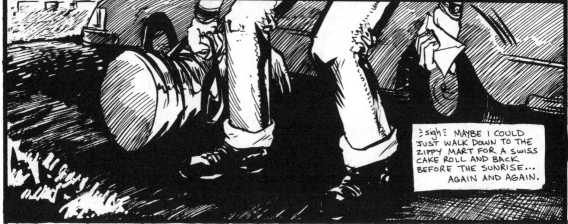

≷sigh≷ MAYBE I COULD JUST WALK DOWN TO THE ZIPPY MART FOR A SWISS CAKE ROLL AND BACK BEFORE THE SUNRISE... AGAIN AND AGAIN.

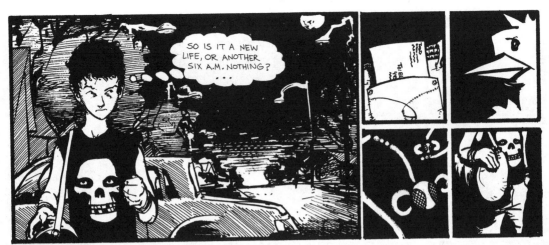

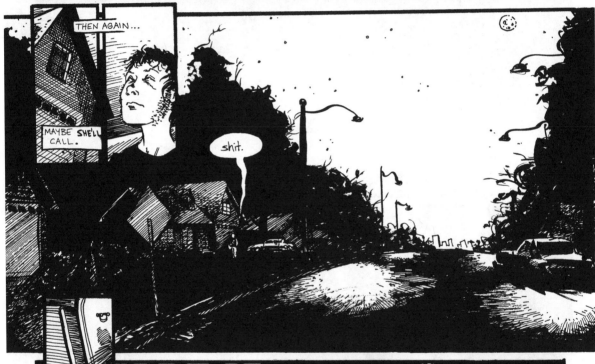

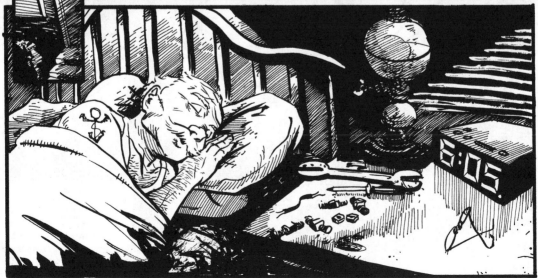

7. EPILOGUE

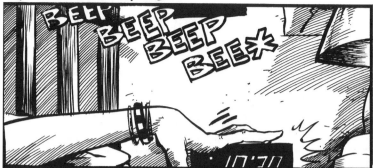

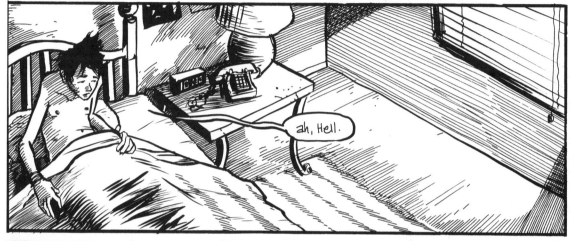

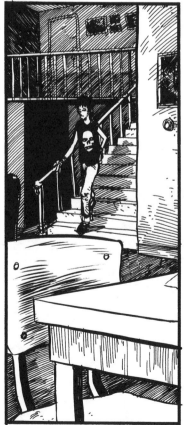

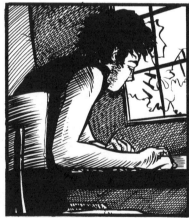

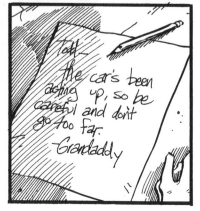

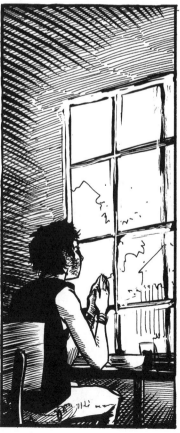

105

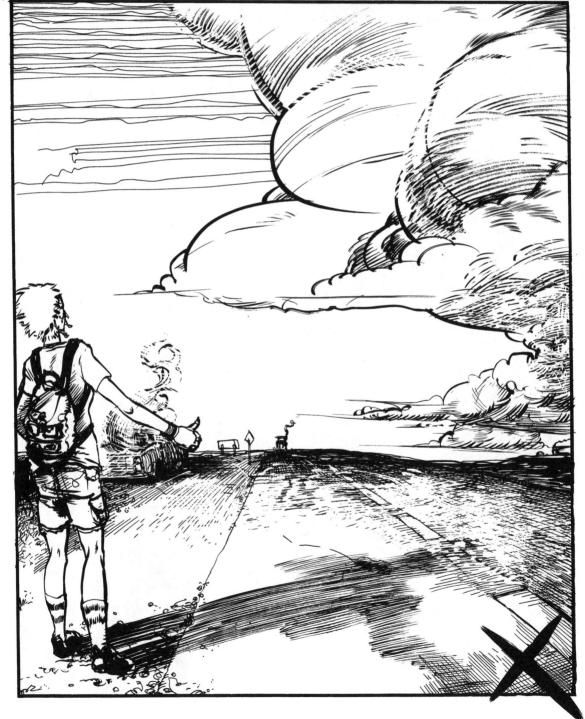

FRANKENBONES

WRITTEN BY EMIL HEIPLE

A SUBJECT FREQUENTLY REVISITED: THE CONNECTION/DISASSOCIATION OF OUR WORLD (THE HUMANOID EXISTENCE) AND THAT OF THE REST OF OUR WIDELY REMOVED NEIGHBORS HERE ON EARTH.

AS EACH DECADE PASSES WE FIND OURSELVES CLEANER, HEALTHIER, NEARER TO THE ETHEREAL OF COMFORT AND ADVANCEMENT, AND OF COURSE, "HAPPIER".

AND IN RETURN, THE BRIDGE JOINING OUR TWO SEPARATE WORLDS TOGETHER KEEPS ROTTING AWAY FROM A STEADILY INCREASING LACK OF USE.

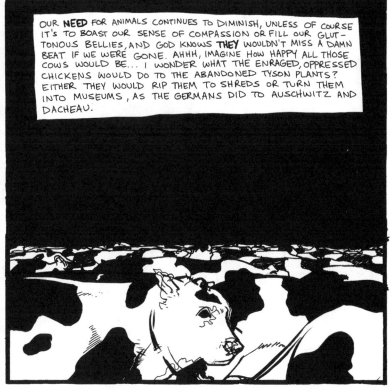

OUR **NEED** FOR ANIMALS CONTINUES TO DIMINISH, UNLESS OF COURSE IT'S TO BOAST OUR SENSE OF COMPASSION OR FILL OUR GLUTTONOUS BELLIES, AND GOD KNOWS **THEY** WOULDN'T MISS A DAMN BEAT IF WE WERE GONE. AHHH, IMAGINE HOW HAPPY ALL THOSE COWS WOULD BE... I WONDER WHAT THE ENRAGED, OPPRESSED CHICKENS WOULD DO TO THE ABANDONED TYSON PLANTS? EITHER THEY WOULD RIP THEM TO SHREDS OR TURN THEM INTO MUSEUMS, AS THE GERMANS DID TO AUSCHWITZ AND DACHEAU.

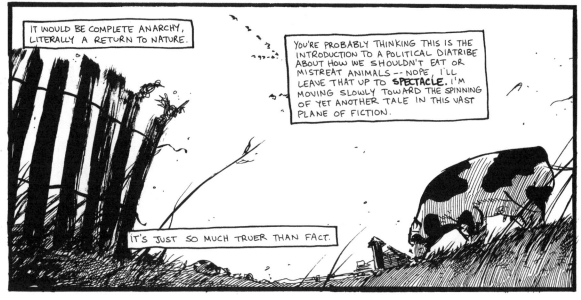

IT WOULD BE COMPLETE ANARCHY, LITERALLY A RETURN TO NATURE.

YOU'RE PROBABLY THINKING THIS IS THE INTRODUCTION TO A POLITICAL DIATRIBE ABOUT HOW WE SHOULDN'T EAT OR MISTREAT ANIMALS -- NOPE, I'LL LEAVE THAT UP TO **SPECTACLE.** I'M MOVING SLOWLY TOWARD THE SPINNING OF YET ANOTHER TALE IN THIS VAST PLANE OF FICTION.

IT'S JUST SO MUCH TRUER THAN FACT.

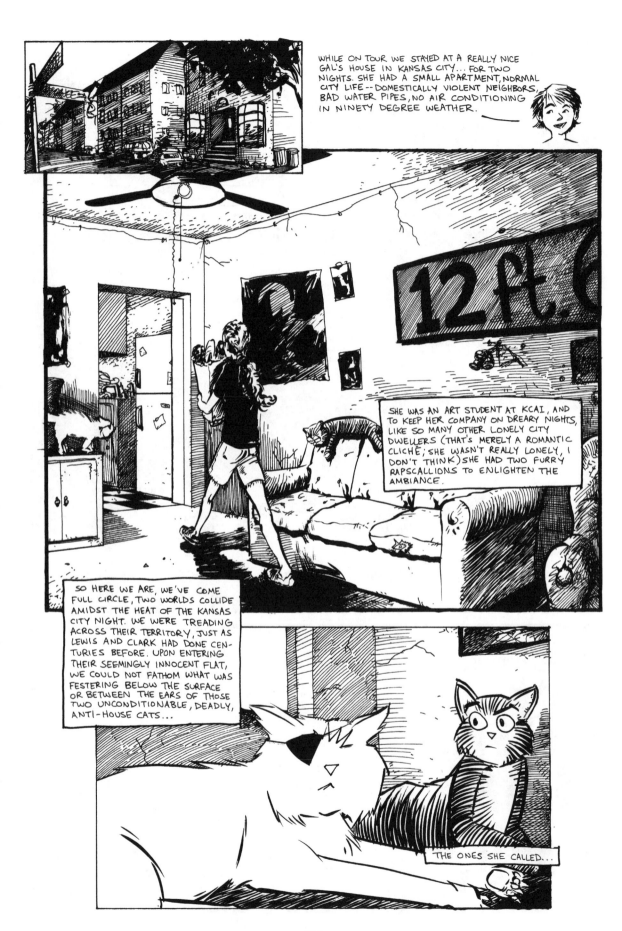

WHILE ON TOUR WE STAYED AT A REALLY NICE GAL'S HOUSE IN KANSAS CITY... FOR TWO NIGHTS. SHE HAD A SMALL APARTMENT, NORMAL CITY LIFE -- DOMESTICALLY VIOLENT NEIGHBORS, BAD WATER PIPES, NO AIR CONDITIONING IN NINETY DEGREE WEATHER.

SHE WAS AN ART STUDENT AT KCAI, AND TO KEEP HER COMPANY ON DREARY NIGHTS, LIKE SO MANY OTHER LONELY CITY DWELLERS (THAT'S MERELY A ROMANTIC CLICHÉ; SHE WASN'T REALLY LONELY, I DON'T THINK) SHE HAD TWO FURRY RAPSCALLIONS TO ENLIGHTEN THE AMBIANCE.

SO HERE WE ARE, WE'VE COME FULL CIRCLE, TWO WORLDS COLLIDE AMIDST THE HEAT OF THE KANSAS CITY NIGHT. WE WERE TREADING ACROSS THEIR TERRITORY, JUST AS LEWIS AND CLARK HAD DONE CENTURIES BEFORE. UPON ENTERING THEIR SEEMINGLY INNOCENT FLAT, WE COULD NOT FATHOM WHAT WAS FESTERING BELOW THE SURFACE OR BETWEEN THE EARS OF THOSE TWO UNCONDITIONABLE, DEADLY, ANTI-HOUSE CATS...

THE ONES SHE CALLED...

110

FRANKENbones!

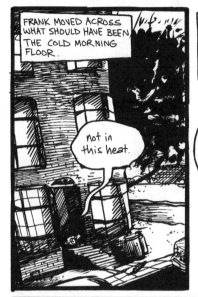

FRANK MOVED ACROSS WHAT SHOULD HAVE BEEN THE COLD MORNING FLOOR.

not in this heat.

SHE WAS STILL ASLEEP-- IT WAS THAT DAY AGAIN, THE ONE WHEN SHE DIDN'T AWAKE UNTIL ALMOST NIGHTFALL. HE LOVED THOSE DAYS; HE JUST MADE SURE HE ATE A HELL OF A LOT THE NIGHT BEFORE. FRANK TOOK THE LIBERTY OF UNRAVELLING THE NEWSPAPER AND GIVING IT A NICE ONCE-THROUGH.

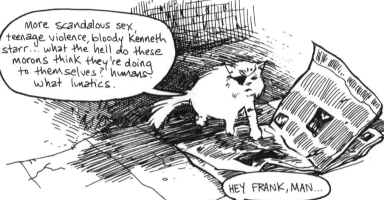

More scandalous sex, teenage violence, bloody Kenneth starr... what the hell do these morons think they're doing to themselves? humans! what lunatics.

HEY FRANK, MAN...

...SHE'S AWAKE AND SHE'S TALKIN' ABOUT VISATAS OR SOMETHIN-- A BAND. MAN, I HOPE IT AIN'T GONNA BE MORE OF THOSE BORING ART DUDES. THOSE HIPSTER ASS TRICKS DON'T FOOL ME, FRANK...

BUT YOU KNOW, I DO REMEMBER WHEN I PEEPED THAT ONE DUDE'S COFFEE-- I THOUGHT MY EYES WERE GONNA BURST OUT OF MY HEAD AND START BREAKDANCIN--

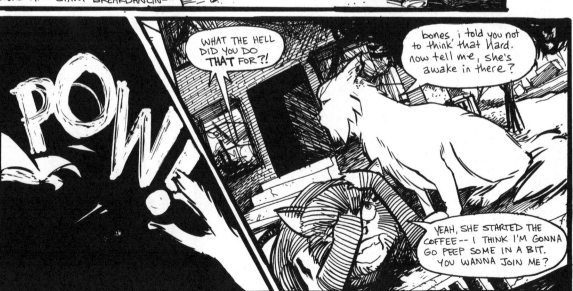

POW

WHAT THE HELL DID YOU DO **THAT** FOR?!

bones, i told you not to think that hard. now tell me, she's awake in there?

YEAH, SHE STARTED THE COFFEE-- I THINK I'M GONNA GO PEEP SOME IN A BIT. YOU WANNA JOIN ME?

111

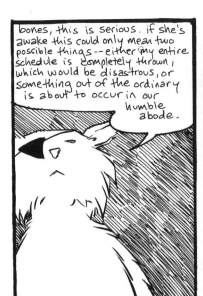

bones, this is serious. if she's awake this could only mean two possible things -- either my entire schedule is completely thrown, which would be disastrous, or something out of the ordinary is about to occur in our humble abode.

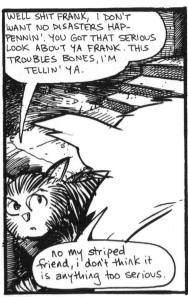

WELL SHIT FRANK, I DON'T WANT NO DISASTERS HAP-PENNIN'. YOU GOT THAT SERIOUS LOOK ABOUT YA FRANK. THIS TROUBLES BONES, I'M TELLIN' YA.

no my striped friend, i don't think it is anything too serious.

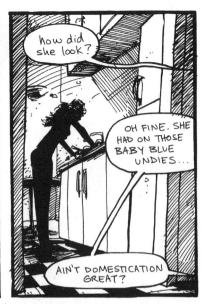

how did she look?

OH FINE. SHE HAD ON THOSE BABY BLUE UNDIES...

AIN'T DOMESTICATION GREAT?

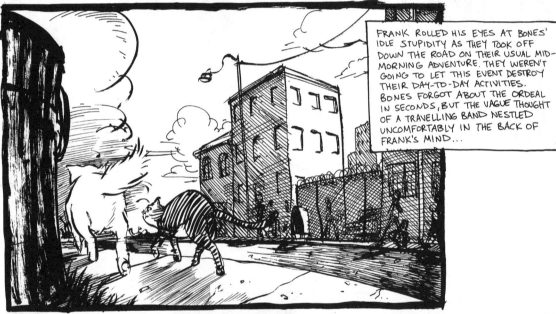

FRANK ROLLED HIS EYES AT BONES' IDLE STUPIDITY AS THEY TOOK OFF DOWN THE ROAD ON THEIR USUAL MID-MORNING ADVENTURE. THEY WEREN'T GOING TO LET THIS EVENT DESTROY THEIR DAY-TO-DAY ACTIVITIES. BONES FORGOT ABOUT THE ORDEAL IN SECONDS, BUT THE VAGUE THOUGHT OF A TRAVELLING BAND NESTLED UNCOMFORTABLY IN THE BACK OF FRANK'S MIND...

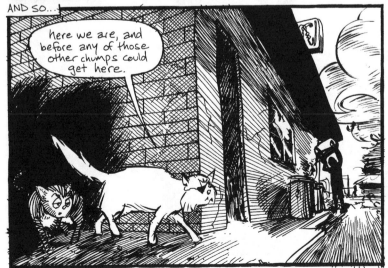

AND SO...

here we are, and before any of those other chumps could get here.

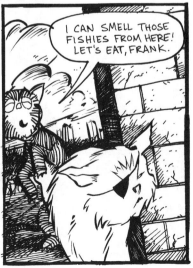

I CAN SMELL THOSE FISHIES FROM HERE! LET'S EAT, FRANK.

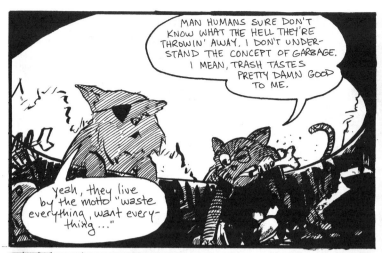

MAN HUMANS SURE DON'T KNOW WHAT THE HELL THEY'RE THROWIN' AWAY. I DON'T UNDERSTAND THE CONCEPT OF GARBAGE. I MEAN, TRASH TASTES PRETTY DAMN GOOD TO ME.

yeah, they live by the motto "waste everything, want everything..."

i can't really complain. their habits keep my belly swollen.

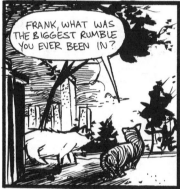

FRANK, WHAT WAS THE BIGGEST RUMBLE YOU EVER BEEN IN?

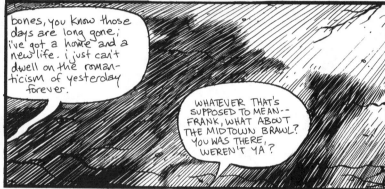

bones, you know those days are long gone; i've got a home and a new life. i just can't dwell on the romanticism of yesterday forever.

WHATEVER THAT'S SUPPOSED TO MEAN-- FRANK, WHAT ABOUT THE MIDTOWN BRAWL? YOU WAS THERE, WEREN'T YA?

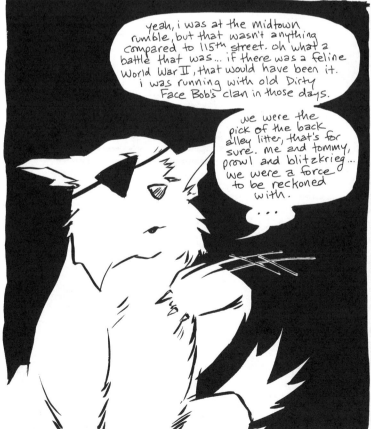

yeah, i was at the midtown rumble, but that wasn't anything compared to 115th street. oh what a battle that was... if there was a feline World War II, that would have been it. i was running with old Dirty Face Bob's clan in those days.

we were the pick of the back alley litter, that's for sure. me and tommy, prowl and blitzkrieg... we were a force to be reckoned with.
...

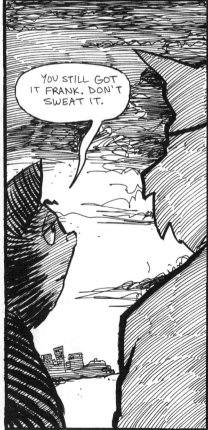

YOU STILL GOT IT FRANK. DON'T SWEAT IT.

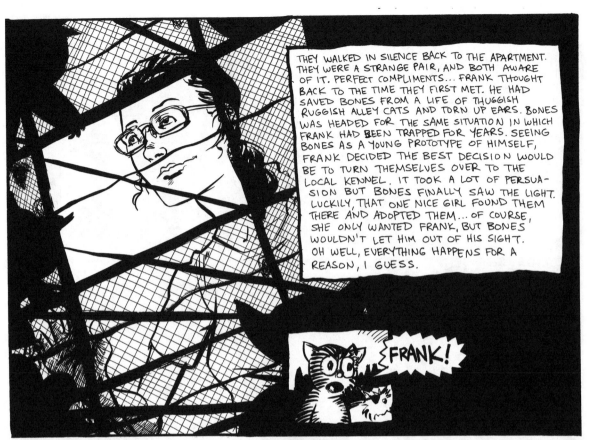

THEY WALKED IN SILENCE BACK TO THE APARTMENT. THEY WERE A STRANGE PAIR, AND BOTH AWARE OF IT. PERFECT COMPLIMENTS... FRANK THOUGHT BACK TO THE TIME THEY FIRST MET. HE HAD SAVED BONES FROM A LIFE OF THUGGISH RUGGISH ALLEY CATS AND TORN UP EARS. BONES WAS HEADED FOR THE SAME SITUATION IN WHICH FRANK HAD BEEN TRAPPED FOR YEARS. SEEING BONES AS A YOUNG PROTOTYPE OF HIMSELF, FRANK DECIDED THE BEST DECISION WOULD BE TO TURN THEMSELVES OVER TO THE LOCAL KENNEL. IT TOOK A LOT OF PERSUASION BUT BONES FINALLY SAW THE LIGHT. LUCKILY, THAT ONE NICE GIRL FOUND THEM THERE AND ADOPTED THEM... OF COURSE, SHE ONLY WANTED FRANK, BUT BONES WOULDN'T LET HIM OUT OF HIS SIGHT. OH WELL, EVERYTHING HAPPENS FOR A REASON, I GUESS.

FRANK!

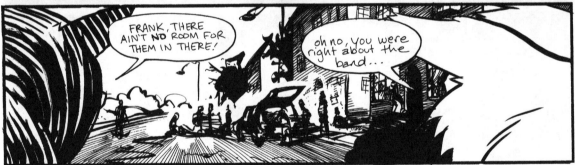

FRANK, THERE AIN'T **NO** ROOM FOR THEM IN THERE!

oh no, you were right about the band...

... and they've got twice as many as Crass!

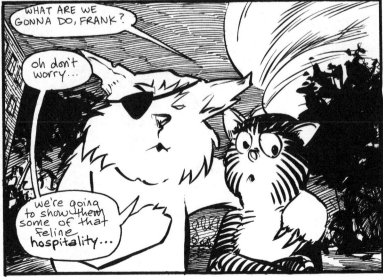

WHAT ARE WE GONNA DO, FRANK?

oh don't worry...

we're going to show them some of that feline hospitality...

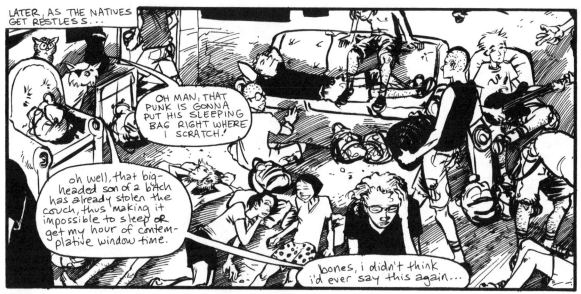

LATER, AS THE NATIVES GET RESTLESS...

OH MAN, THAT PUNK IS GONNA PUT HIS SLEEPING BAG RIGHT WHERE I SCRATCH!

oh well, that big-headed son of a bitch has already stolen the couch, thus making it impossible to sleep or get my hour of contemplative window time.

bones, i didn't think i'd ever say this again...

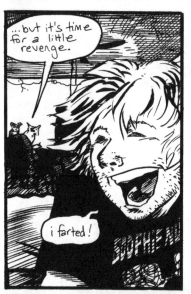

...but it's time for a little revenge.

i farted!

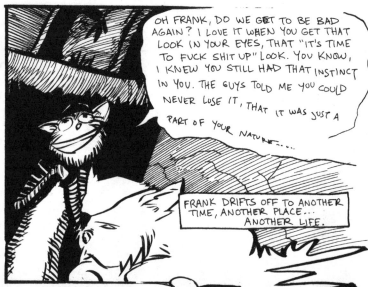

OH FRANK, DO WE GET TO BE BAD AGAIN? I LOVE IT WHEN YOU GET THAT LOOK IN YOUR EYES, THAT "IT'S TIME TO FUCK SHIT UP" LOOK. YOU KNOW, I KNEW YOU STILL HAD THAT INSTINCT IN YOU. THE GUYS TOLD ME YOU COULD NEVER LOSE IT, THAT IT WAS JUST A PART OF YOUR NATURE...

FRANK DRIFTS OFF TO ANOTHER TIME, ANOTHER PLACE... ANOTHER LIFE.

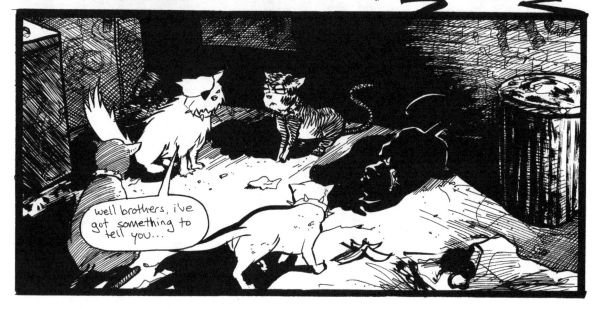

well brothers, i've got something to tell you...

115

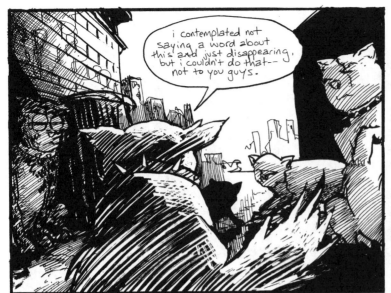

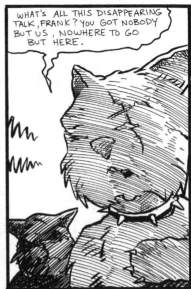

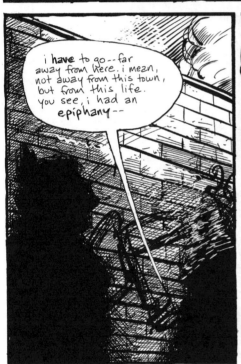

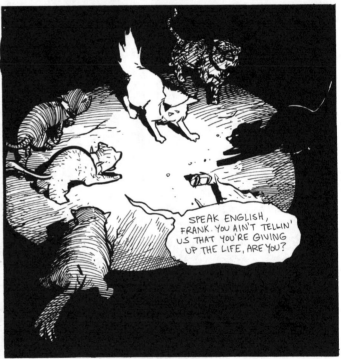

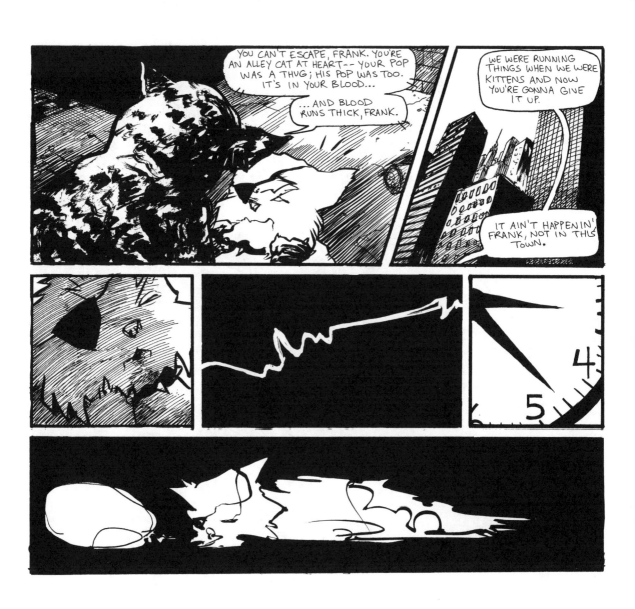

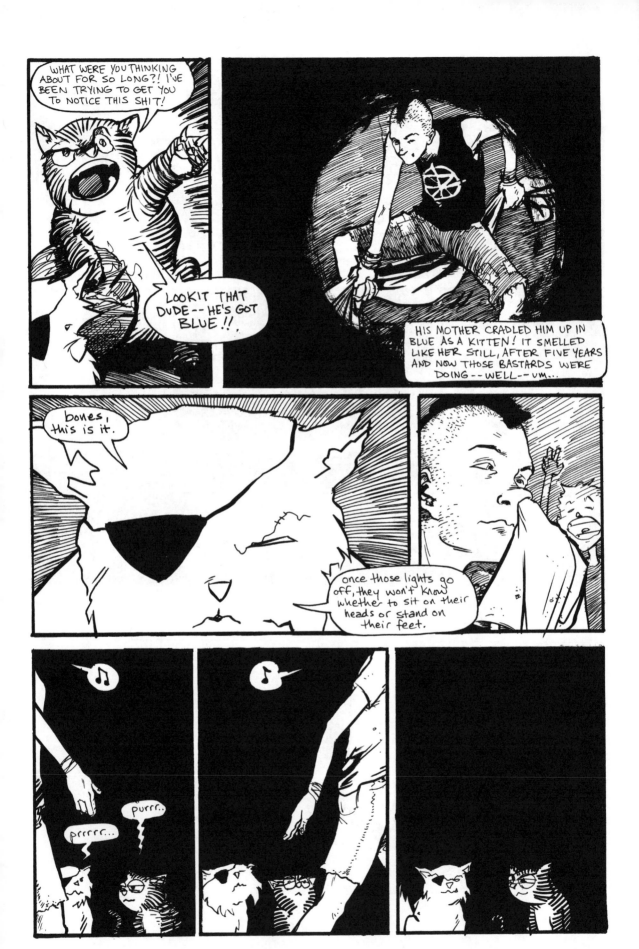

118

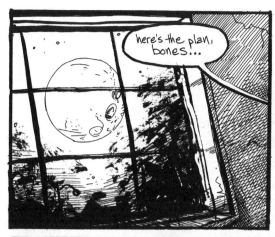

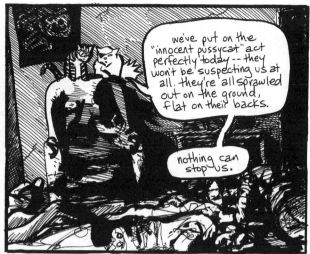

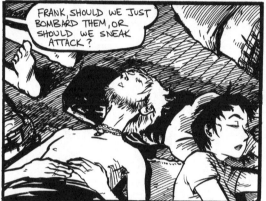

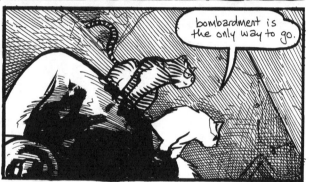

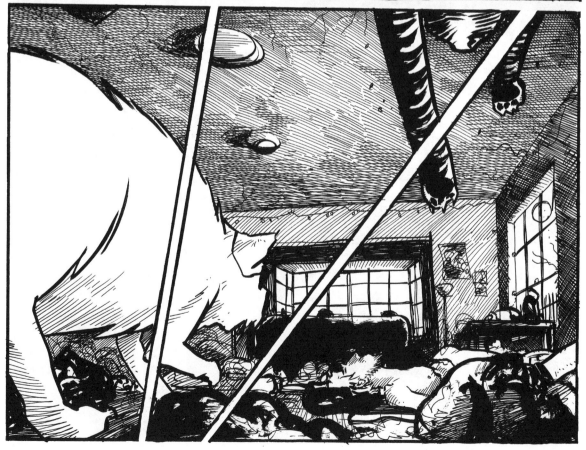

119

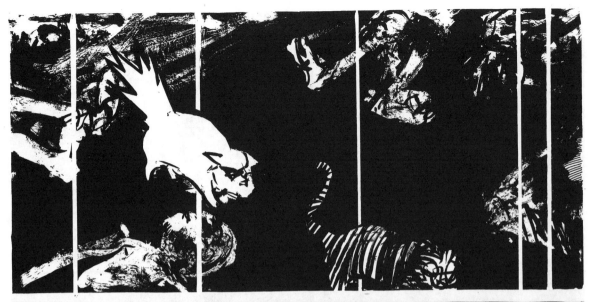

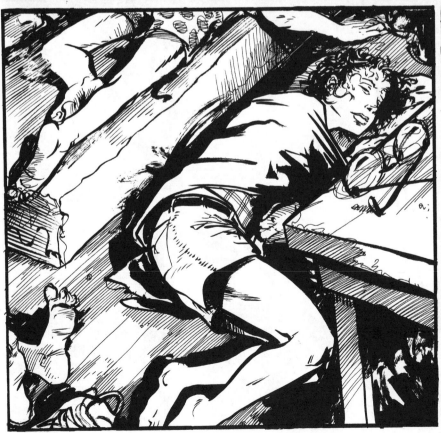
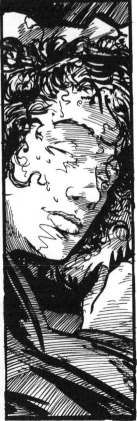

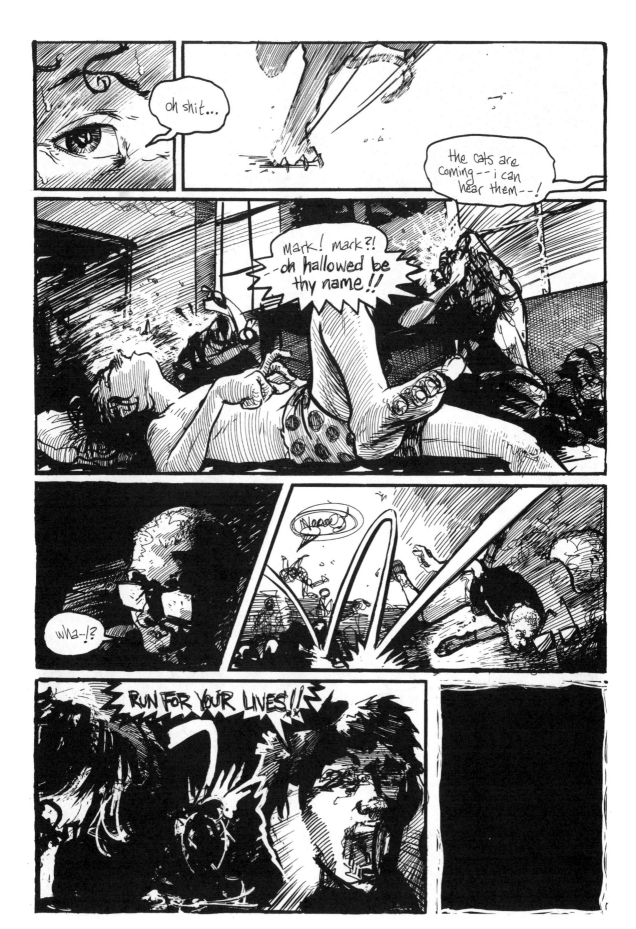

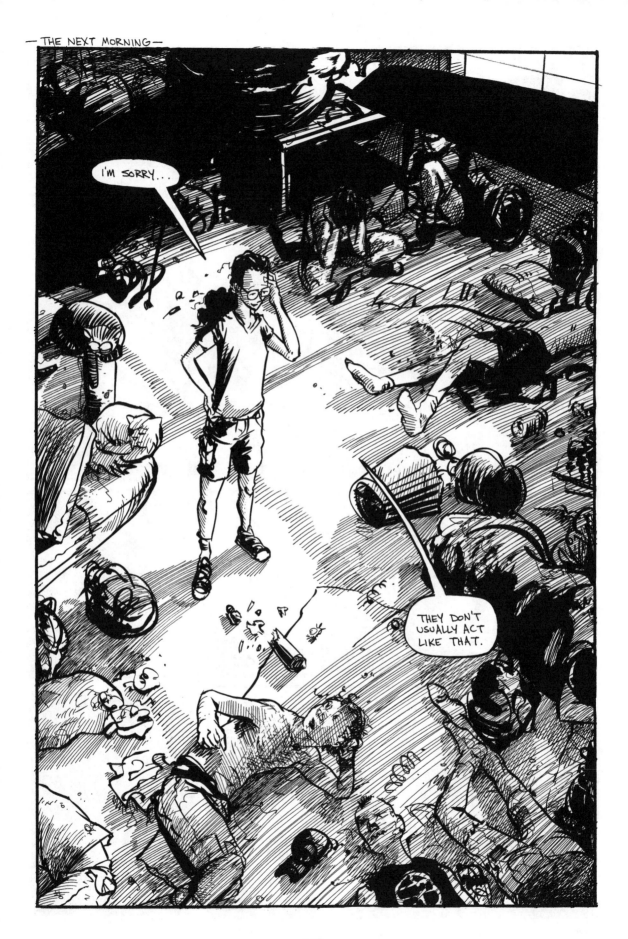

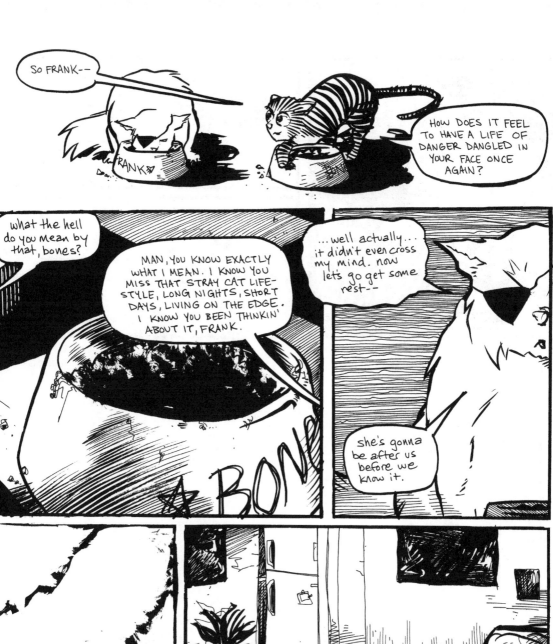

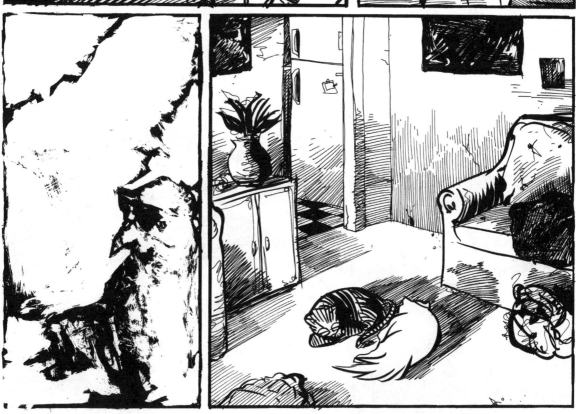

4/99.

PULLING TEETH

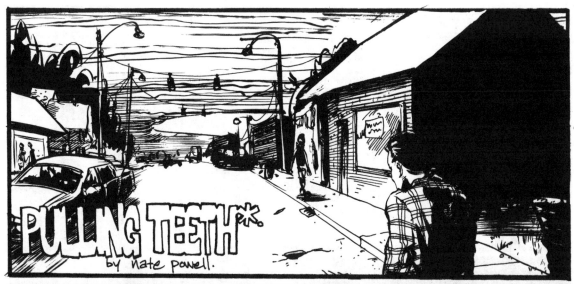

PULLING TEETH

by nate powell.

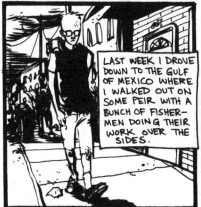

LAST WEEK I DROVE DOWN TO THE GULF OF MEXICO WHERE I WALKED OUT ON SOME PEIR WITH A BUNCH OF FISHER-MEN DOING THEIR WORK OVER THE SIDES.

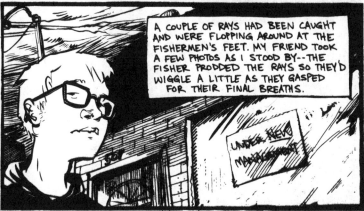

A COUPLE OF RAYS HAD BEEN CAUGHT AND WERE FLOPPING AROUND AT THE FISHERMEN'S FEET. MY FRIEND TOOK A FEW PHOTOS AS I STOOD BY--THE FISHER PRODDED THE RAYS SO THEY'D WIGGLE A LITTLE AS THEY GASPED FOR THEIR FINAL BREATHS.

THE RAYS' EYES WERE JUST LIKE THE FISHERS'-- ALL SUNKEN IN AND SAD, LIKE SLIPPERY LITTLE BASSET HOUNDS PANICKING IN THE AUGUST SUN. THEY SOON DIED AND SIMPLY ENOUGH, I WATCHED THEIR LITTLE SKINS BAKE AND HARDEN. THE MEN NEED THOSE FISH FOR NOTHING MORE THAN RENT AND A LITTLE FOOD. MORE SPOKES IN THE WHEEL.

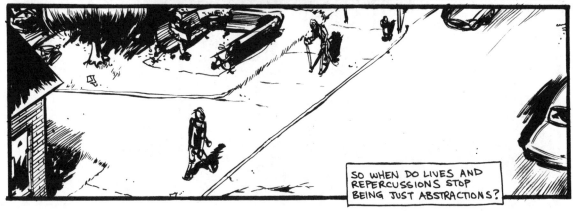

SO WHEN DO LIVES AND REPERCUSSIONS STOP BEING JUST ABSTRACTIONS?

127

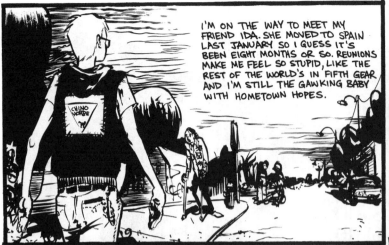

I'M ON THE WAY TO MEET MY FRIEND IDA. SHE MOVED TO SPAIN LAST JANUARY SO I GUESS IT'S BEEN EIGHT MONTHS OR SO. REUNIONS MAKE ME FEEL SO STUPID, LIKE THE REST OF THE WORLD'S IN FIFTH GEAR AND I'M STILL THE GAWKING BABY WITH HOMETOWN HOPES.

I FORGET HOW HARD WE ALL STRUGGLE IN DIFFERENT WAYS, AND THAT IT'S NOT FAIR TO SIZE UP ONE ANOTHER, MEASURING HOW MUCH HARDSHIP HAS BEEN ENDURED OR HOW MUCH PROVERBIAL MARROW HAS BEEN SUCKED FROM THIS LIFE.

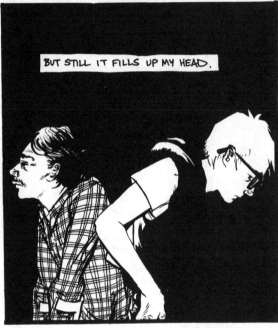

BUT STILL IT FILLS UP MY HEAD.

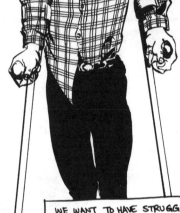

WE WANT TO HAVE STRUGGLED AND STARVED TO HAVE STORIES TO TELL. WE WANT TO DECONSTRUCT ALL THOUGHT AND ACTION DOWN TO SURVIVAL AND SEX FOR AN EASY INSTINCT ON WHICH TO BLAME MISCOMMUNICATION.

LEE!

HEY!! I THOUGHT I'D MEET YOU HALFWAY!

WELL, THAT, AND THE LAST TIME I SAW HER WE WOUND UP MAKING OUT ON MY GRANDMA'S COUCH AND IT WAS KINDA WEIRD. ONE OF THOSE "REBOUND" THINGS.

IT'LL BE FINE.

C'MON, I JUST MADE A BUNCH OF SOUP AND IT'S GETTING COLD!

YEAH, HERE'S MY STREET. IT'S NO "PLEASANT VALLEY" BUT... HEY, SO ARE YOU STILL LIVING WITH YOUR FOLKS?

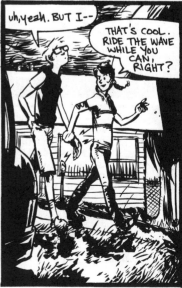

uh, yeah. BUT I--

THAT'S COOL. RIDE THE WAVE WHILE YOU CAN, RIGHT?

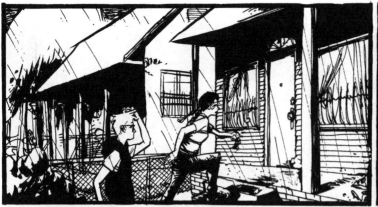

OKAY--

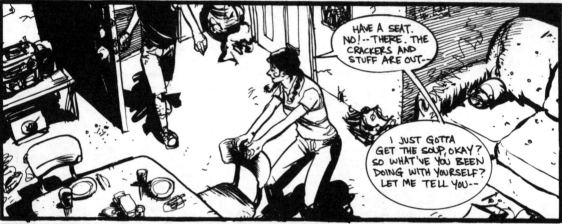

HAVE A SEAT. NO!--THERE. THE CRACKERS AND STUFF ARE OUT--

I JUST GOTTA GET THE SOUP, OKAY? SO WHAT'VE YOU BEEN DOING WITH YOURSELF? LET ME TELL YOU--

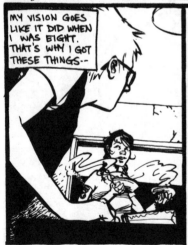

MY VISION GOES LIKE IT DID WHEN I WAS EIGHT. THAT'S WHY I GOT THESE THINGS--

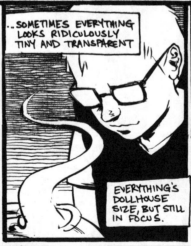

..SOMETIMES EVERYTHING LOOKS RIDICULOUSLY TINY AND TRANSPARENT

EVERYTHING'S DOLLHOUSE SIZE, BUT STILL IN FOCUS.

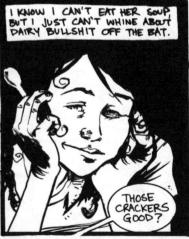

I KNOW I CAN'T EAT HER SOUP BUT I JUST CAN'T WHINE ABOUT DAIRY BULLSHIT OFF THE BAT.

THOSE CRACKERS GOOD?

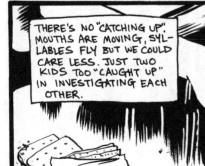

THERE'S NO "CATCHING UP". MOUTHS ARE MOVING, SYLLABLES FLY BUT WE COULD CARE LESS. JUST TWO KIDS TOO "CAUGHT UP" IN INVESTIGATING EACH OTHER.

I'M FAR AWAY IN MY HEAD... AGE NINE, SCREAMING IN THE MIDDLE OF SUNDAY SERVICE IN COLUMBIA, MISSOURI. BEFORE MANNERS, BEFORE PRETENSE, THERE WAS ABSOLUTION AND RESOLUTENESS.

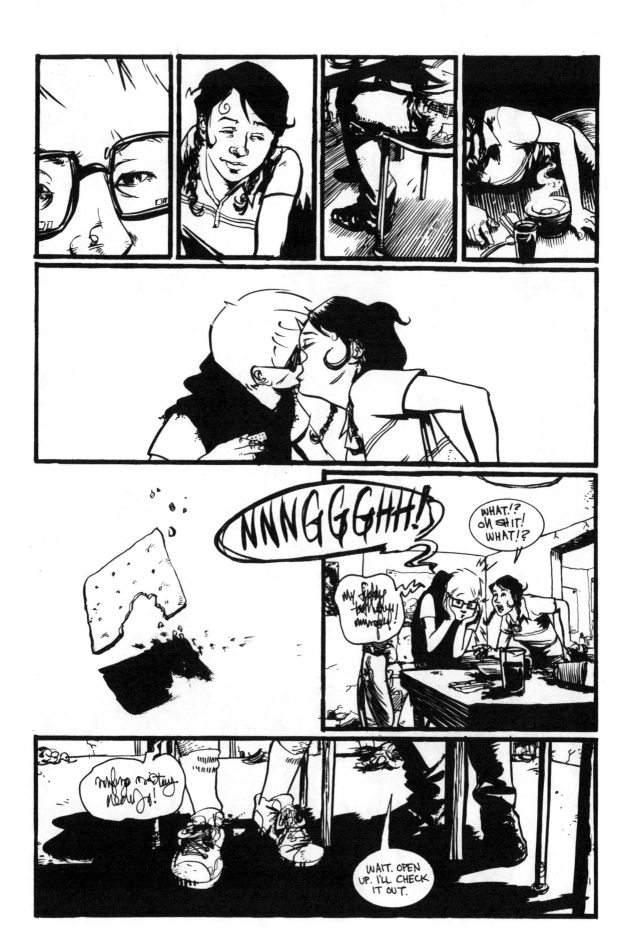

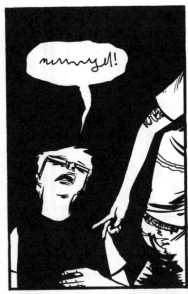

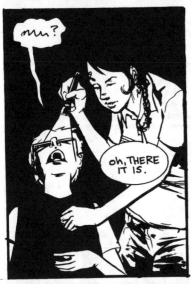

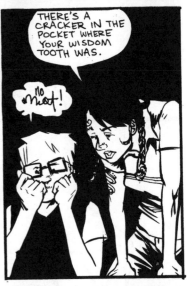

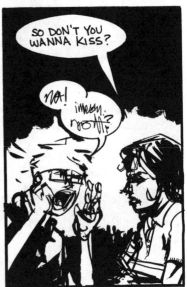

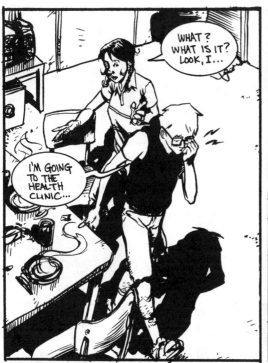

WHAT? WHAT IS IT? LOOK, I...

I'M GOING TO THE HEALTH CLINIC...

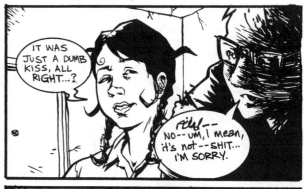

IT WAS JUST A DUMB KISS, ALL RIGHT...?

NO--UM, I MEAN, it's not--SHIT... I'M SORRY.

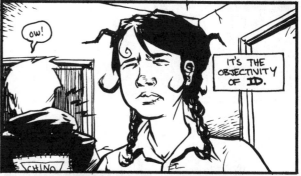

OW!

IT'S THE OBJECTIVITY OF ID.

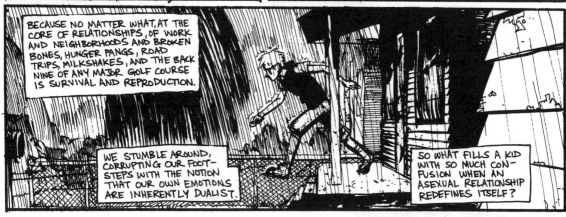

BECAUSE NO MATTER WHAT, AT THE CORE OF RELATIONSHIPS, OF WORK AND NEIGHBORHOODS AND BROKEN BONES, HUNGER PANGS, ROAD TRIPS, MILKSHAKES, AND THE BACK NINE OF ANY MAJOR GOLF COURSE IS SURVIVAL AND REPRODUCTION.

WE STUMBLE AROUND, CORRUPTING OUR FOOT-STEPS WITH THE NOTION THAT OUR OWN EMOTIONS ARE INHERENTLY DUALIST.

SO WHAT FILLS A KID WITH SO MUCH CON-FUSION WHEN AN ASEXUAL RELATIONSHIP REDEFINES ITSELF?

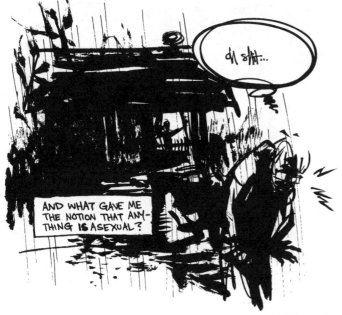

oh shit...

AND WHAT GAVE ME THE NOTION THAT ANY-THING IS ASEXUAL?

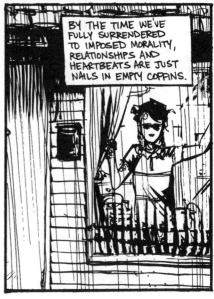

BY THE TIME WE'VE FULLY SURRENDERED TO IMPOSED MORALITY, RELATIONSHIPS AND HEARTBEATS ARE JUST NAILS IN EMPTY COFFINS.

133

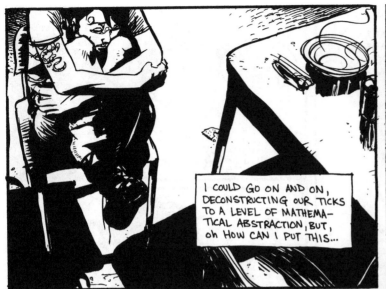

I COULD GO ON AND ON, DECONSTRUCTING OUR TICKS TO A LEVEL OF MATHEMATICAL ABSTRACTION, BUT, oh HOW CAN I PUT THIS...

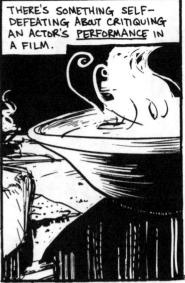

THERE'S SOMETHING SELF-DEFEATING ABOUT CRITIQUING AN ACTOR'S PERFORMANCE IN A FILM.

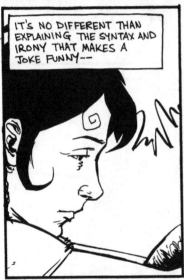

IT'S NO DIFFERENT THAN EXPLAINING THE SYNTAX AND IRONY THAT MAKES A JOKE FUNNY--

IT JUST STOPS BEING FUNNY, YOU KNOW?

OH, I DUNNO.

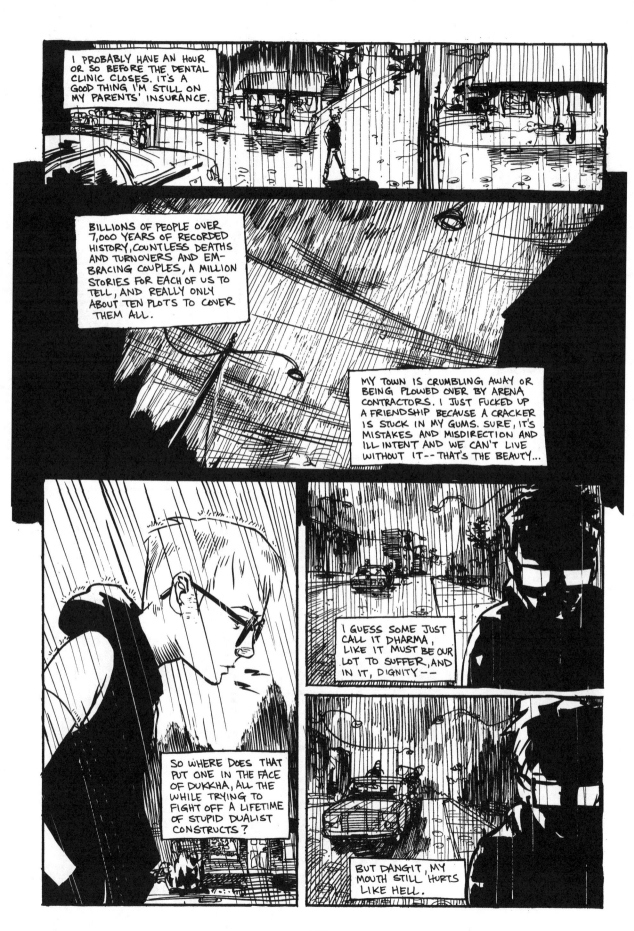

I PROBABLY HAVE AN HOUR OR SO BEFORE THE DENTAL CLINIC CLOSES. IT'S A GOOD THING I'M STILL ON MY PARENTS' INSURANCE.

BILLIONS OF PEOPLE OVER 7,000 YEARS OF RECORDED HISTORY, COUNTLESS DEATHS AND TURNOVERS AND EMBRACING COUPLES, A MILLION STORIES FOR EACH OF US TO TELL, AND REALLY ONLY ABOUT TEN PLOTS TO COVER THEM ALL.

MY TOWN IS CRUMBLING AWAY OR BEING PLOWED OVER BY ARENA CONTRACTORS. I JUST FUCKED UP A FRIENDSHIP BECAUSE A CRACKER IS STUCK IN MY GUMS. SURE, IT'S MISTAKES AND MISDIRECTION AND ILL INTENT AND WE CAN'T LIVE WITHOUT IT-- THAT'S THE BEAUTY...

I GUESS SOME JUST CALL IT DHARMA, LIKE IT MUST BE OUR LOT TO SUFFER, AND IN IT, DIGNITY--

SO WHERE DOES THAT PUT ONE IN THE FACE OF DUKKHA, ALL THE WHILE TRYING TO FIGHT OFF A LIFETIME OF STUPID DUALIST CONSTRUCTS?

BUT DANGIT, MY MOUTH STILL HURTS LIKE HELL.

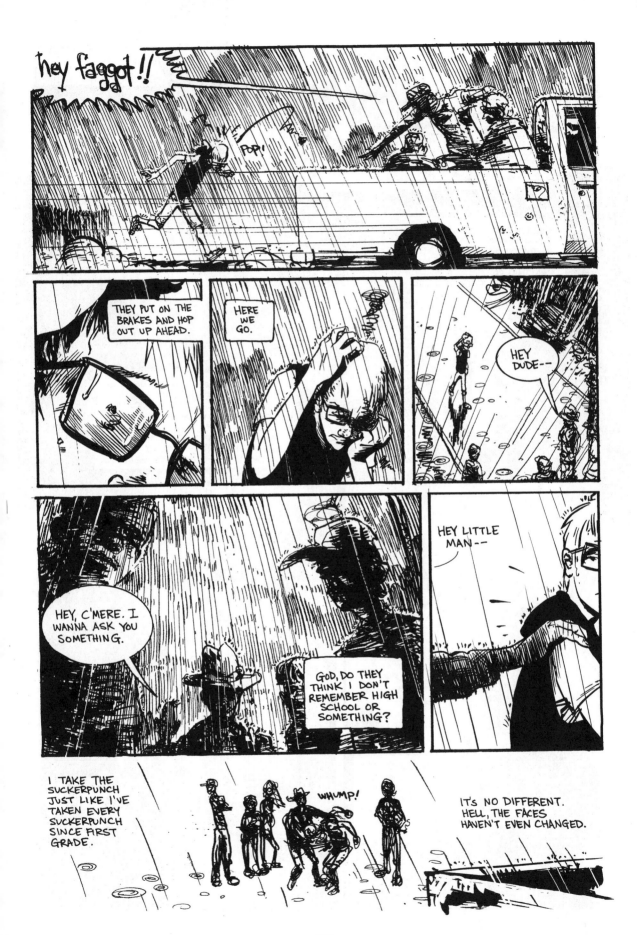

THERE'S REALLY NOTHING TO DO BUT COVER MY HEAD. I KNOW THEY'LL GET BORED SOON.

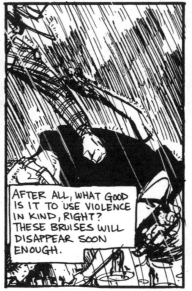

AFTER ALL, WHAT GOOD IS IT TO USE VIOLENCE IN KIND, RIGHT? THESE BRUISES WILL DISAPPEAR SOON ENOUGH.

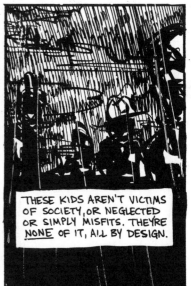

THESE KIDS AREN'T VICTIMS OF SOCIETY, OR NEGLECTED OR SIMPLY MISFITS. THEY'RE NONE OF IT, ALL BY DESIGN.

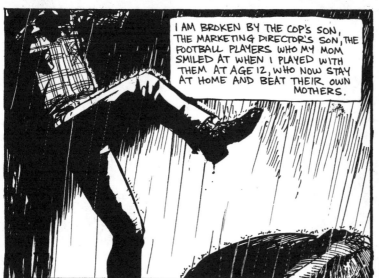

I AM BROKEN BY THE COP'S SON, THE MARKETING DIRECTOR'S SON, THE FOOTBALL PLAYERS WHO MY MOM SMILED AT WHEN I PLAYED WITH THEM AT AGE 12, WHO NOW STAY AT HOME AND BEAT THEIR OWN MOTHERS.

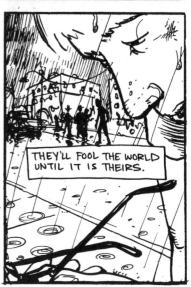

THEY'LL FOOL THE WORLD UNTIL IT IS THEIRS.

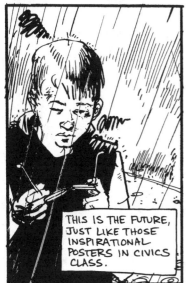

THIS IS THE FUTURE, JUST LIKE THOSE INSPIRATIONAL POSTERS IN CIVICS CLASS.

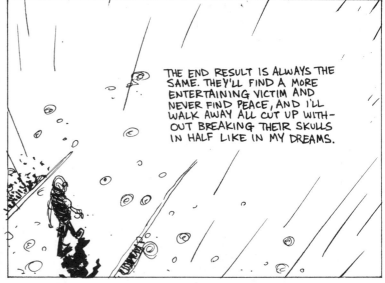

THE END RESULT IS ALWAYS THE SAME. THEY'LL FIND A MORE ENTERTAINING VICTIM AND NEVER FIND PEACE, AND I'LL WALK AWAY ALL CUT UP WITH- OUT BREAKING THEIR SKULLS IN HALF LIKE IN MY DREAMS.

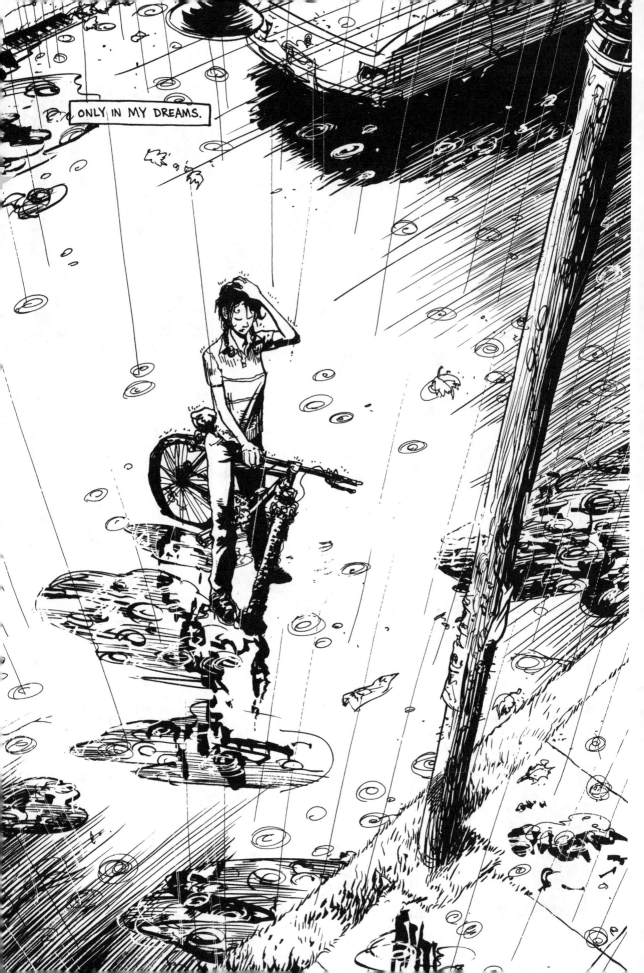

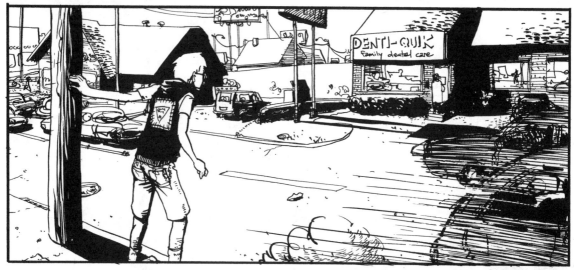

HEY!

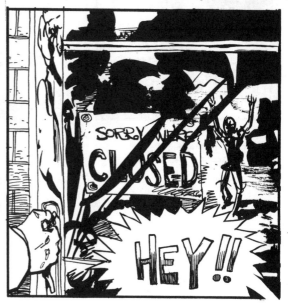

SORRY CLOSED

HEY!!

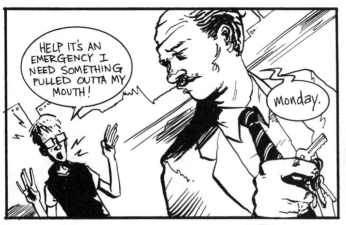

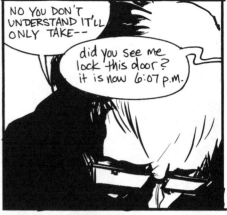

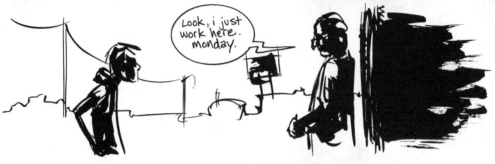

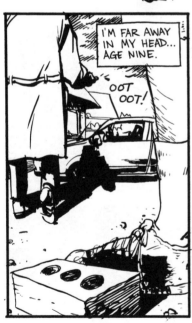

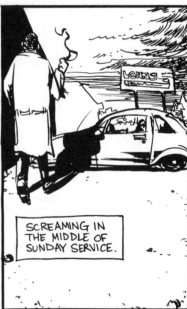

BEFORE MANNERS,
BEFORE PRETENSE,
THERE WAS...

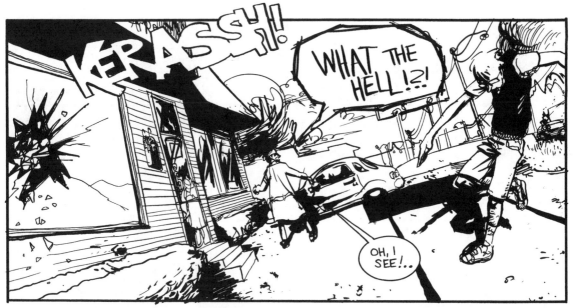

KERASSH!!

WHAT THE HELL!?!

OH, I SEE!...

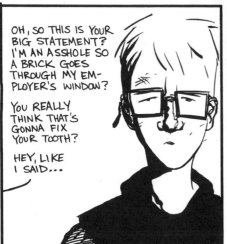

OH, SO THIS IS YOUR BIG STATEMENT? I'M AN ASSHOLE SO A BRICK GOES THROUGH MY EMPLOYER'S WINDOW?

YOU REALLY THINK THAT'S GONNA FIX YOUR TOOTH?

HEY, LIKE I SAID...

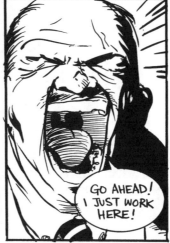

GO AHEAD! I JUST WORK HERE!

I WORK BY THE HOUR. I DON'T GIVE A GOD DAMN-- IT'S NOT COMING OUT OF MY CHECK.

IT'S ALL ON THE INSURANCE. SEE IF I CARE.

SO TELL ME--

WHY ARE WE REALLY OUT HERE ANYWAY?

IT'S GETTING DARK. GO HOME AND READ UP IF YOU WANT TO HAVE SOMETHING VALID TO SAY. JUST DON'T WASTE MY TIME.

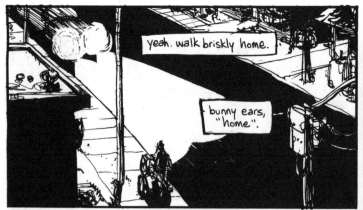

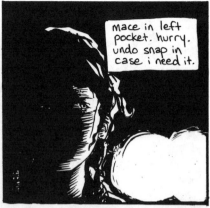

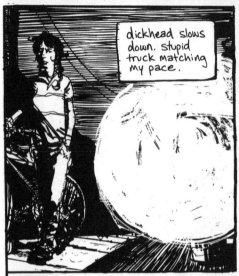

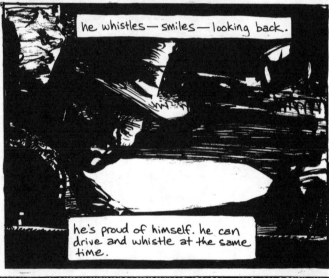

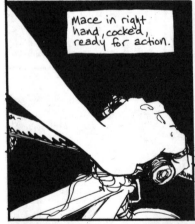

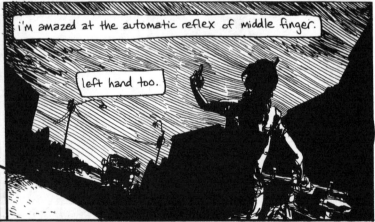

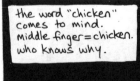

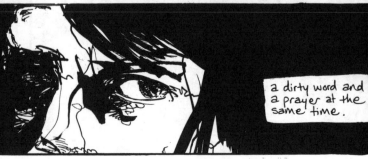

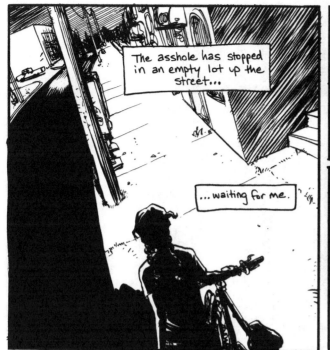

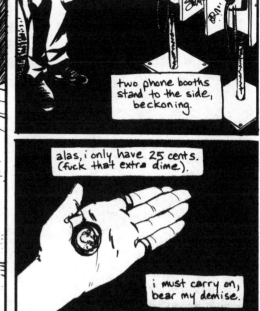

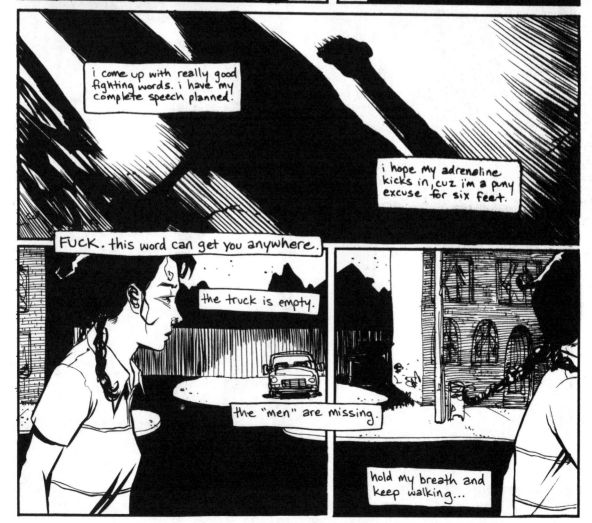

143

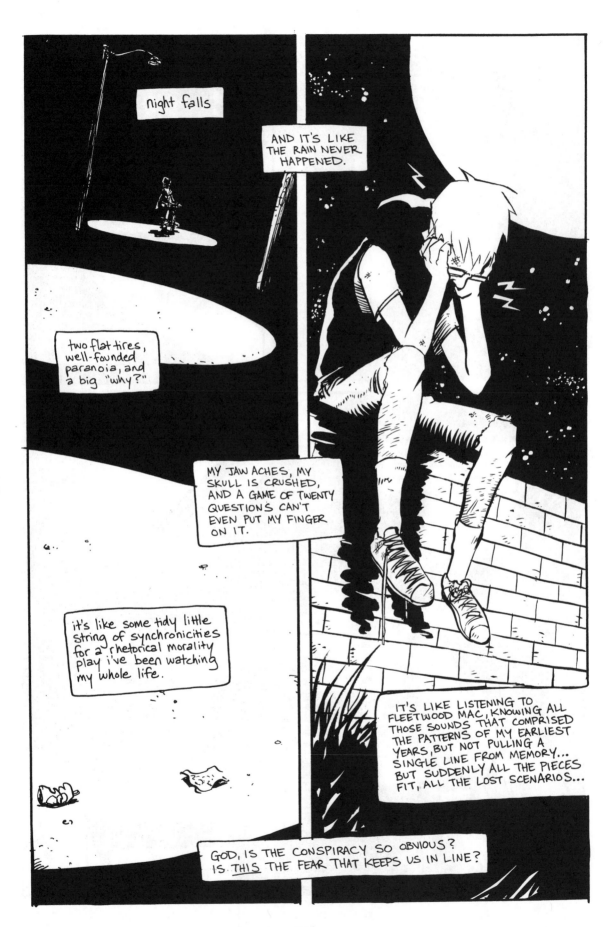

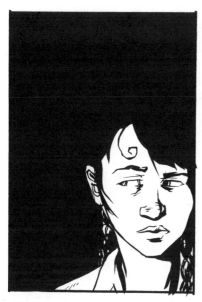

BEEP
BEEP
BEEP :00

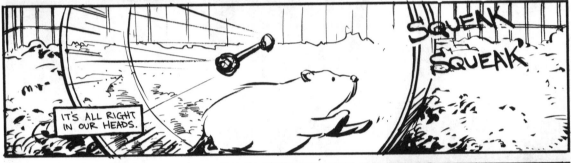

SQUEAK
SQUEAK

IT'S ALL RIGHT IN OUR HEADS.

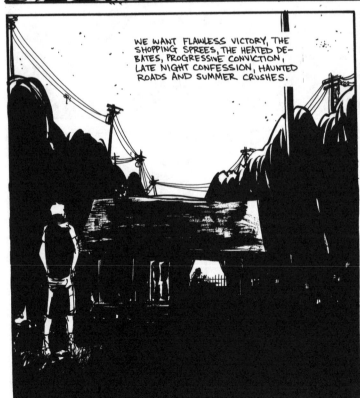

WE WANT FLAWLESS VICTORY, THE SHOPPING SPREES, THE HEATED DE-BATES, PROGRESSIVE CONVICTION, LATE NIGHT CONFESSION, HAUNTED ROADS AND SUMMER CRUSHES.

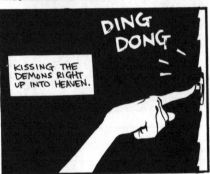

DING DONG

KISSING THE DEMONS RIGHT UP INTO HEAVEN.

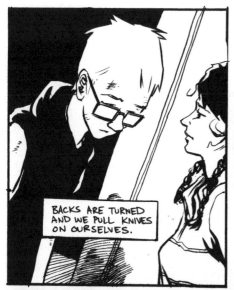

BACKS ARE TURNED AND WE PULL KNIVES ON OURSELVES.

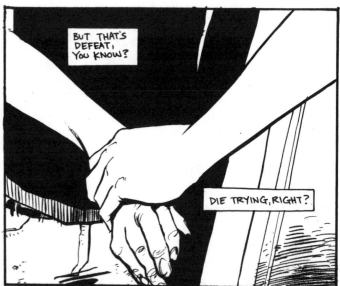

BUT THAT'S DEFEAT, YOU KNOW?

DIE TRYING, RIGHT?

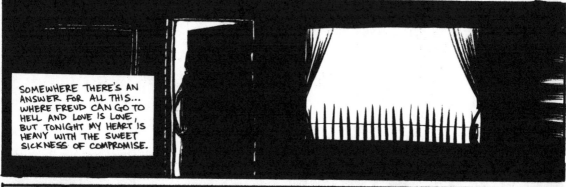

SOMEWHERE THERE'S AN ANSWER FOR ALL THIS... WHERE FREUD CAN GO TO HELL AND LOVE IS LOVE, BUT TONIGHT MY HEART'S HEAVY WITH THE SWEET SICKNESS OF COMPROMISE.

AUTOPILOT

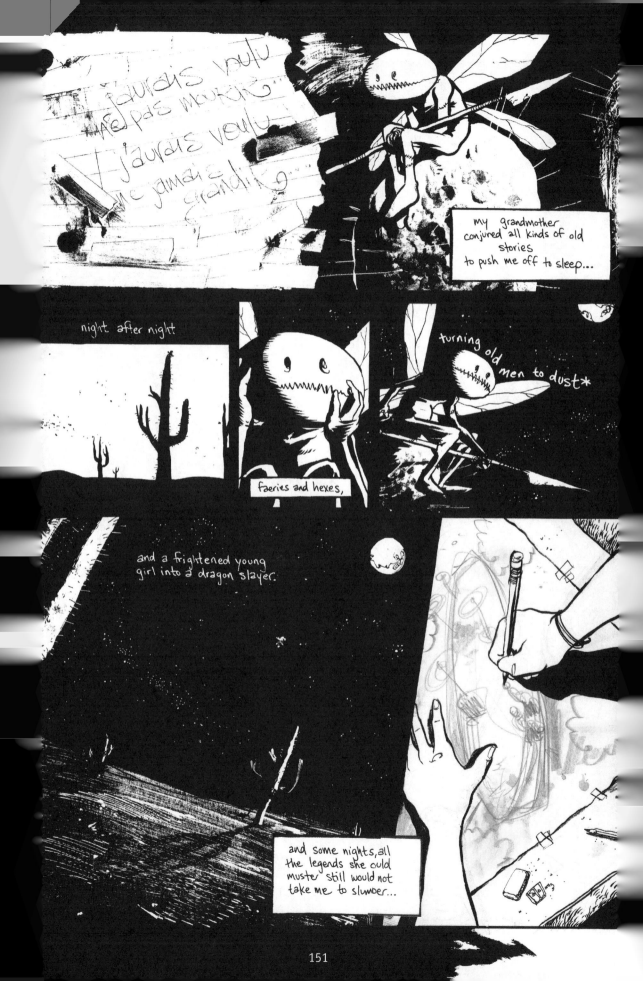

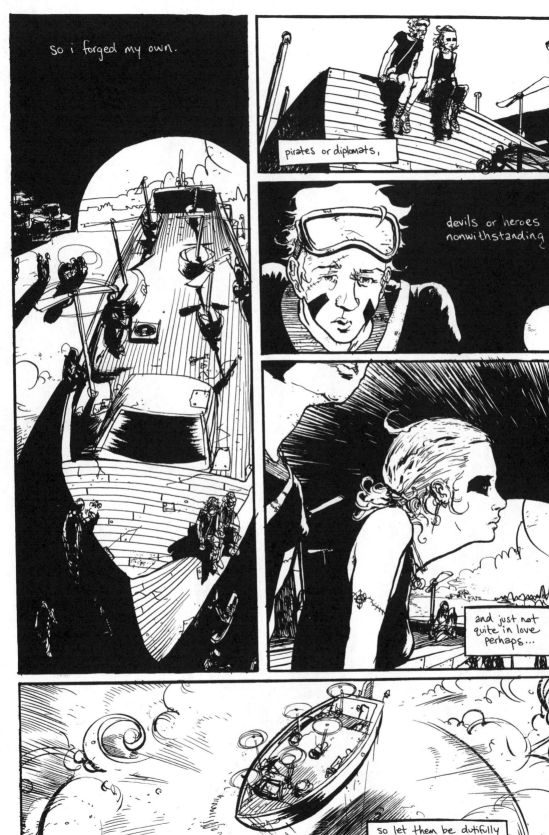

so i forged my own.

pirates or diplomats,

devils or heroes
nonwithstanding

and just not
quite in love
perhaps...

so let them be dutifully
resigned to their fates.

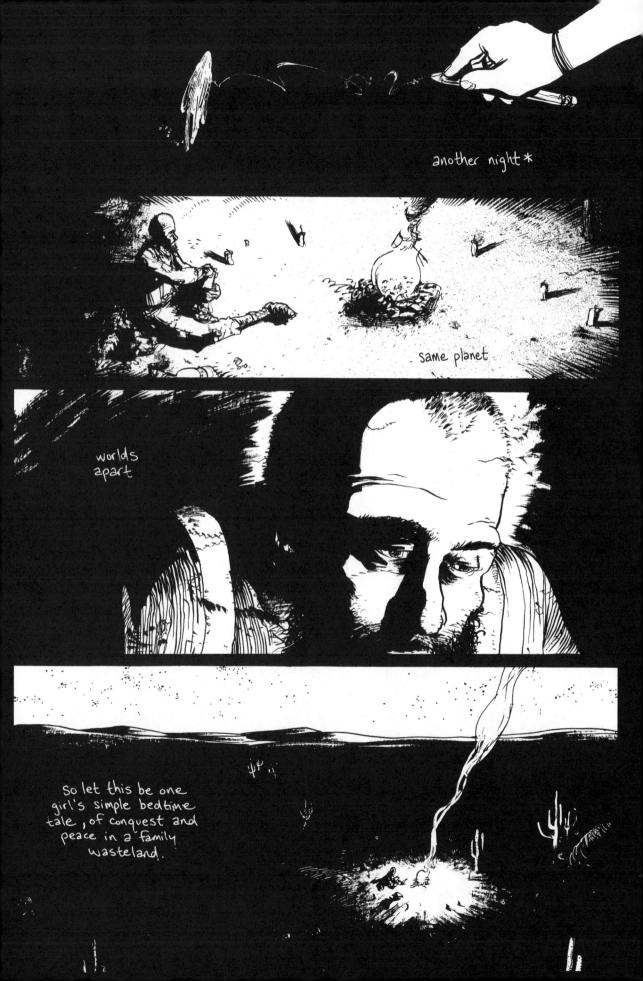

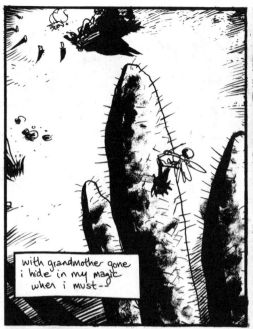

with grandmother gone
i hide in my magic
when i must—

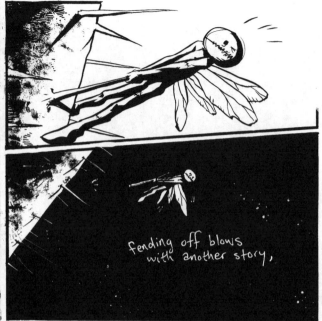

fending off blows
with another story,

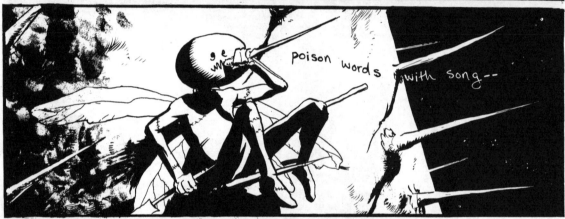

poison words with song—

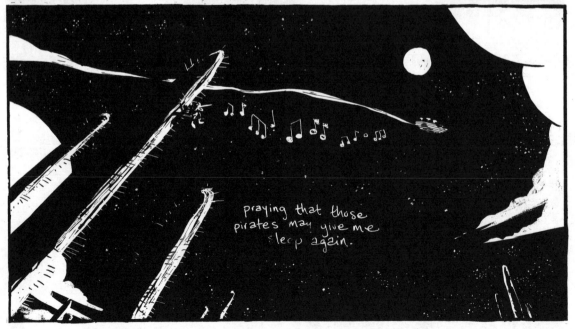

praying that those
pirates may give me
sleep again.

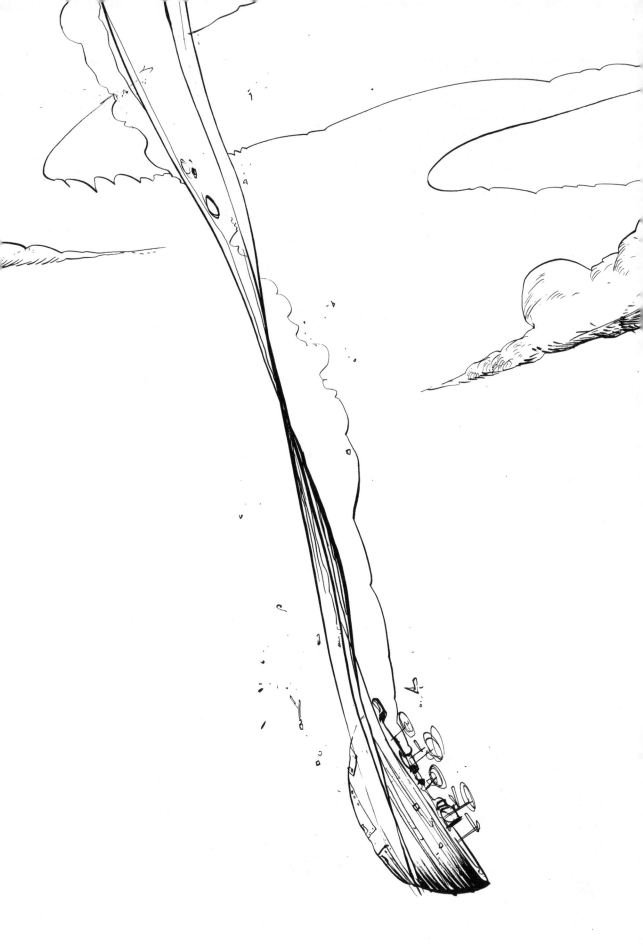

AUTOPILOT*

by nate powell

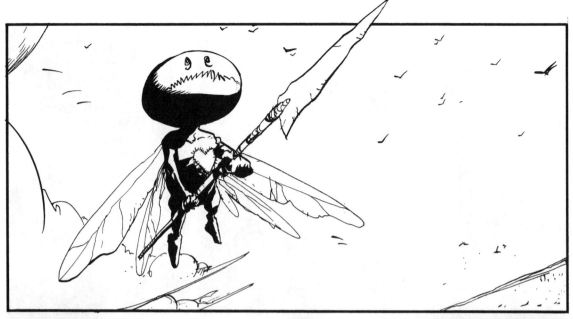

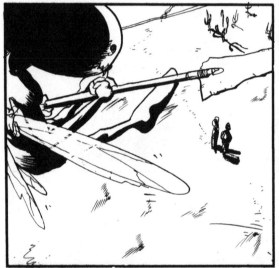

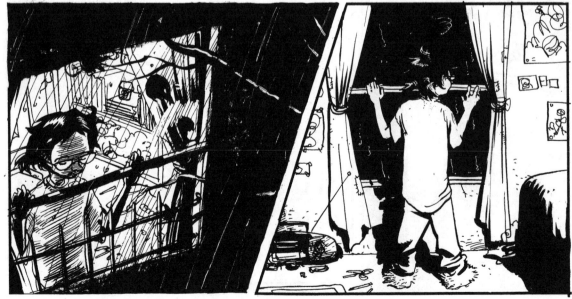

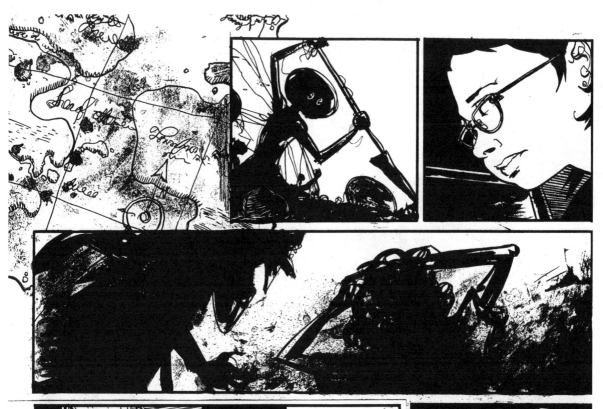

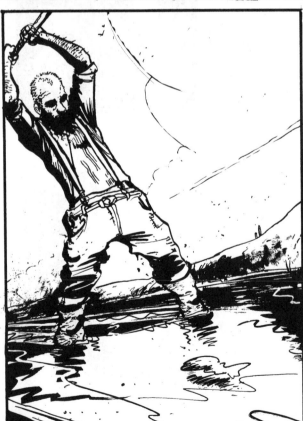

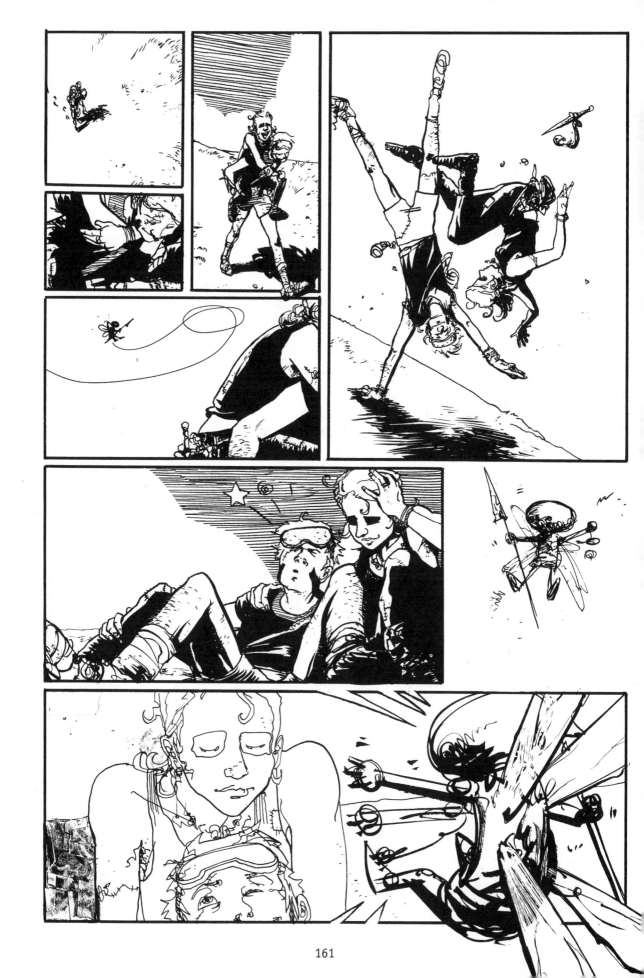

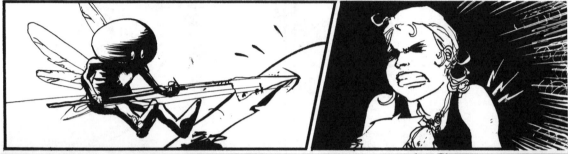

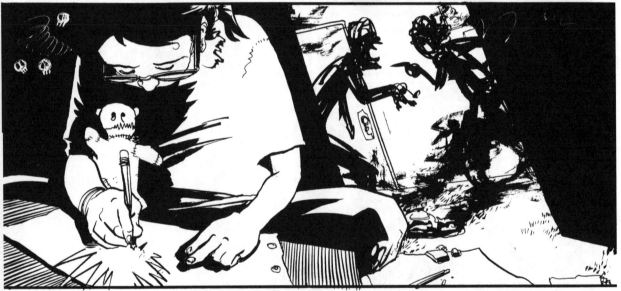

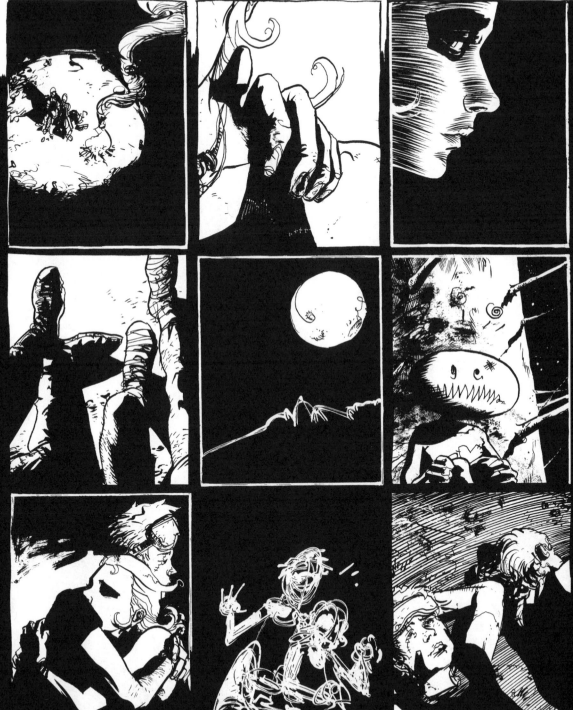

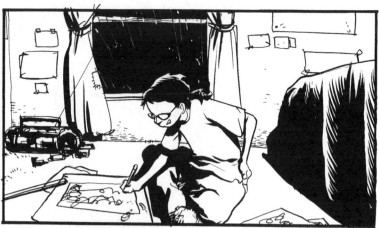
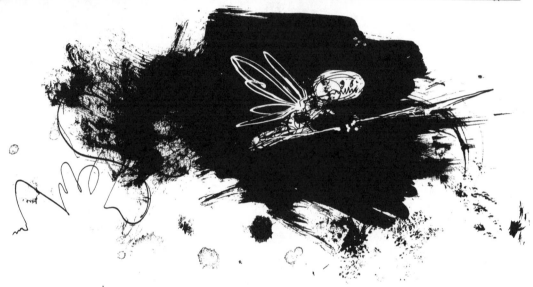
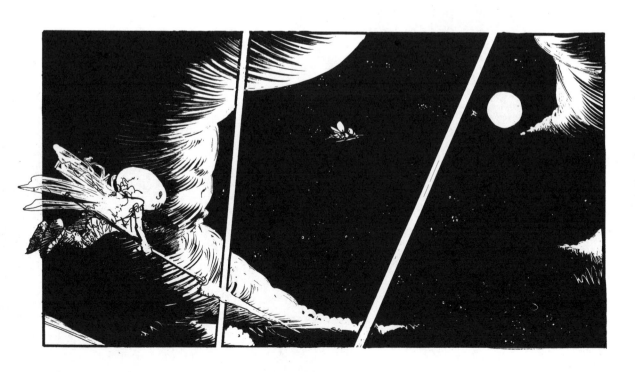

most of
all i want
to live
in a cloud
and have

stars

or friends

and see

endless

blue

skies.

very
far
when i

wake

from

dreams

I

count

my

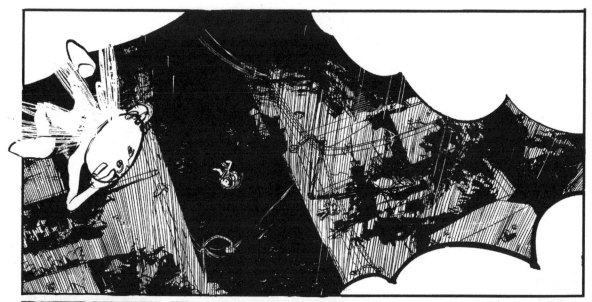

CORE BULLET BOMB

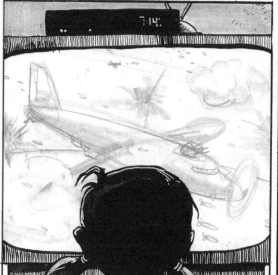

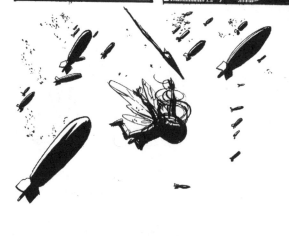

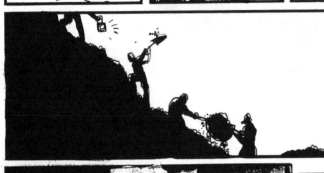

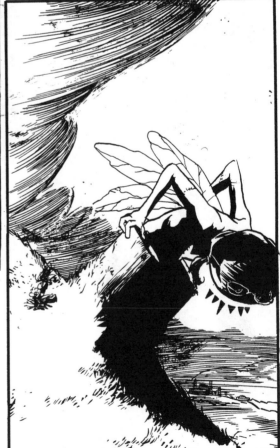

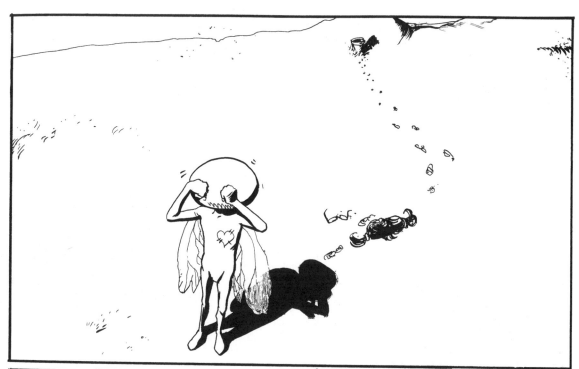

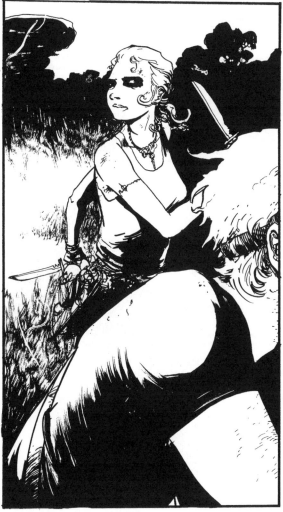

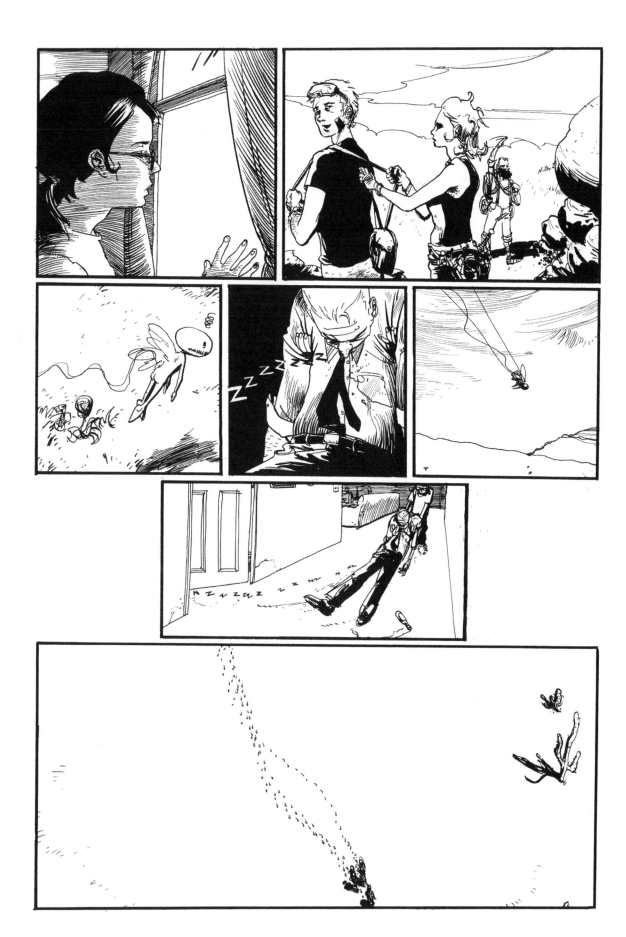

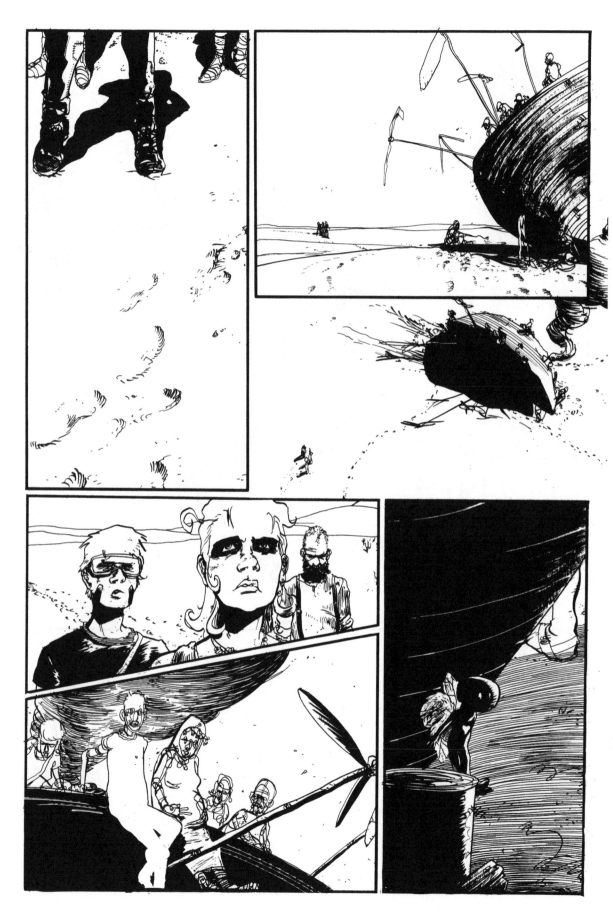

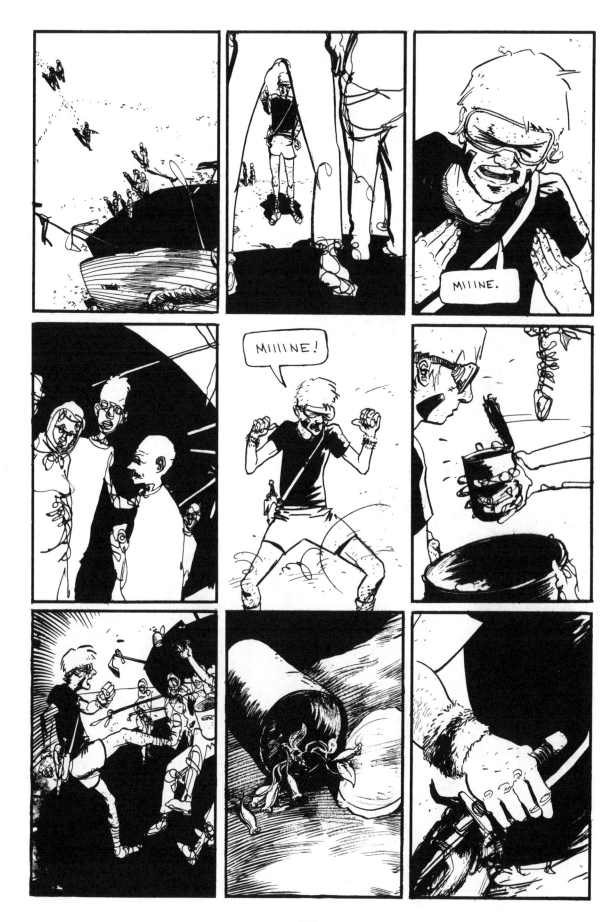

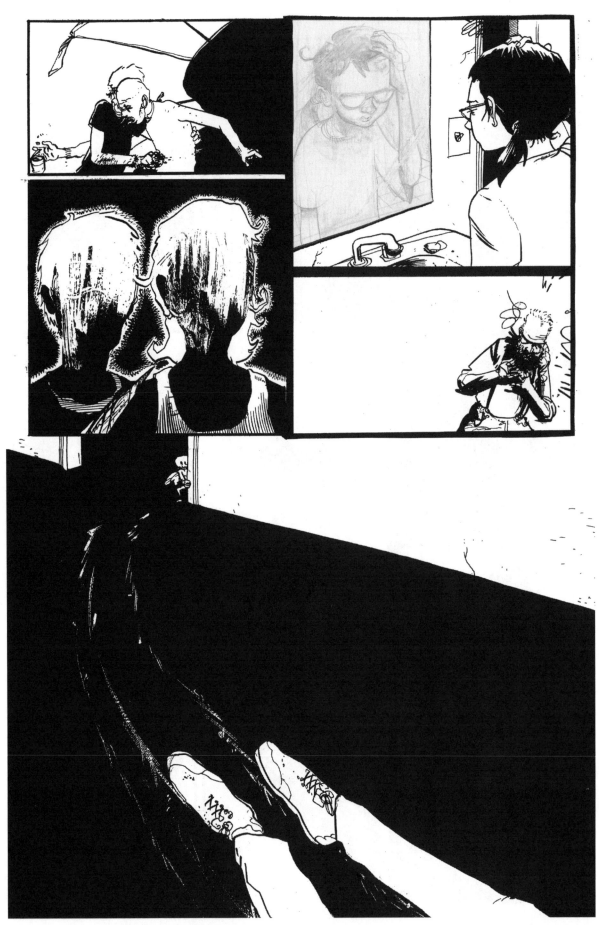

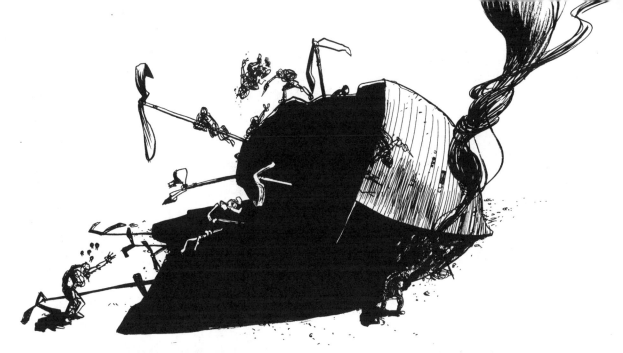

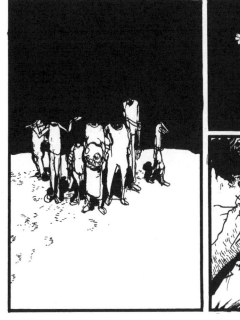

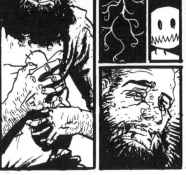

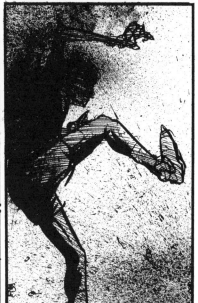

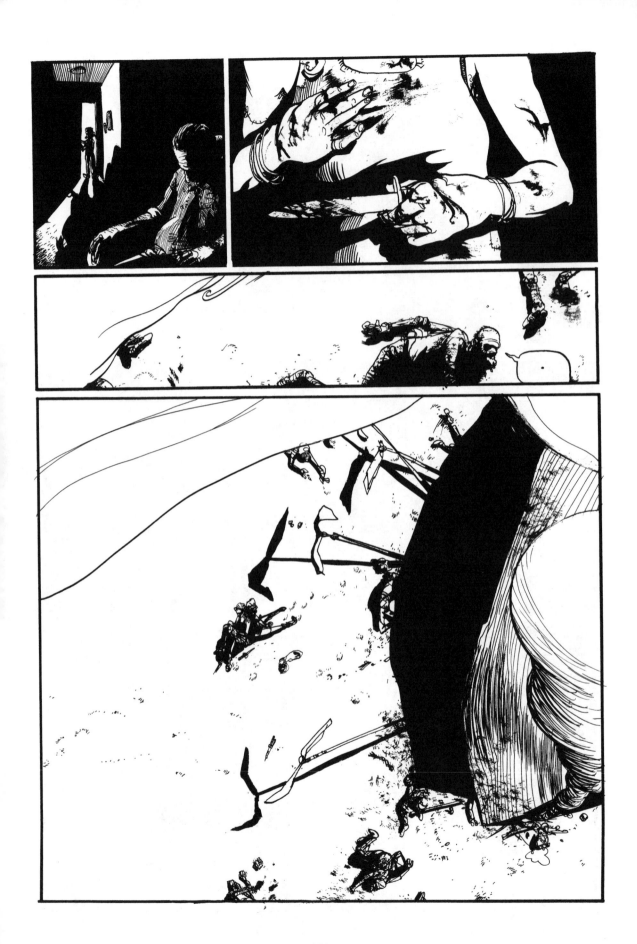

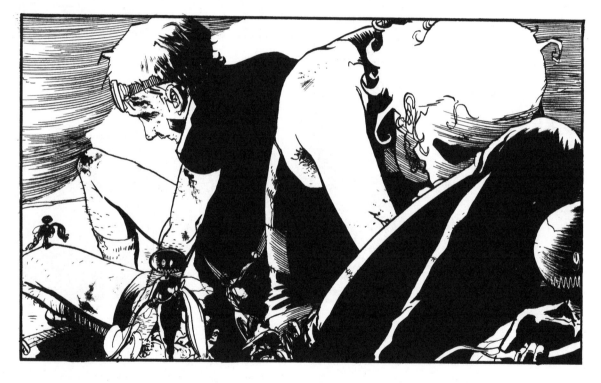

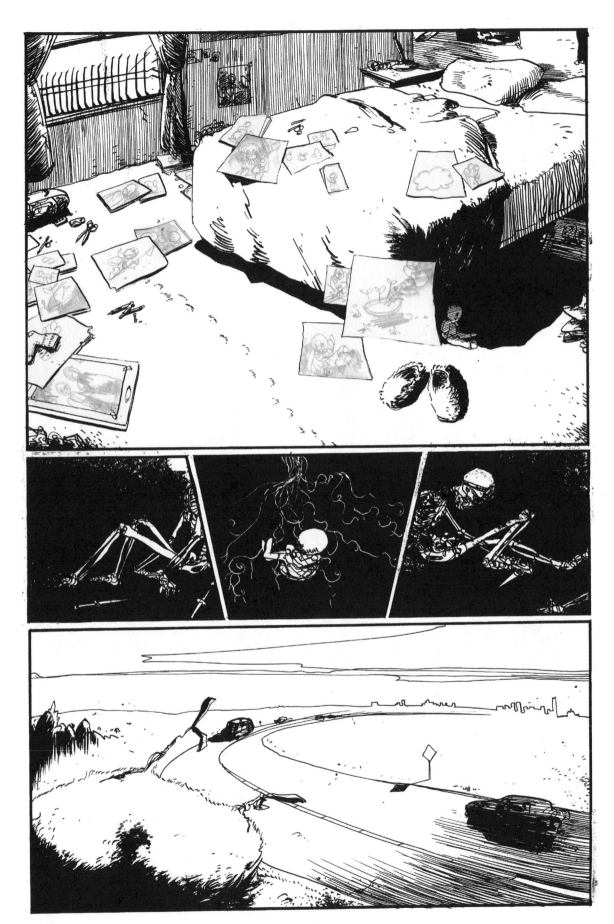

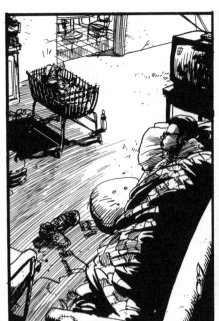
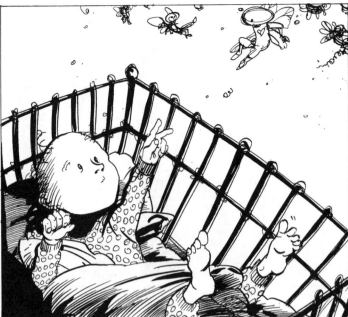

＊ Something happened or happens just as it always does, and always will, just as freeways will always just be skeletons of the old storytellers, our lives laid across their tracks. sometimes we can't help but to feel small and i guess we're just terrified of disappearing after it all. it still keeps me up late, staring at the patterns on the ceiling, knowing that when all the songs have been sung it'll still never be quite enough. so when will we rise? when the words overcome us? when conflict becomes inspiration beyond us? our pockets are starved as the sky drops and we live on in dreams but that's the part of the story we cross out with a little grown-up smile or a roll of the eyes.
 so when will we rise?
 from now till we win
 or until it's over..?

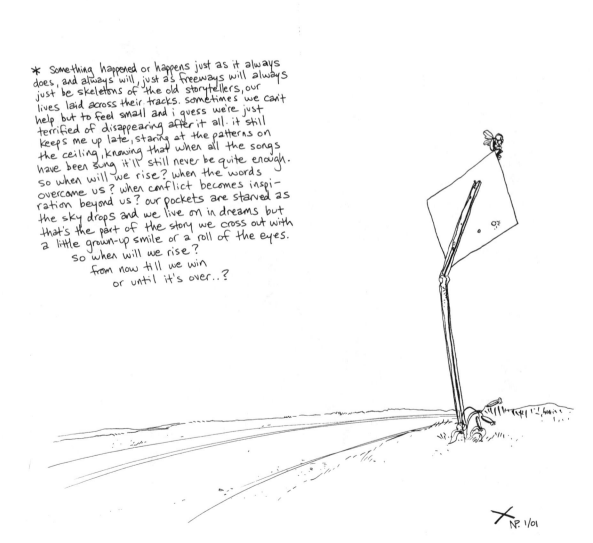

NP. 1/01

SATELLITE WORLDS

NOW SON,...

YOU'RE JUST GOING TO FEEL A LITTLE PRICK.

... I'M JUST SAYING --

THEY BETTER NOT HIT ON ME, THAT'S ALL.

NOW GO TRICK-OR-TREAT, DEAR.

IT'S NOT THAT --

I, I, I HAVE BLACK FRIENDS EVEN!

NOW DON'T GET ME WRONG

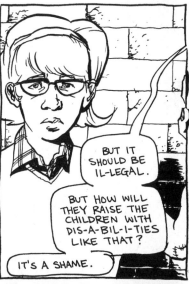

BUT IT SHOULD BE IL-LEGAL.

BUT HOW WILL THEY RAISE THE CHILDREN WITH DIS-A-BIL-I-TIES LIKE THAT?

IT'S A SHAME.

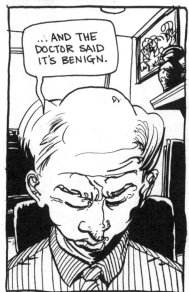

... AND THE DOCTOR SAID IT'S BENIGN.

DO YOU KNOW WHAT THAT MEANS?

OKAY.

GOOD NIGHT, NOW.

THERE'S A BIG DAY TOMORROW!

185

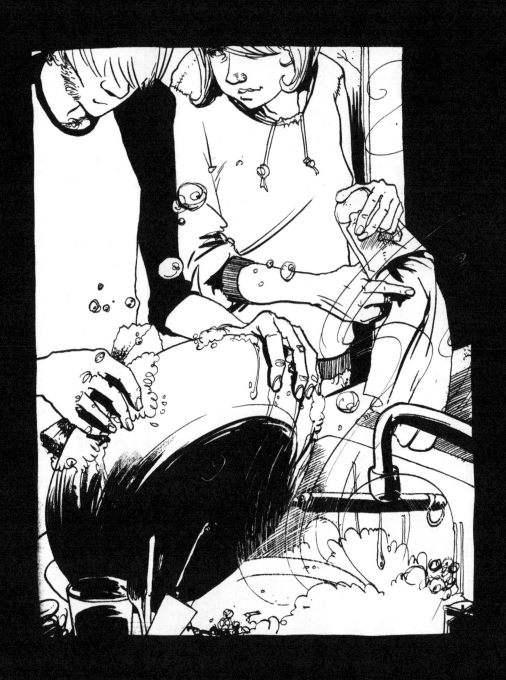

Satellite worlds

by nate powell ◆

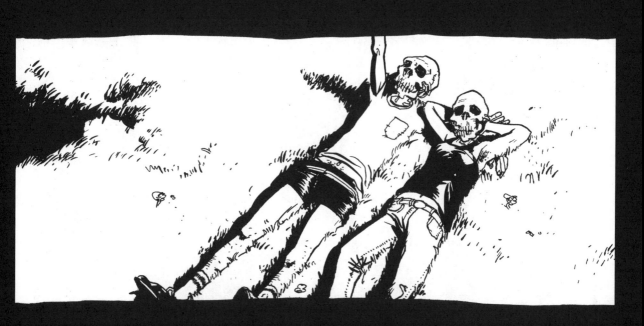

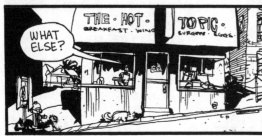

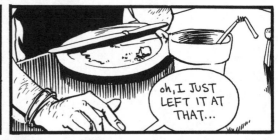

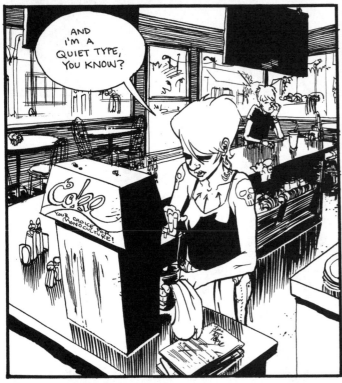

188

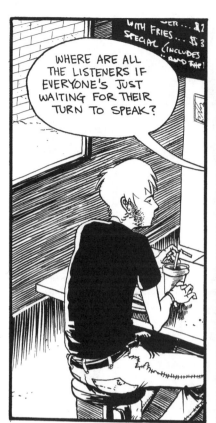

WHERE ARE ALL THE LISTENERS IF EVERYONE'S JUST WAITING FOR THEIR TURN TO SPEAK?

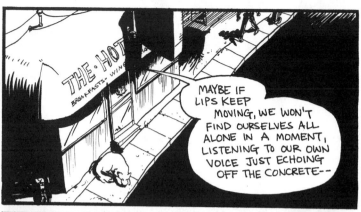

MAYBE IF LIPS KEEP MOVING, WE WON'T FIND OURSELVES ALL ALONE IN A MOMENT, LISTENING TO OUR OWN VOICE JUST ECHOING OFF THE CONCRETE--

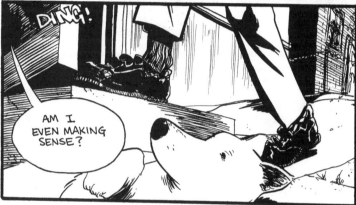

DING!

AM I EVEN MAKING SENSE?

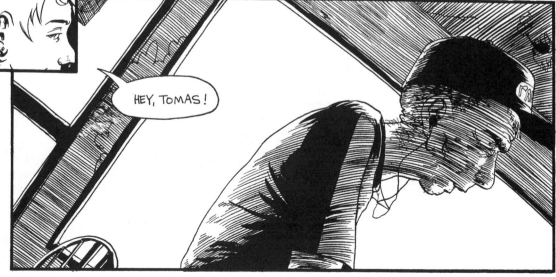

HEY, TOMAS!

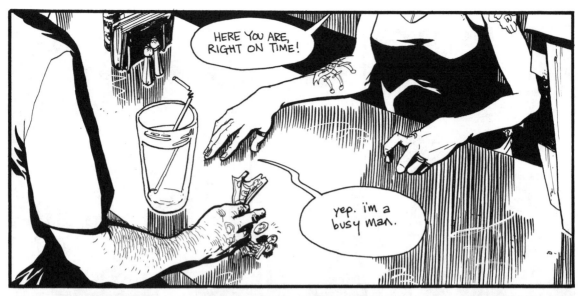

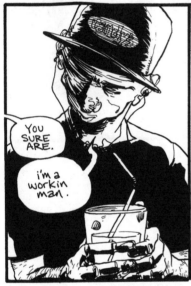

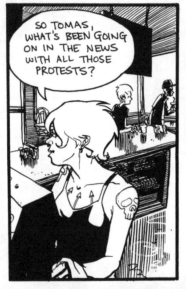

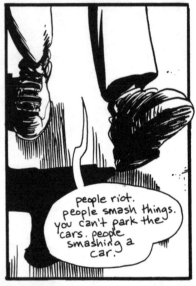

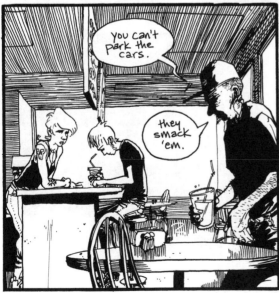

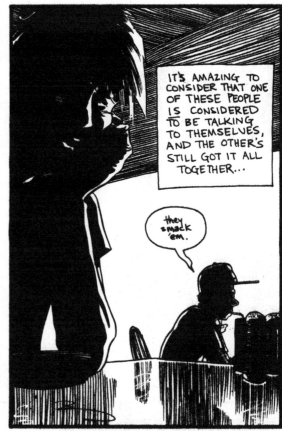

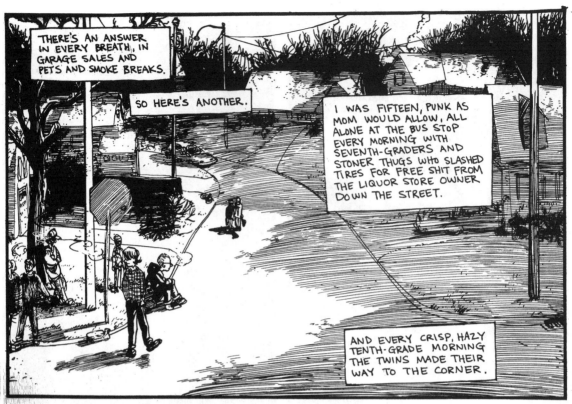

THERE'S AN ANSWER IN EVERY BREATH, IN GARAGE SALES AND PETS AND SMOKE BREAKS.

SO HERE'S ANOTHER.

I WAS FIFTEEN, PUNK AS MOM WOULD ALLOW, ALL ALONE AT THE BUS STOP EVERY MORNING WITH SEVENTH-GRADERS AND STONER THUGS WHO SLASHED TIRES FOR FREE SHIT FROM THE LIQUOR STORE OWNER DOWN THE STREET.

AND EVERY CRISP, HAZY TENTH-GRADE MORNING THE TWINS MADE THEIR WAY TO THE CORNER.

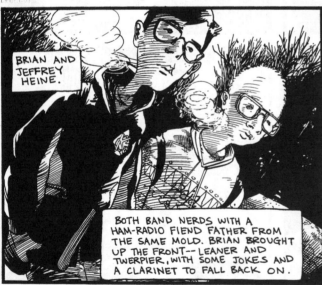

BRIAN AND JEFFREY HEINE.

BOTH BAND NERDS WITH A HAM-RADIO FIEND FATHER FROM THE SAME MOLD. BRIAN BROUGHT UP THE FRONT--LEANER AND TWERPIER, WITH SOME JOKES AND A CLARINET TO FALL BACK ON.

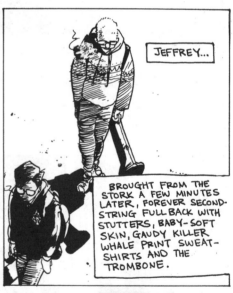

JEFFREY...

BROUGHT FROM THE STORK A FEW MINUTES LATER, FOREVER SECOND-STRING FULLBACK WITH STUTTERS, BABY-SOFT SKIN, GAUDY KILLER WHALE PRINT SWEAT-SHIRTS AND THE TROMBONE.

ALL THE ROUTINES STUCK.

HEY--

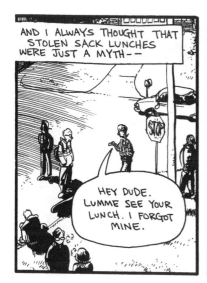

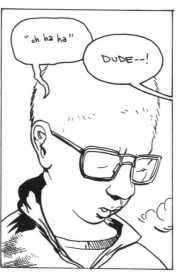

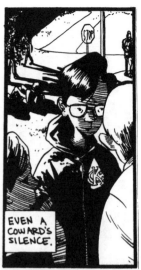

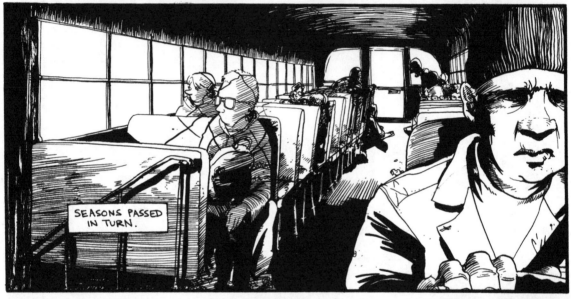

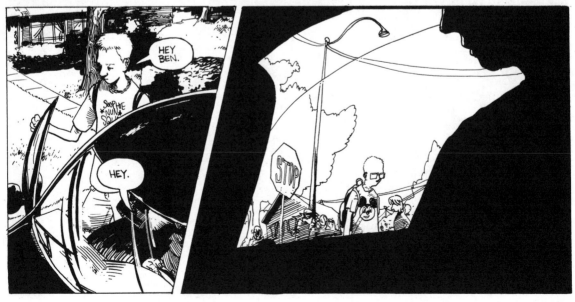

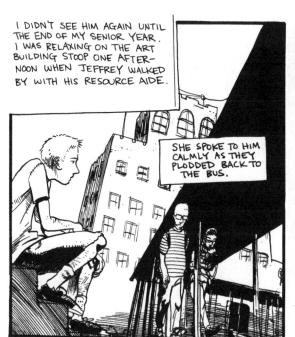

I DIDN'T SEE HIM AGAIN UNTIL THE END OF MY SENIOR YEAR. I WAS RELAXING ON THE ART BUILDING STOOP ONE AFTERNOON WHEN JEFFREY WALKED BY WITH HIS RESOURCE AIDE.

SHE SPOKE TO HIM CALMLY AS THEY PLODDED BACK TO THE BUS.

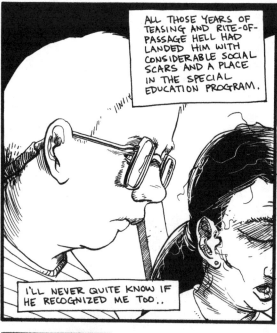

ALL THOSE YEARS OF TEASING AND RITE-OF-PASSAGE HELL HAD LANDED HIM WITH CONSIDERABLE SOCIAL SCARS AND A PLACE IN THE SPECIAL EDUCATION PROGRAM.

I'LL NEVER QUITE KNOW IF HE RECOGNIZED ME TOO..

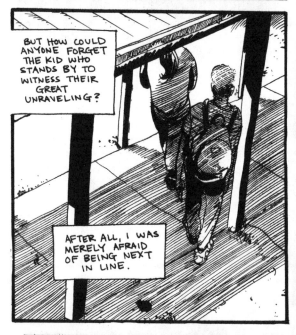

BUT HOW COULD ANYONE FORGET THE KID WHO STANDS BY TO WITNESS THEIR GREAT UNRAVELING?

AFTER ALL, I WAS MERELY AFRAID OF BEING NEXT IN LINE.

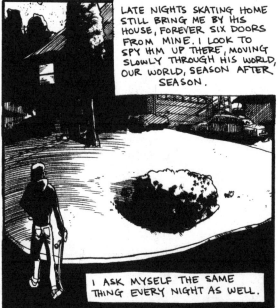

LATE NIGHTS SKATING HOME STILL BRING ME BY HIS HOUSE, FOREVER SIX DOORS FROM MINE. I LOOK TO SPY HIM UP THERE, MOVING SLOWLY THROUGH HIS WORLD, OUR WORLD, SEASON AFTER SEASON.

I ASK MYSELF THE SAME THING EVERY NIGHT AS WELL.

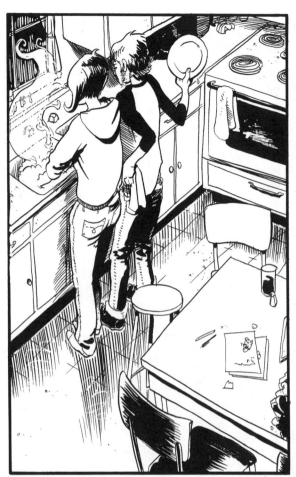

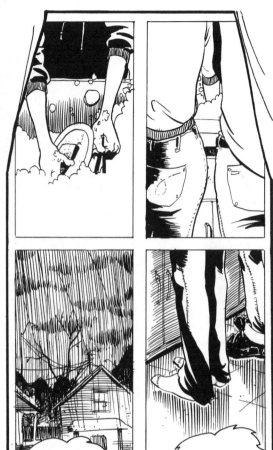

C'MON...

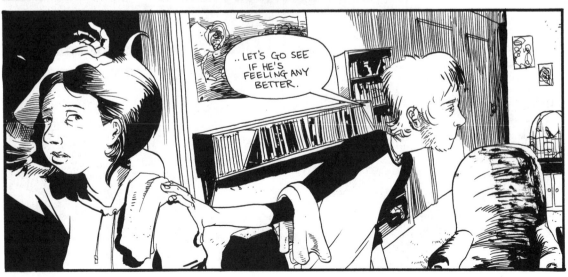

..LET'S GO SEE IF HE'S FEELING ANY BETTER.

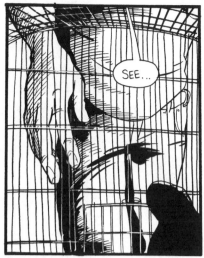

SEE...

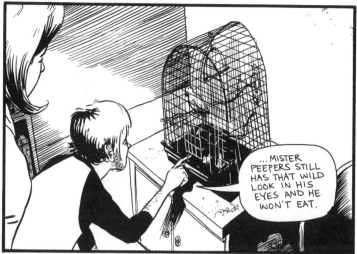

...MISTER PEEPERS STILL HAS THAT WILD LOOK IN HIS EYES AND HE WON'T EAT.

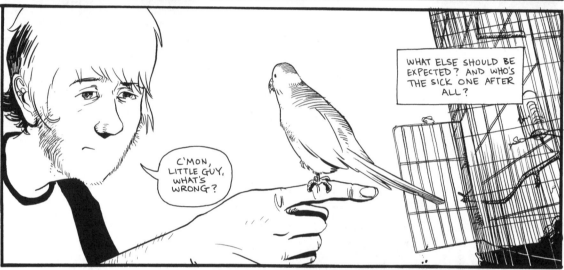

C'MON, LITTLE GUY, WHAT'S WRONG?

WHAT ELSE SHOULD BE EXPECTED? AND WHO'S THE SICK ONE AFTER ALL?

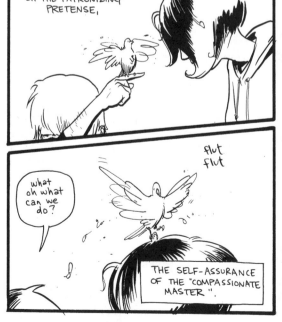

OH THE PATRONIZING PRETENSE,

flut flut

what oh what can we do?

THE SELF-ASSURANCE OF THE "COMPASSIONATE MASTER".

OH THE HORROR!

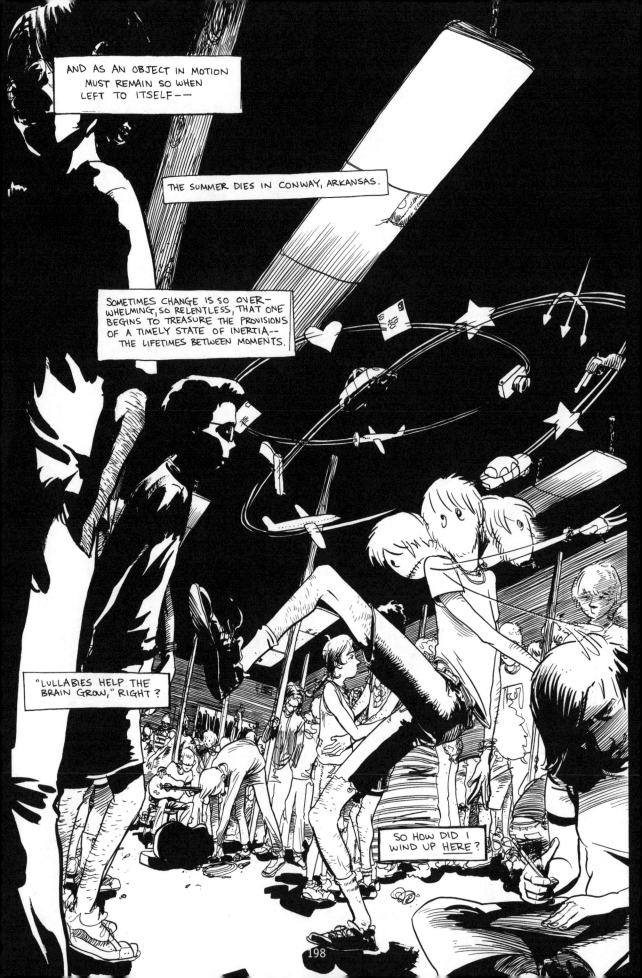

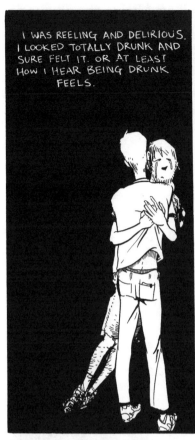

I WAS REELING AND DELIRIOUS. I LOOKED TOTALLY DRUNK AND SURE FELT IT. OR AT LEAST HOW I HEAR BEING DRUNK FEELS.

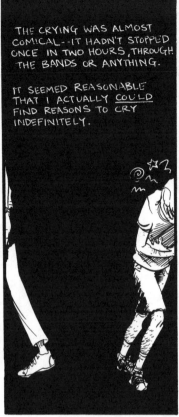

THE CRYING WAS ALMOST COMICAL--IT HADN'T STOPPED ONCE IN TWO HOURS, THROUGH THE BANDS OR ANYTHING.

IT SEEMED REASONABLE THAT I ACTUALLY COULD FIND REASONS TO CRY INDEFINITELY.

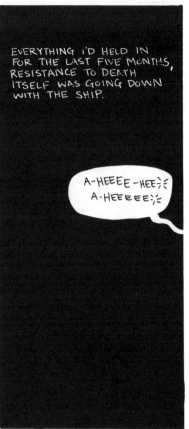

EVERYTHING I'D HELD IN FOR THE LAST FIVE MONTHS, RESISTANCE TO DEATH ITSELF WAS GOING DOWN WITH THE SHIP.

A-HEEEE-HEE
A-HEEEEE

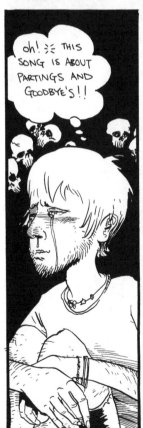

oh! THIS SONG IS ABOUT PARTINGS AND GOODBYE'S!!

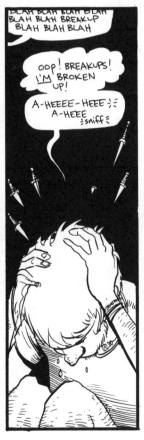

BLAH BLAH BLAH BLAH BLAH BLAH BREAKUP BLAH BLAH BLAH

OOP! BREAKUPS! I'M BROKEN UP!

A-HEEEE-HEE
A-HEE
sniff

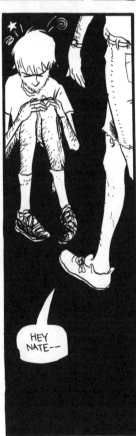

HEY NATE--

I WANT YOU TO MEET SOMEBODY NEW WHO'S JUST MOVED IN WITH US.

HEY DOOOD. I'M JOHN.

hey!

hey, SO WHERE ARE YOU FROM?

DON'T SAY "MICHIGAN"... DON'T SAY "MICHIGAN"...

WELL, I'M FROM MICHIGAN.

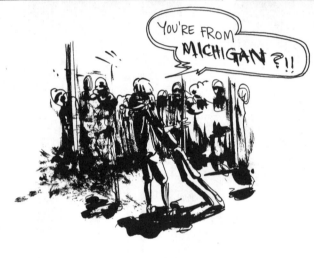

YOU'RE FROM MICHIGAN ?!!

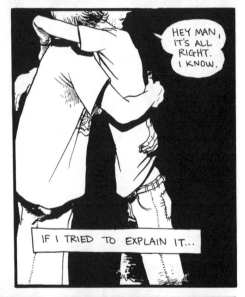

HEY MAN, IT'S ALL RIGHT. I KNOW.

IF I TRIED TO EXPLAIN IT...

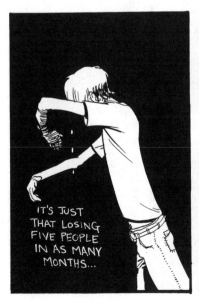

IT'S JUST THAT LOSING FIVE PEOPLE IN AS MANY MONTHS...

NO, IT'S...

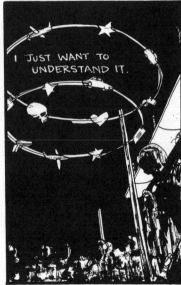

I JUST WANT TO UNDERSTAND IT.

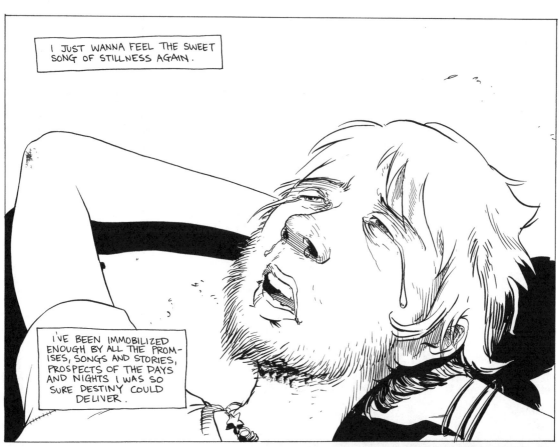

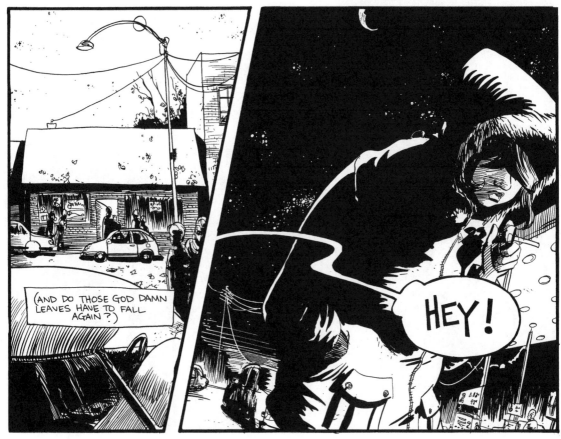

201

ARE YOU COMIN' OR NOT?

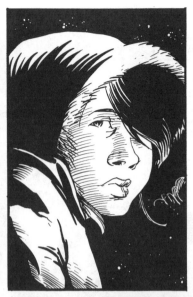

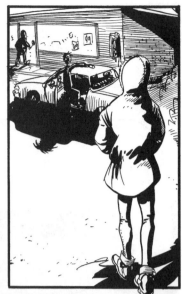

"So what does the odometer say..?"

"and how far out was this party anyway.?"

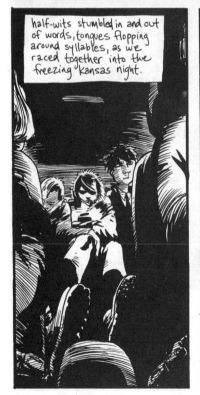

half-wits stumbled in and out of words, tongues flopping around syllables, as we raced together into the freezing kansas night.

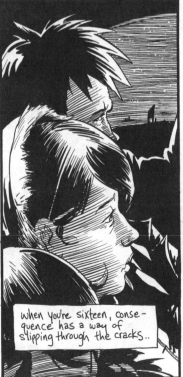

when you're sixteen, conse- quence has a way of slipping through the cracks..

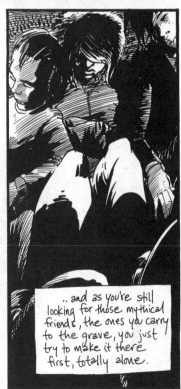

.. and as you're still looking for those mythical friends, the ones you carry to the grave, you just try to make it there first, totally alone.

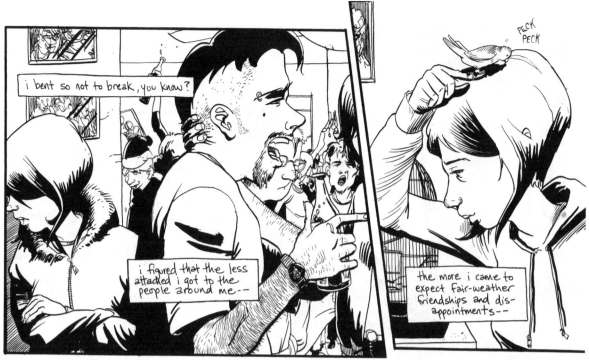

"PECK PECK"

i bent so not to break, you know?

i figured that the less attached i got to the people around me--

the more i came to expect fair-weather friendships and dis- appointments--

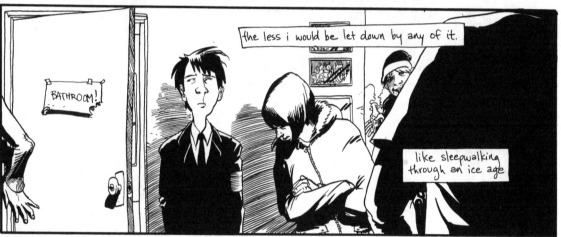

the less i would be let down by any of it.

BATHROOM!

like sleepwalking through an ice age

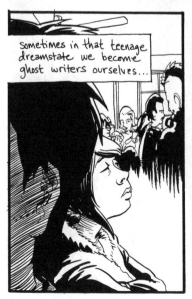

sometimes in that teenage dreamstate we become ghost writers ourselves...

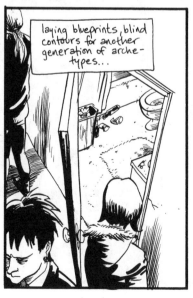

laying blueprints, blind contours for another generation of arche- types...

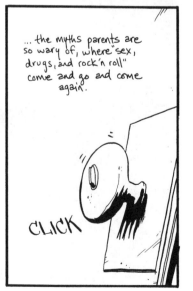

... the myths parents are so wary of, where "sex, drugs, and rock'n roll" come and go and come again.

CLICK

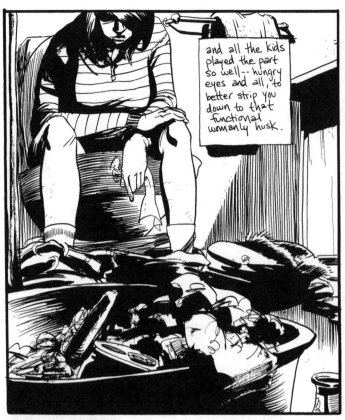

and all the kids played the part so well -- hungry eyes and all, to better strip you down to that functional womanly husk.

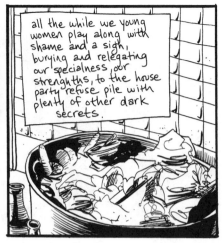

all the while we young women play along with shame and a sigh, burying and relegating our specialness our strengths, to the house party refuse pile with plenty of other dark secrets.

and as those boys around me *did* make me feel objectified, i gradually assumed that the surest way to be appreciated or noticed was with that goddamn husk.

at the time, sleepwalking was simply survival.

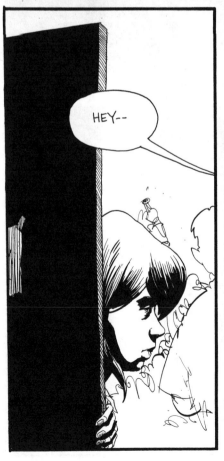

HEY--

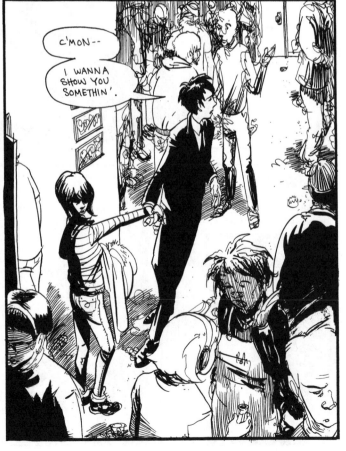

C'MON--

I WANNA SHOW YOU SOMETHIN'.

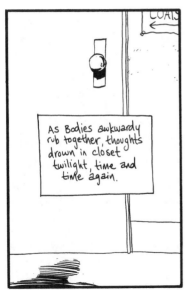

As Bodies awkwardly rub together, thoughts drown in closet twilight, time and time again.

and it really had nothing to do with "dudes" and popularity and submission--

those boys didn't have any more idea what they were doing than i did.

BUMP."

neither party could stand up for themselves.

BUMP!

i just figured if some boy wanted to know me, it was in regards to my body

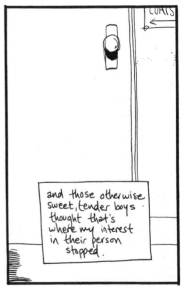

and those otherwise sweet, tender boys thought that's where my interest in their person stopped.

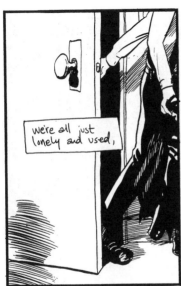

we're all just lonely and used,

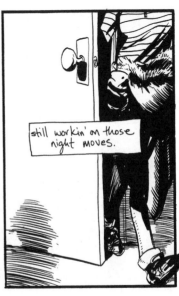

still workin' on those night moves.

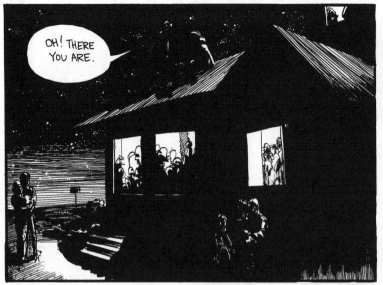

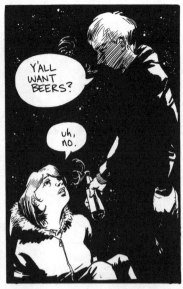

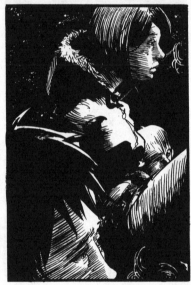

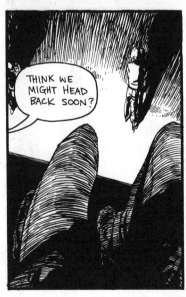

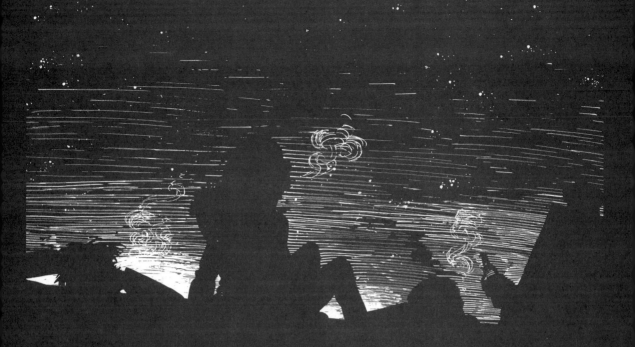

i got lost in the city after that...

it made it all so much
more natural, really.

and i was empowered to
smile again in years to come.

in time, isn't everybody?

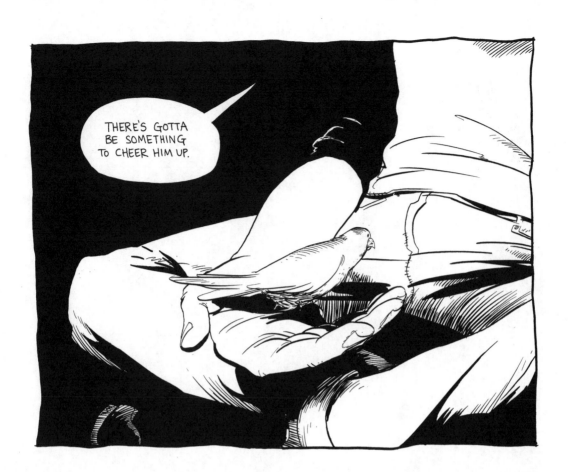

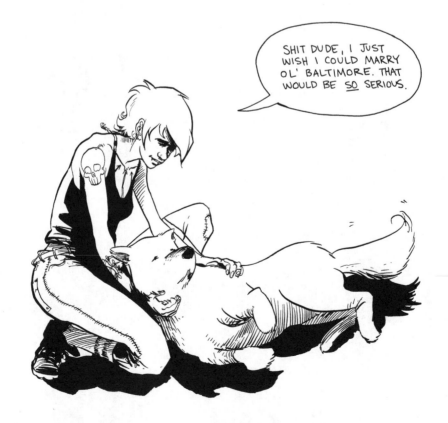

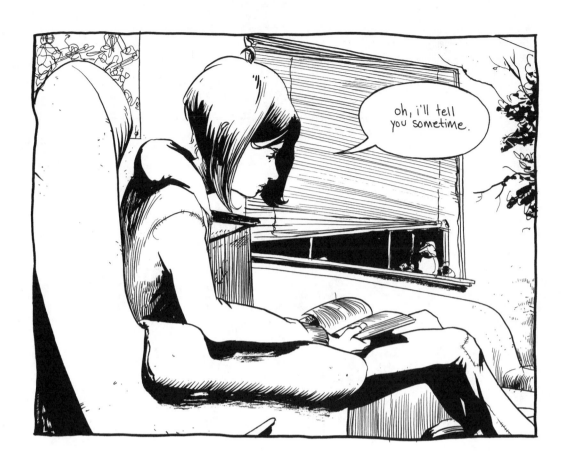

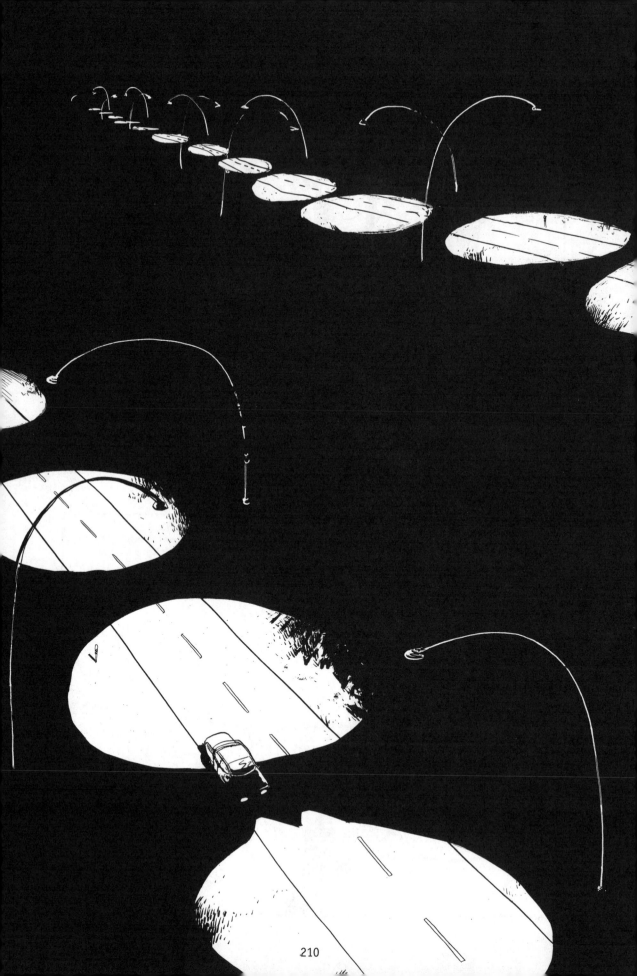

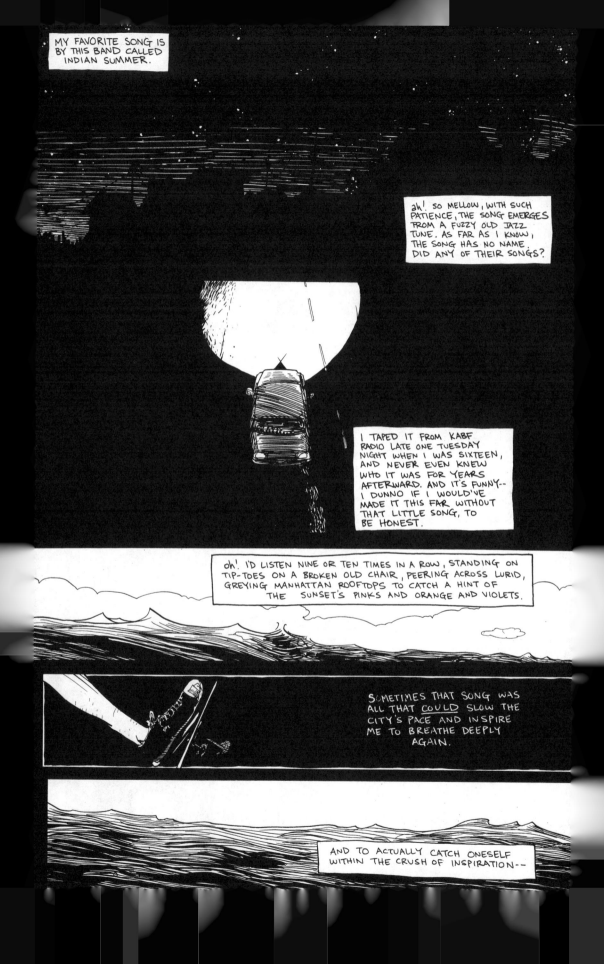

TO REALIZE THAT MOMENT OF CLARITY, BREATHING AGAIN--YES! TO KNOW PEACE--

TO SEE OBJECTIVELY OUR SELF-PERPETUATED DESTRUCTION--

FROM PASSIVE CONSUMER OPPRESSION TO SIMPLE, DEVESTATING ALONENESS...

STILL, RIVERS RISE AND CARS MOVE FASTER.

IT'S NOT HARD TO LOSE ONESELF ENTIRELY FOR A TIME, SUFFOCATING ON THE WEIGHT OF THE UNCONSUMMATED.

WE SURE HAVE MORE THAN ENOUGH OF THOSE REGRETS.

WELL..

?!

and it seems everybody's
playing dead for a few
months at a time,
sooner or later.

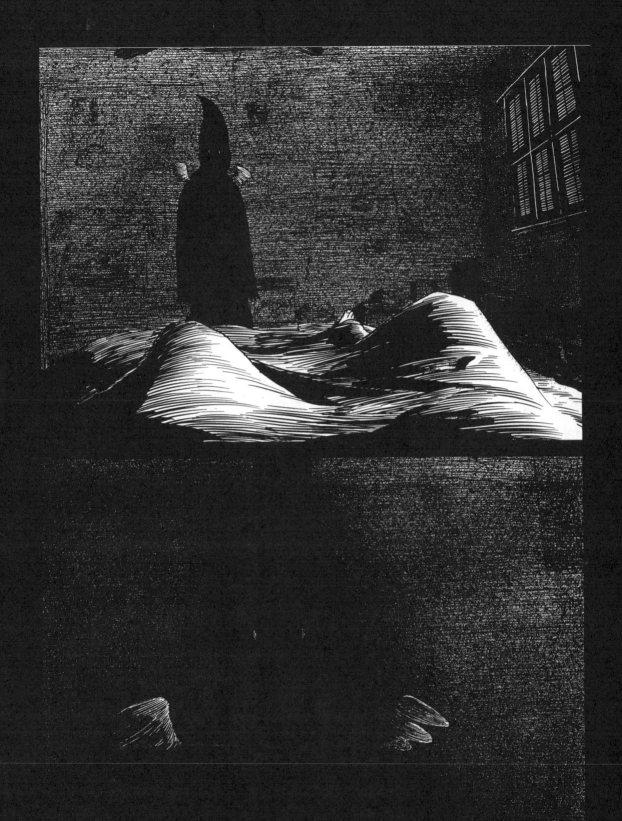

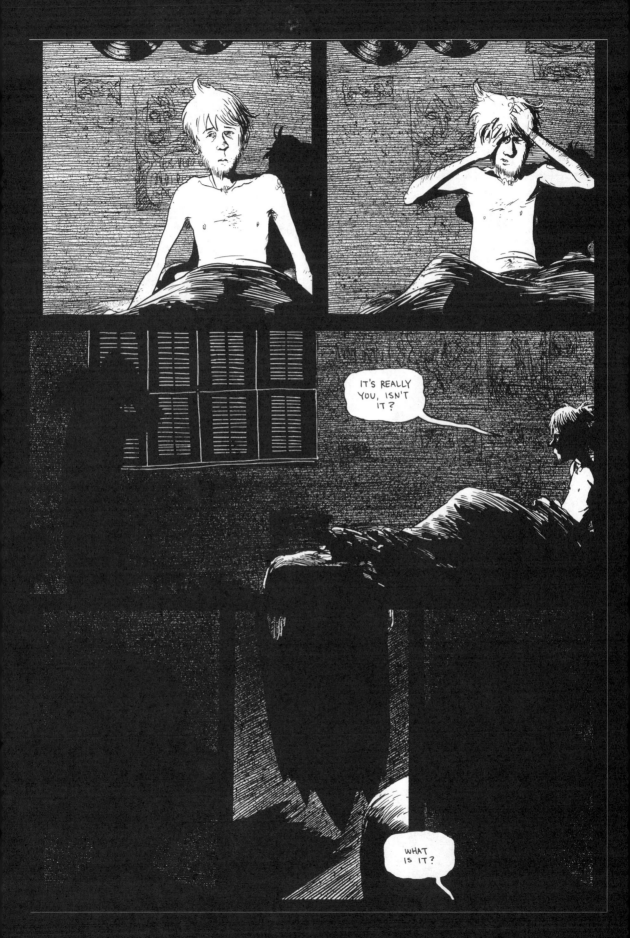

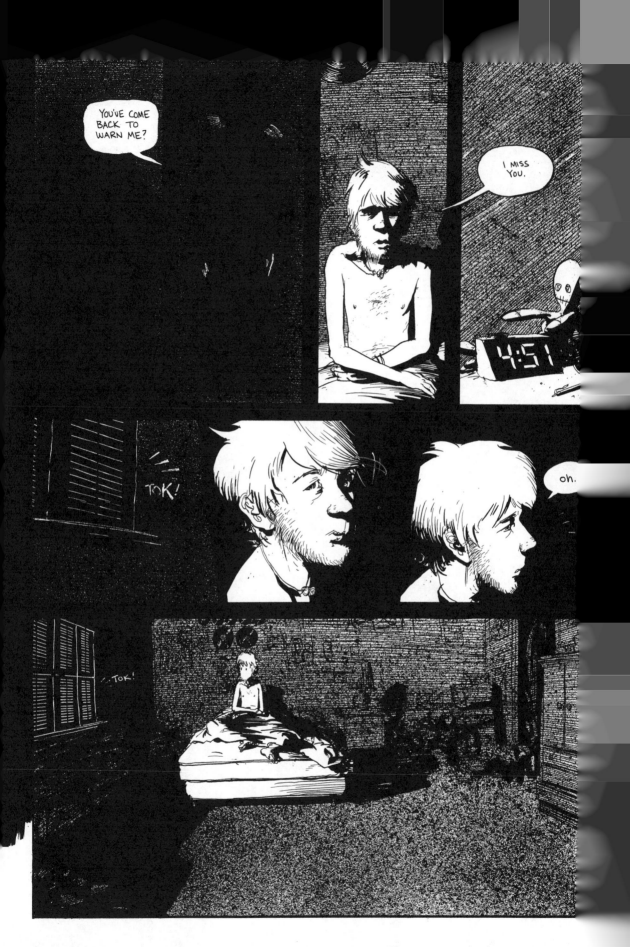

PECK!

PECK!

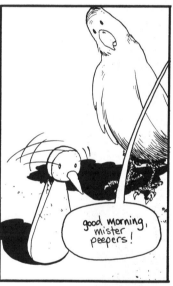

good morning, mister peepers!

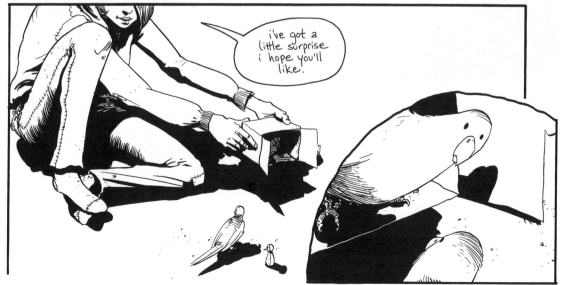

i've got a little surprise i hope you'll like.

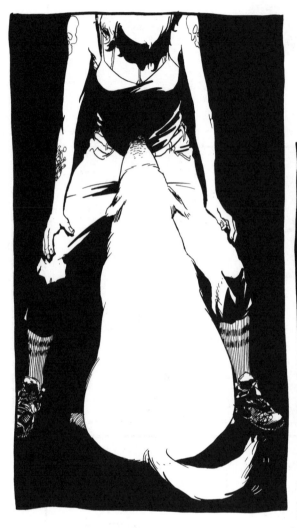

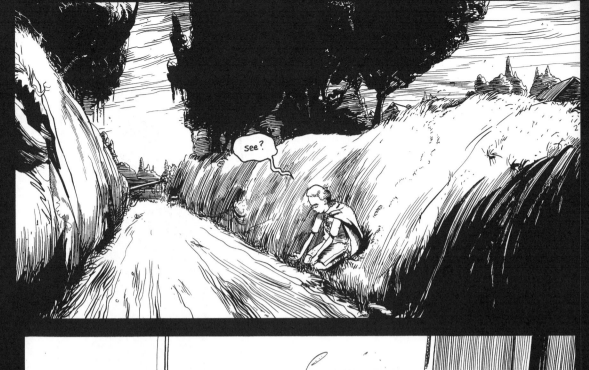

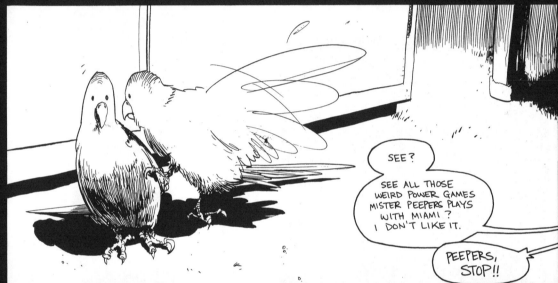

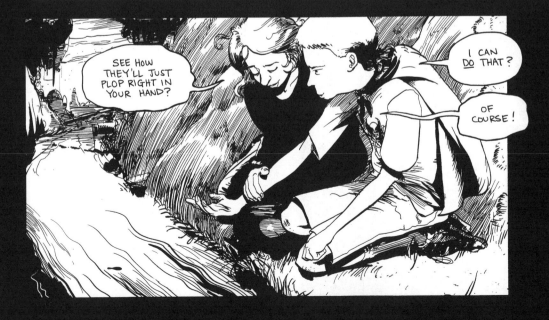

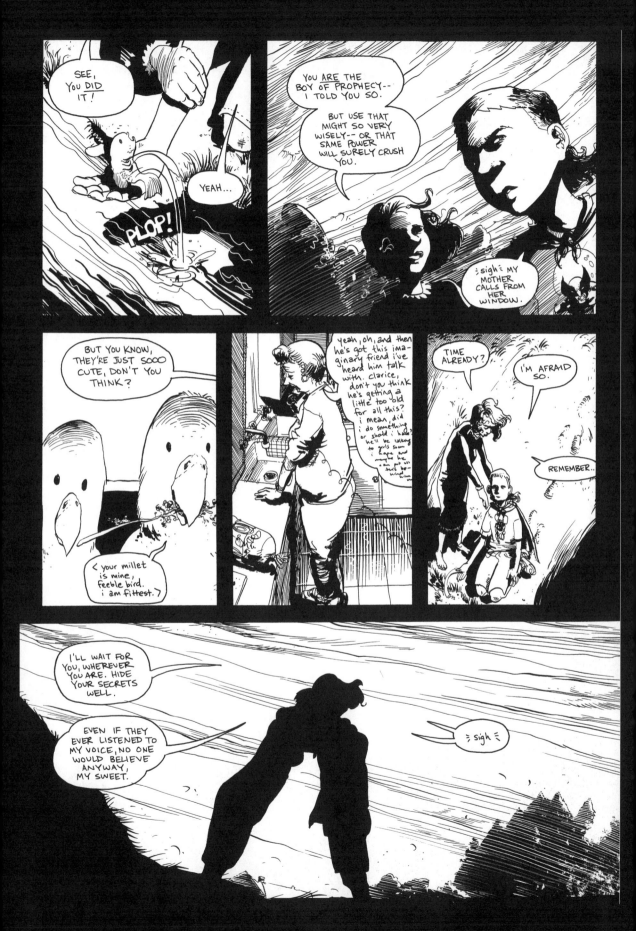

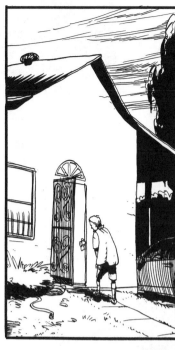

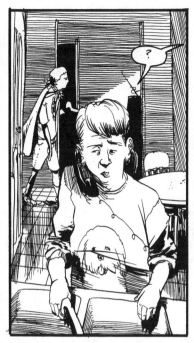

DID YOU HAVE A BAD DAY AT SCHOOL, JONAH?

HERE, HAVE SOME LITTLE CRACKERS AND CHEESES...

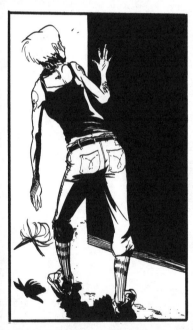

‹in short days, we love with an iron fist.›

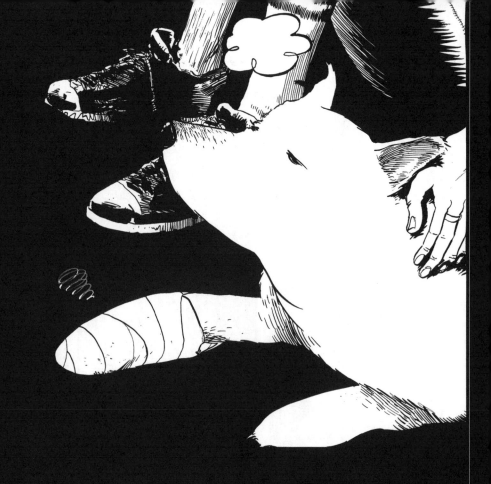

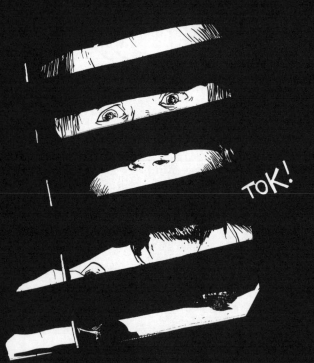

TOK!

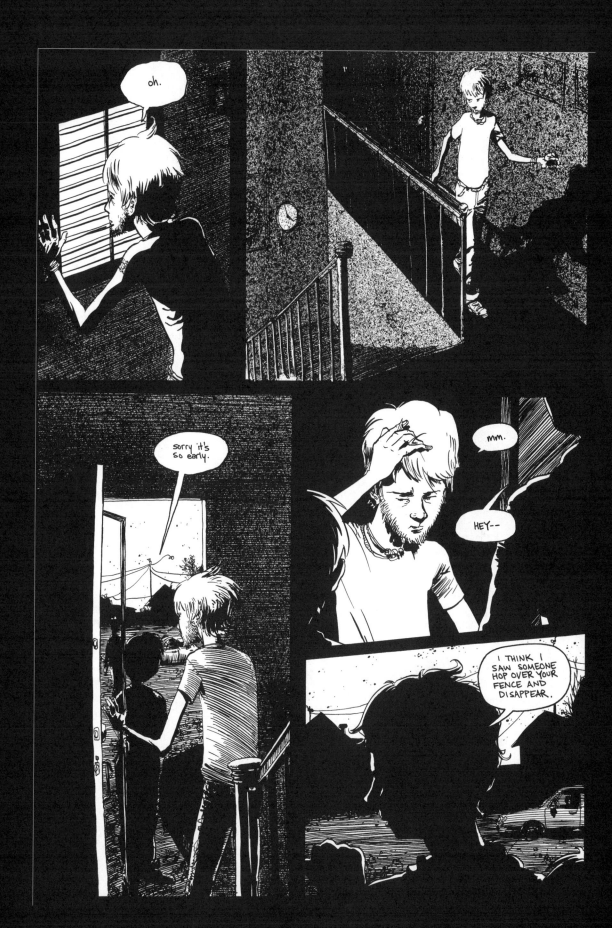

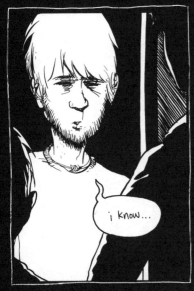

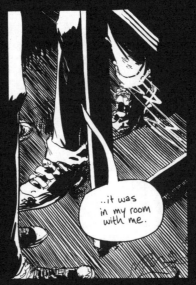

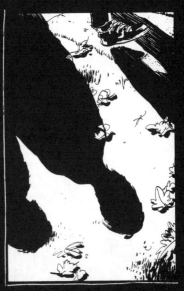

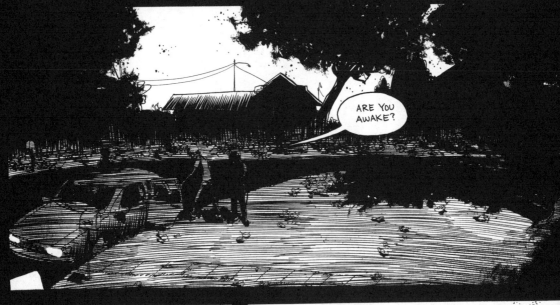

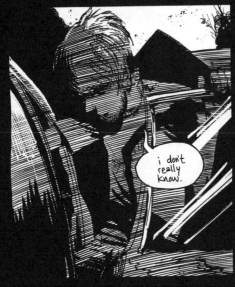

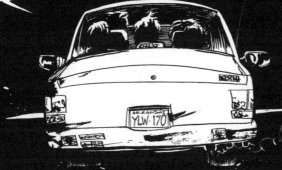
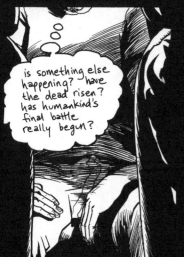
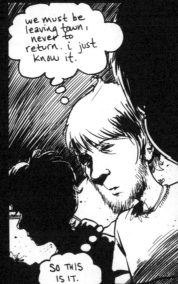

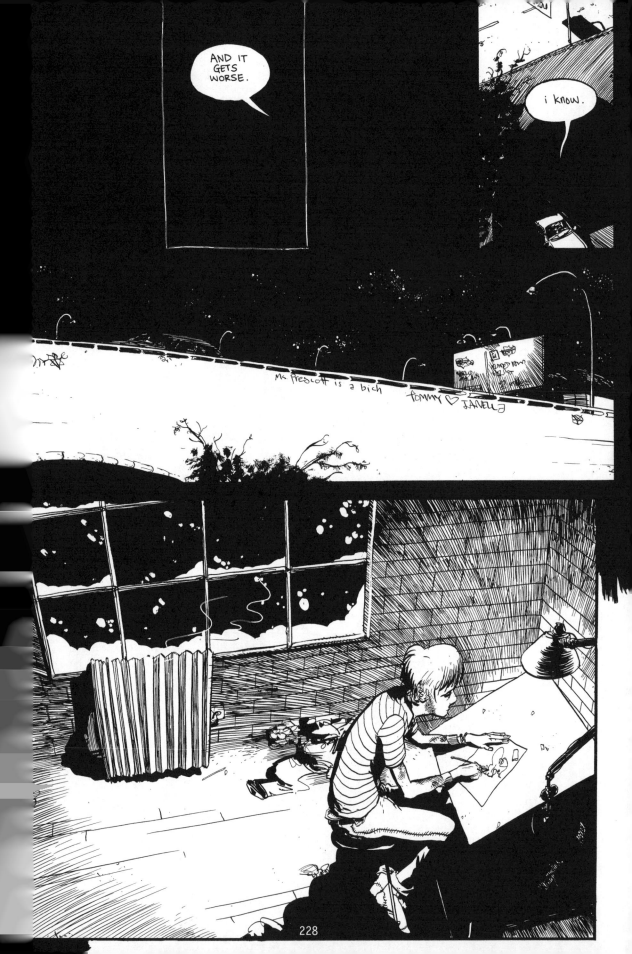

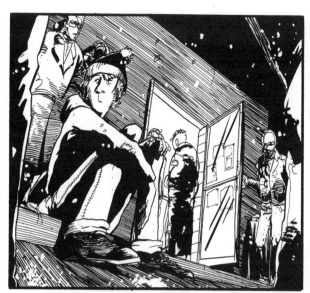

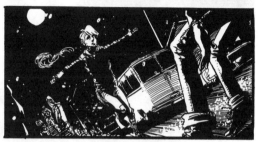

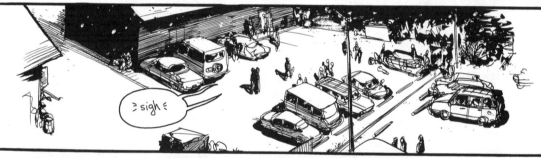

≶ sigh ≶

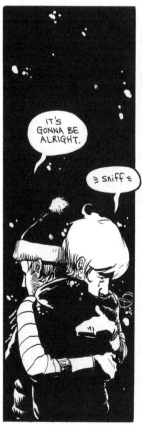

IT'S GONNA BE ALRIGHT.

≶ sniff ≶

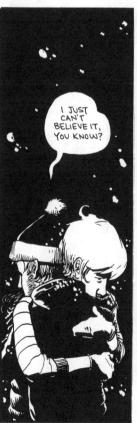

I JUST CAN'T BELIEVE IT, YOU KNOW?

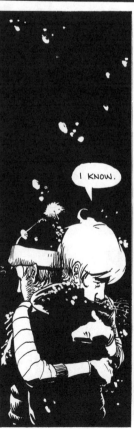

I KNOW.

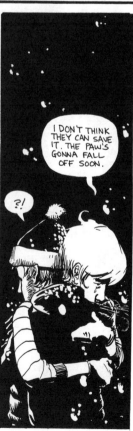

I DON'T THINK THEY CAN SAVE IT. THE PAW'S GONNA FALL OFF SOON.

?!

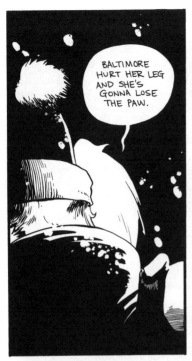

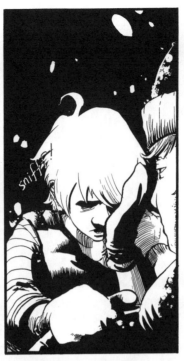

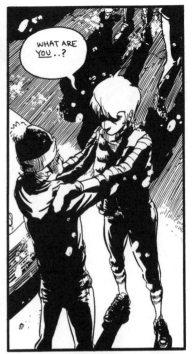

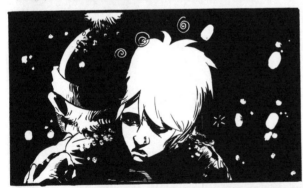

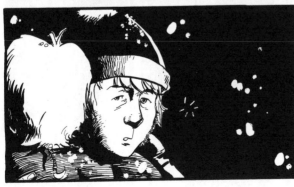

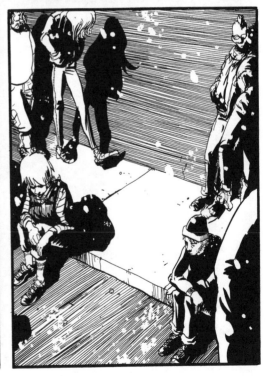

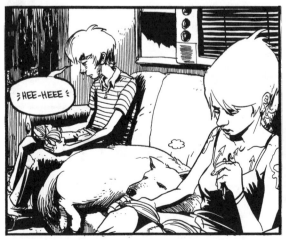

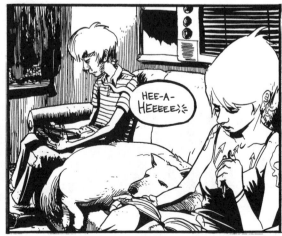

233

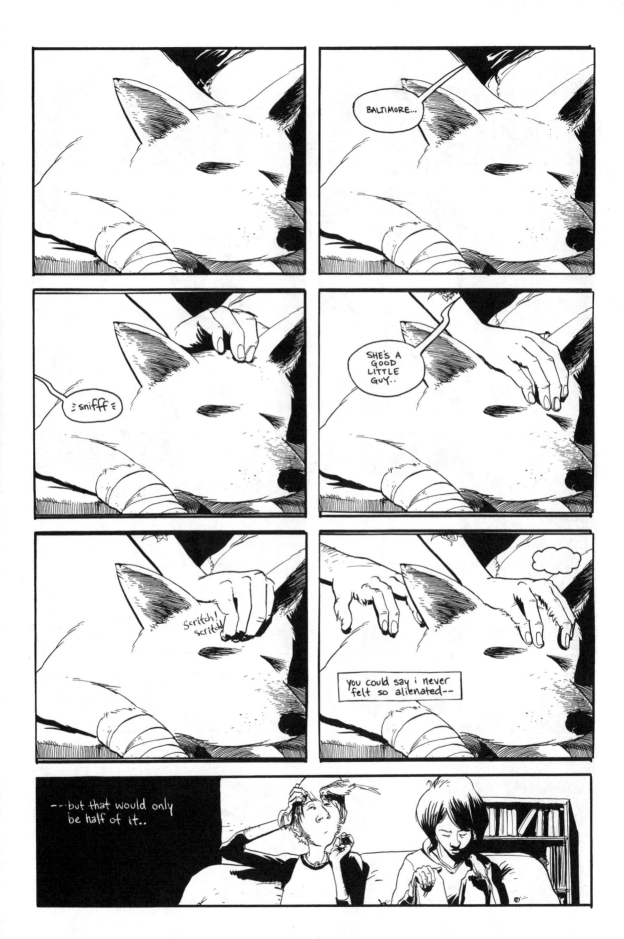

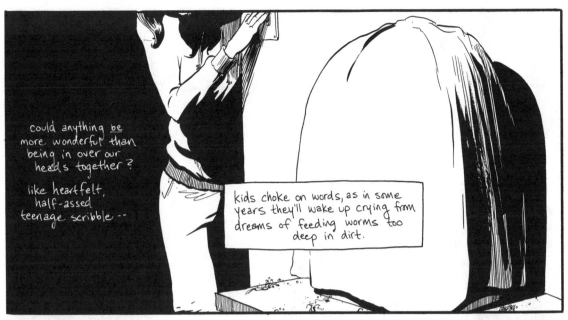

could anything <u>be</u> more wonderful than being in over our heads together?

like heartfelt, half-assed teenage scribble --

kids choke on words, as in some years they'll wake up crying from dreams of feeding worms too deep in dirt.

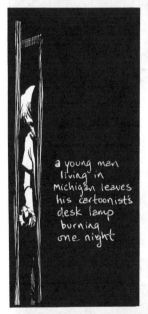

a young man living in michigan leaves his cartoonist's desk lamp burning one night

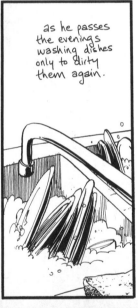

as he passes the evenings washing dishes only to dirty them again.

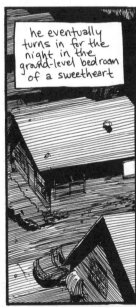

he eventually turns in for the night in the ground-level bedroom of a sweetheart

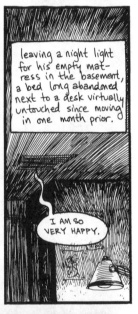

leaving a night light for his empty mattress in the basement, a bed long abandoned next to a desk virtually untouched since moving in one month prior.

I AM SO VERY HAPPY.

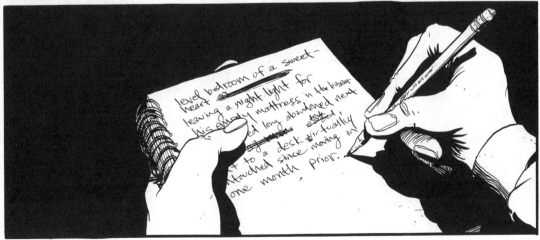

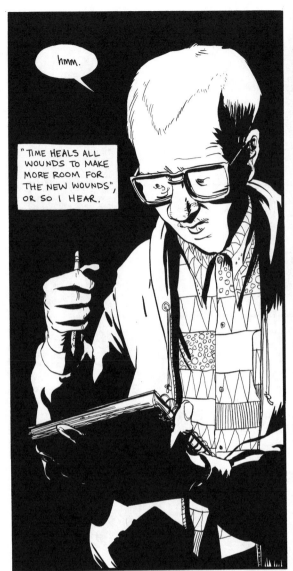

hmm.

"TIME HEALS ALL WOUNDS TO MAKE MORE ROOM FOR THE NEW WOUNDS", OR SO I HEAR.

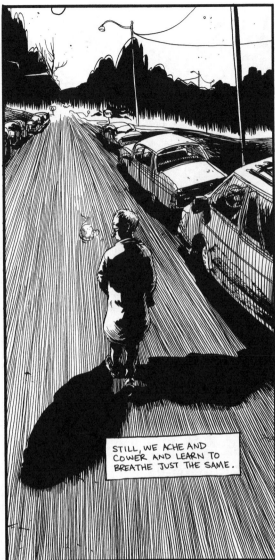

STILL, WE ACHE AND COWER AND LEARN TO BREATHE JUST THE SAME.

IT DISAPPEARS

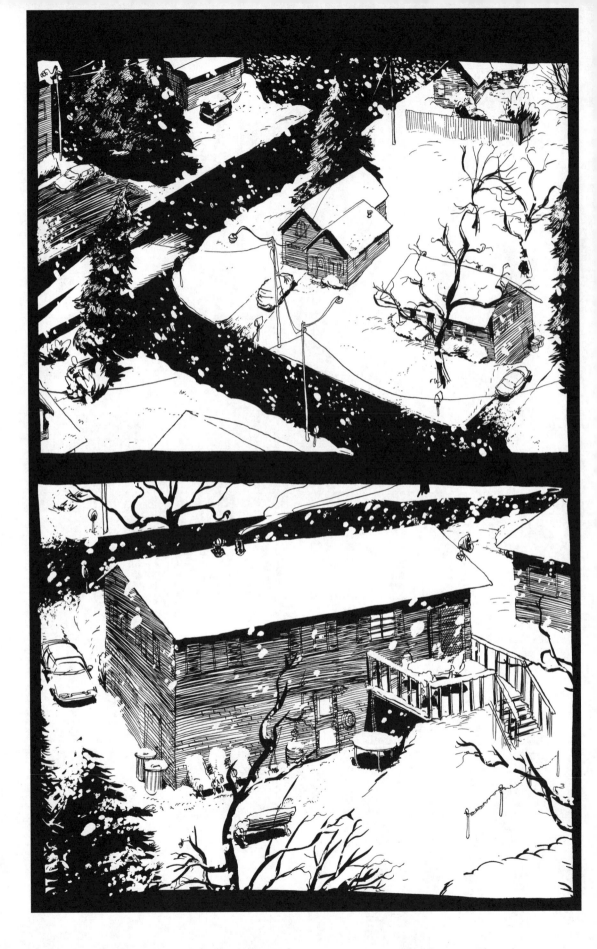

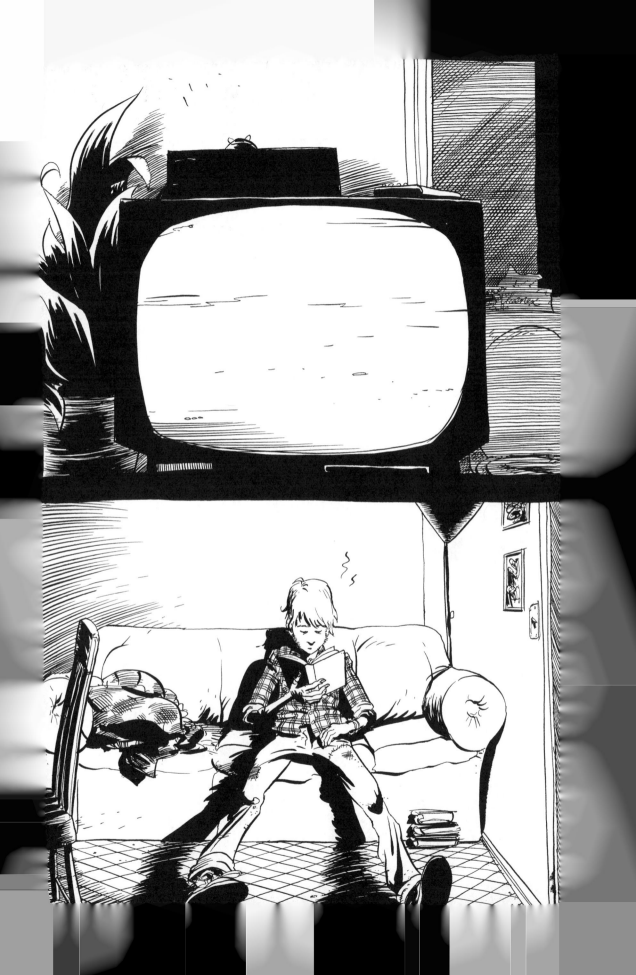

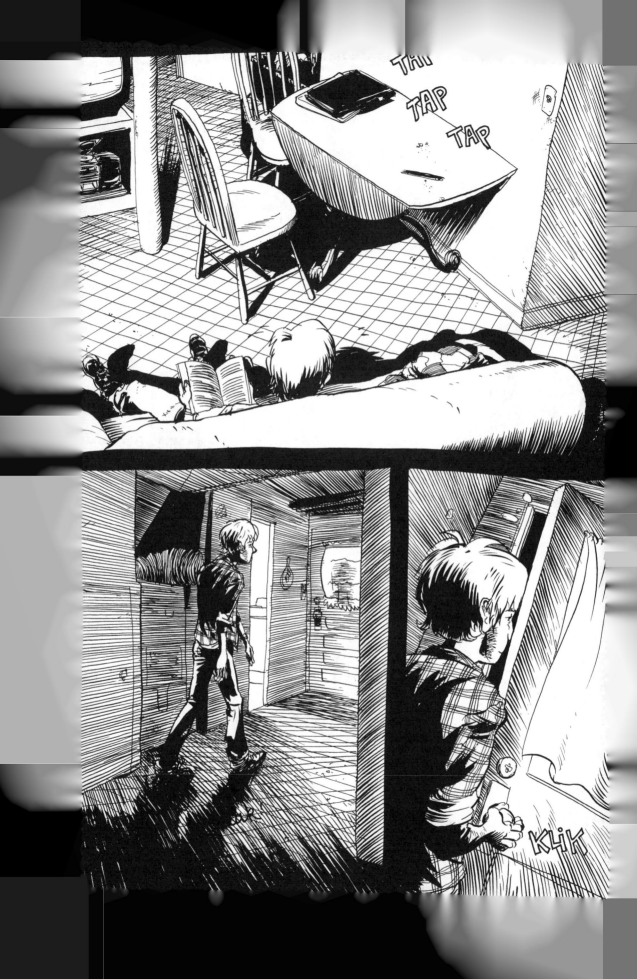

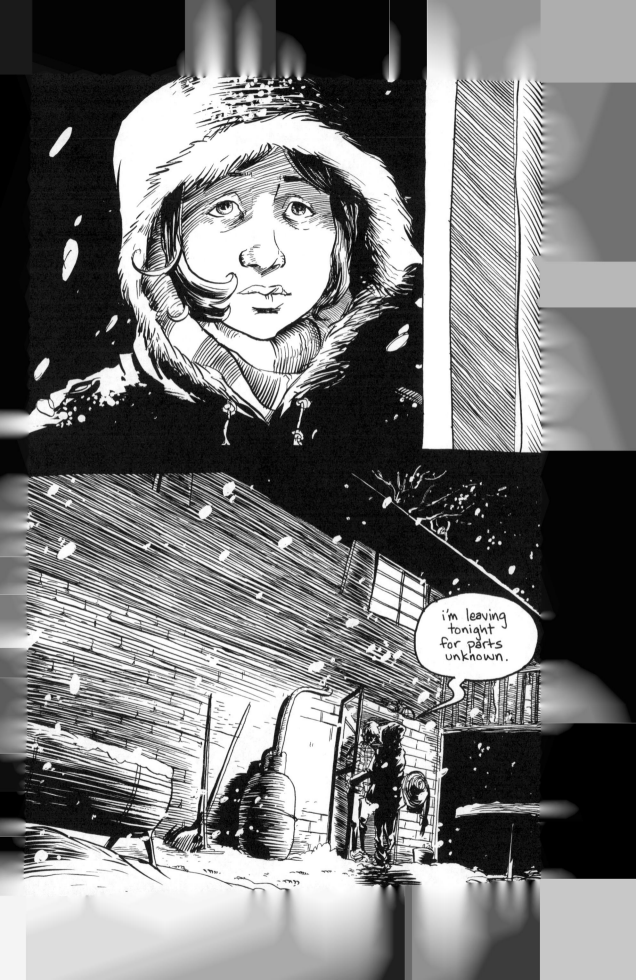

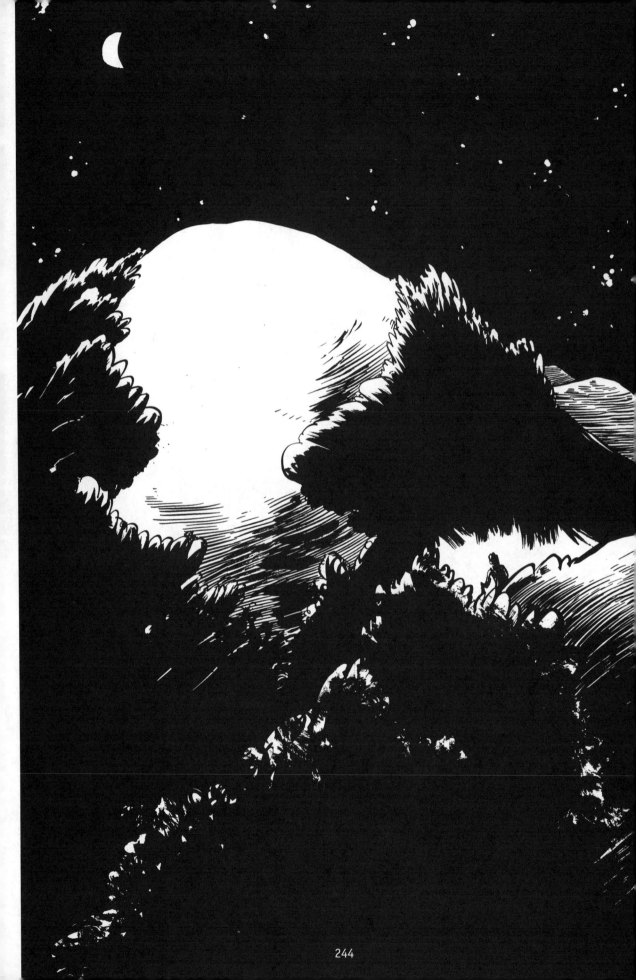

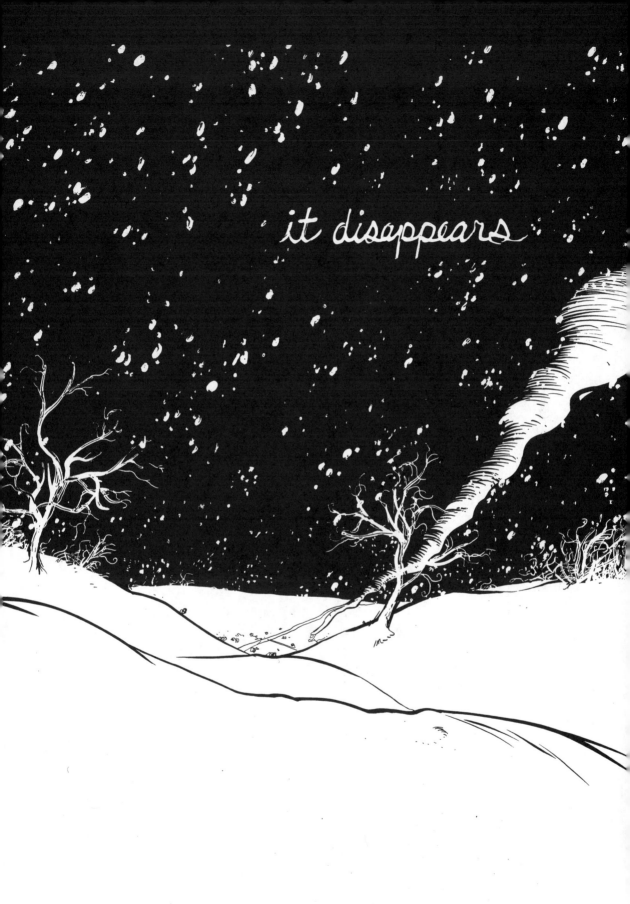

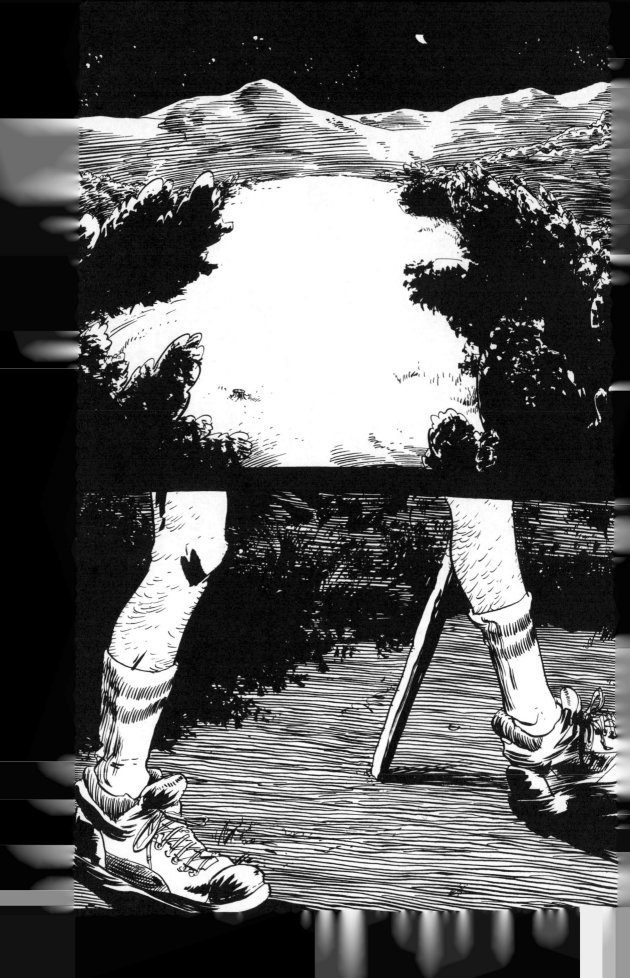

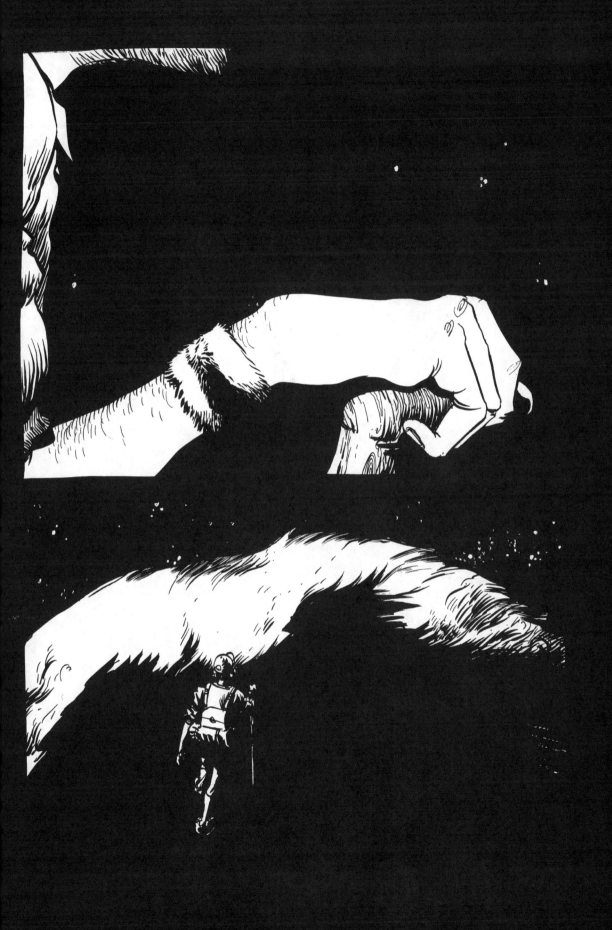

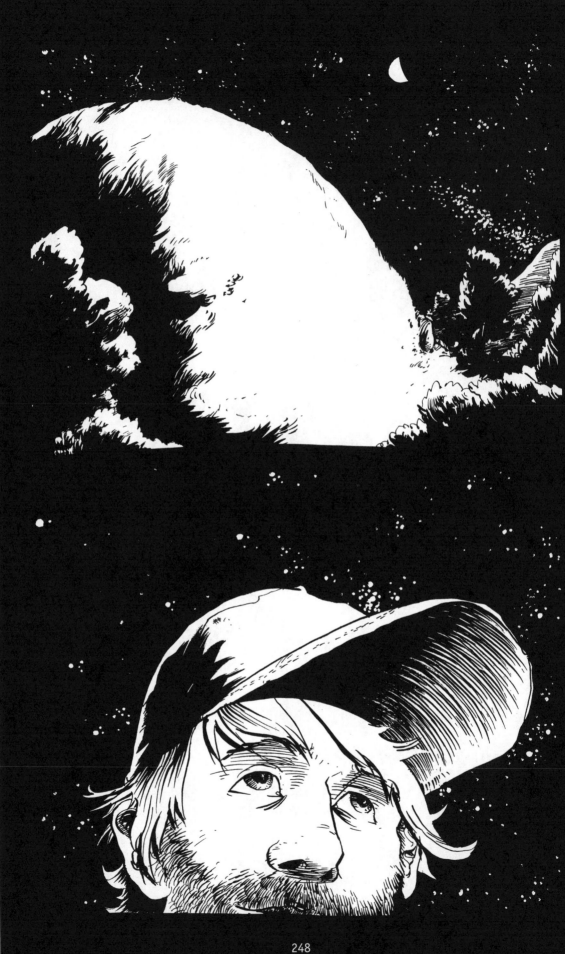

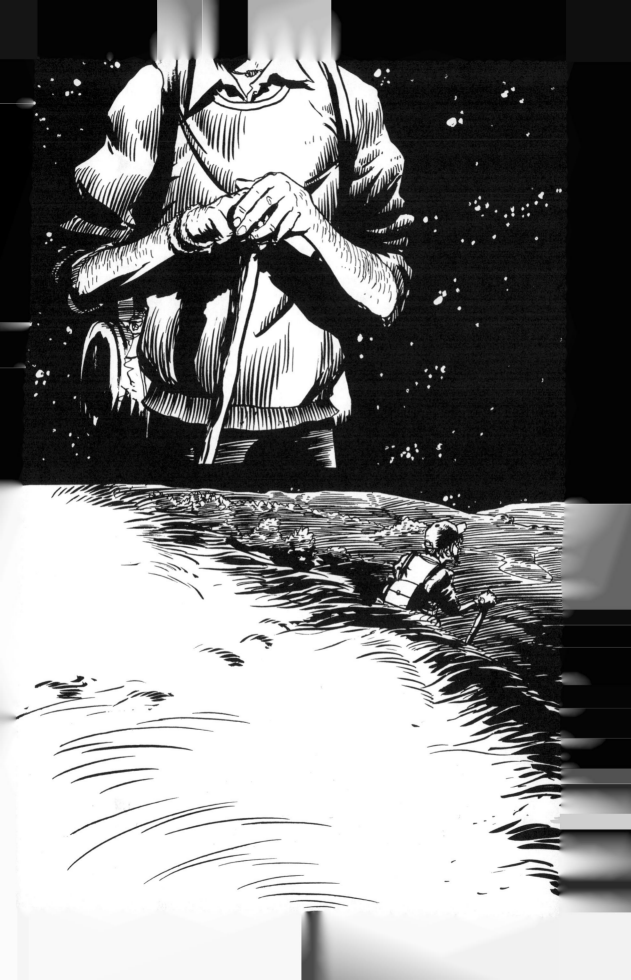

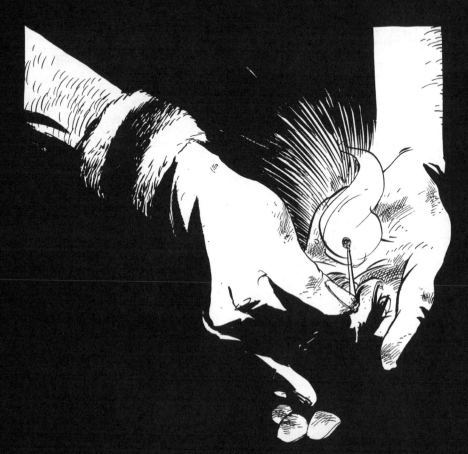

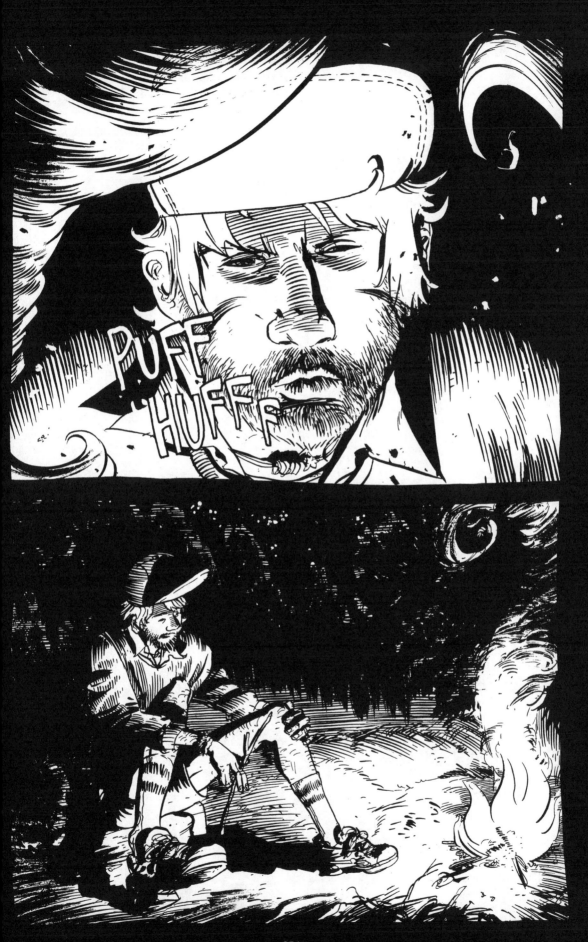

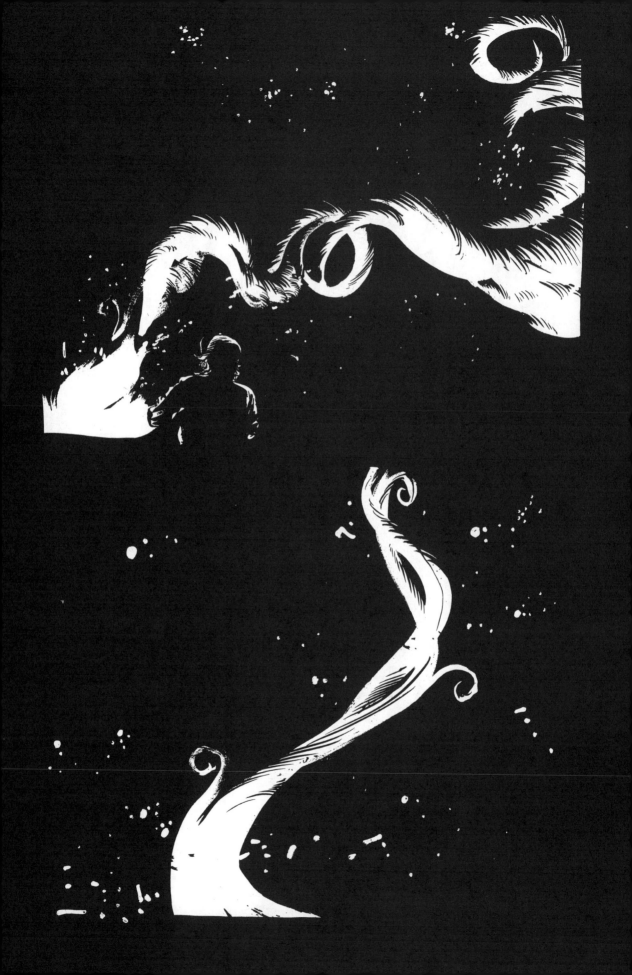

you made it.

you're
here.

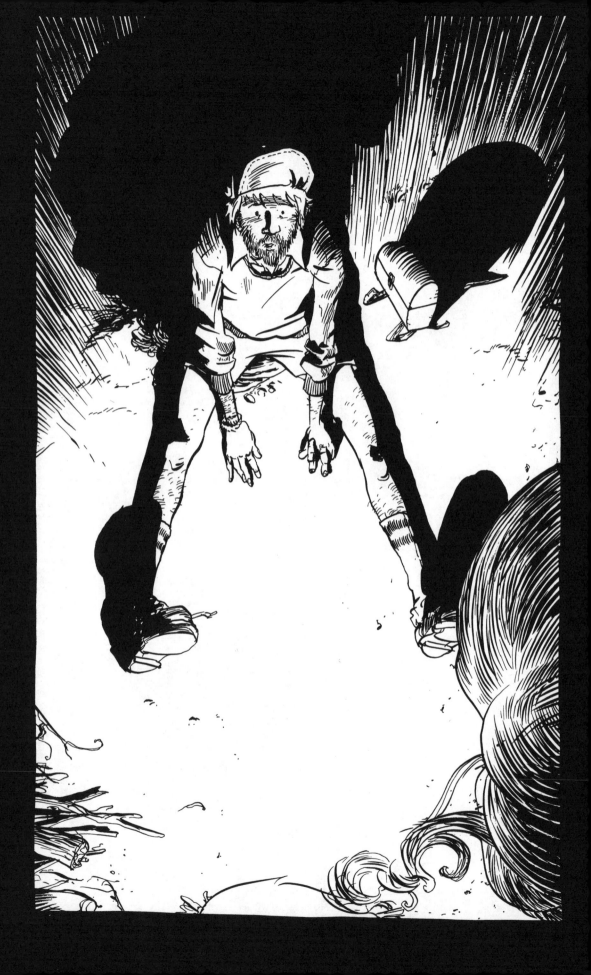

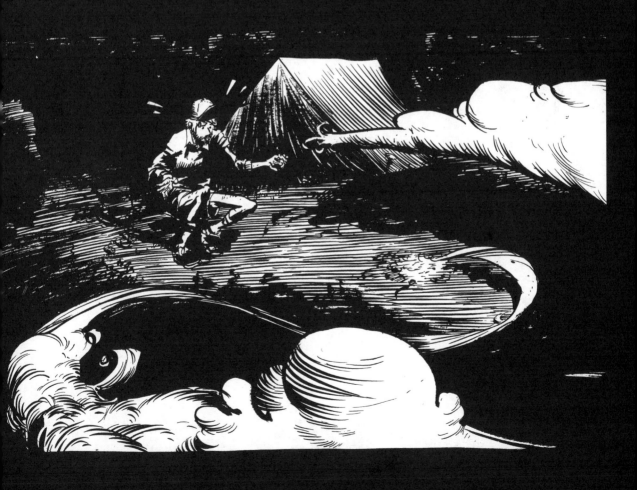

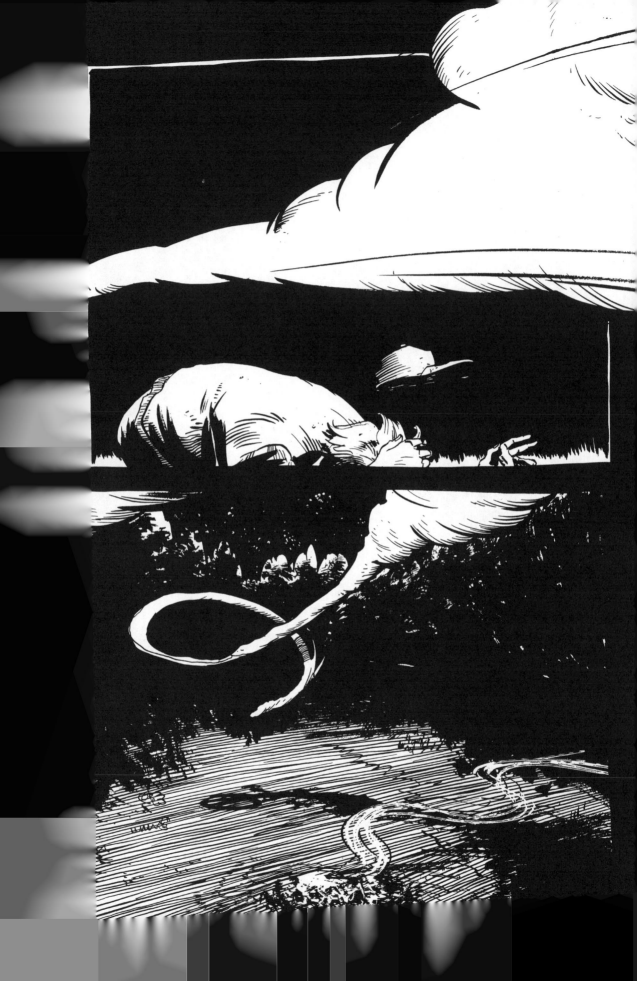

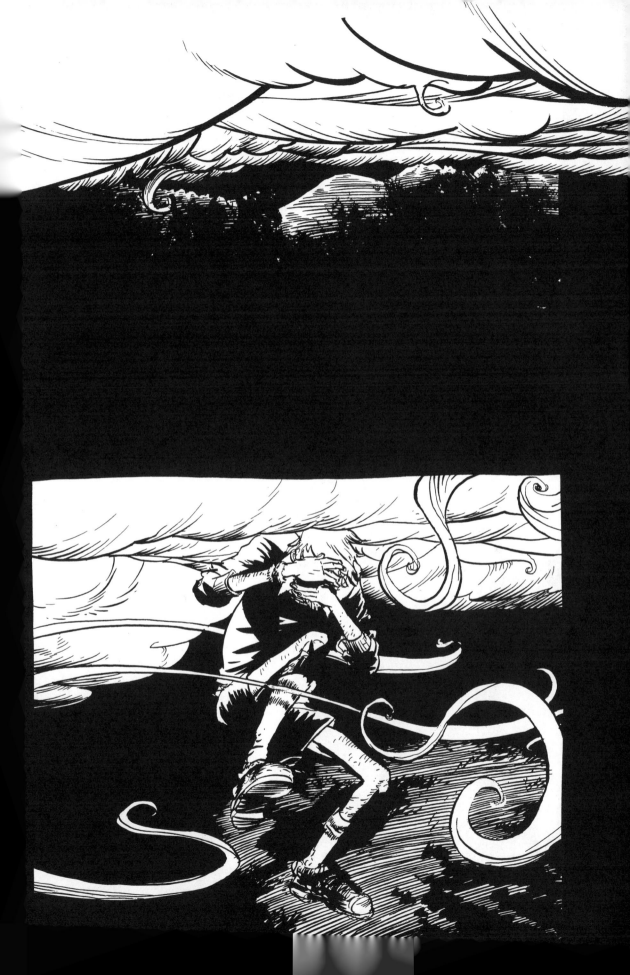

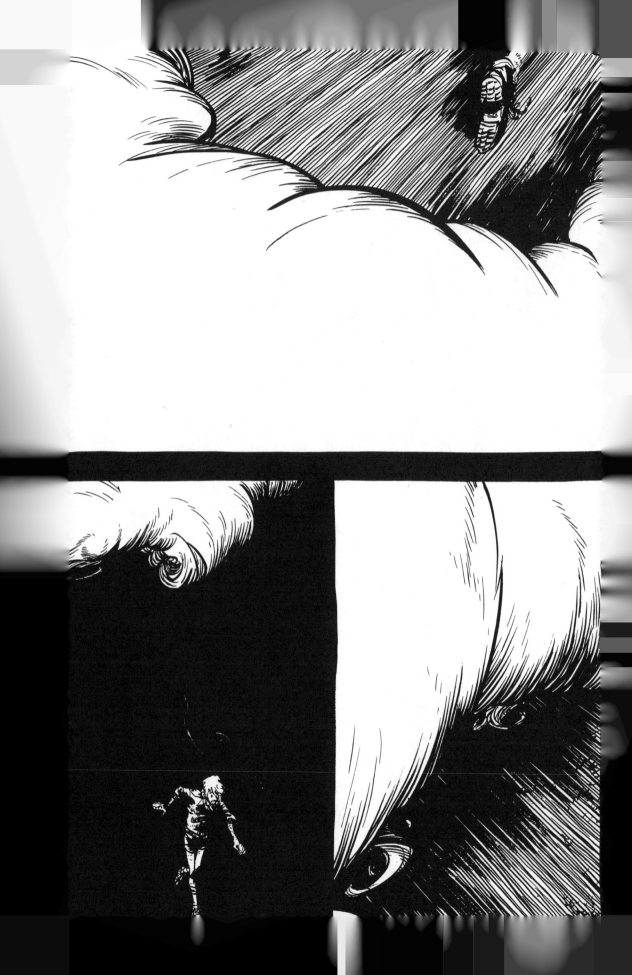

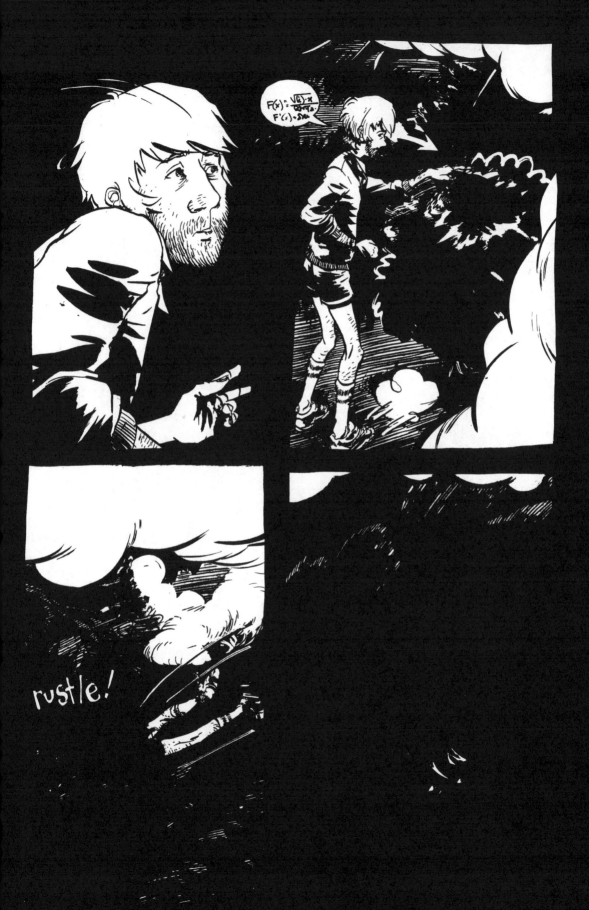

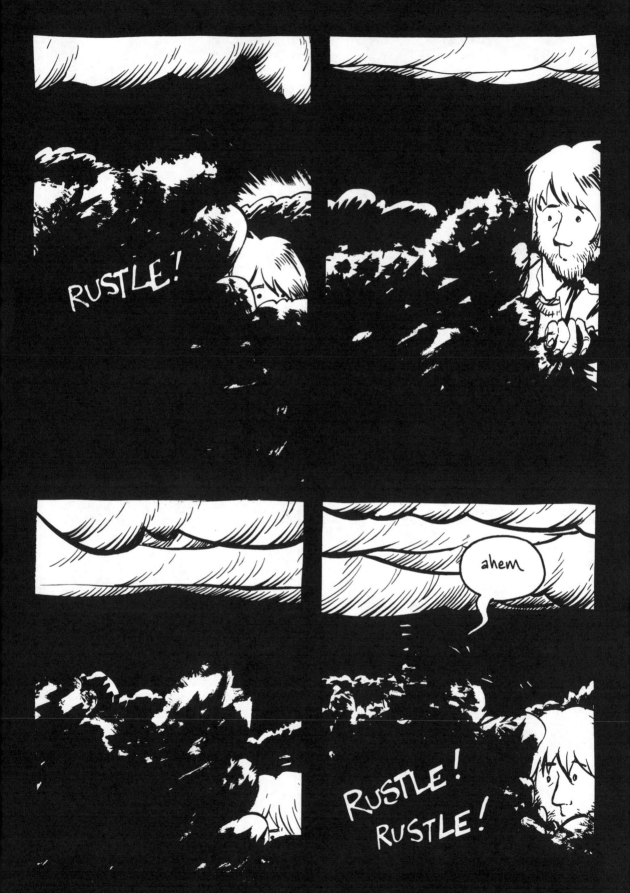

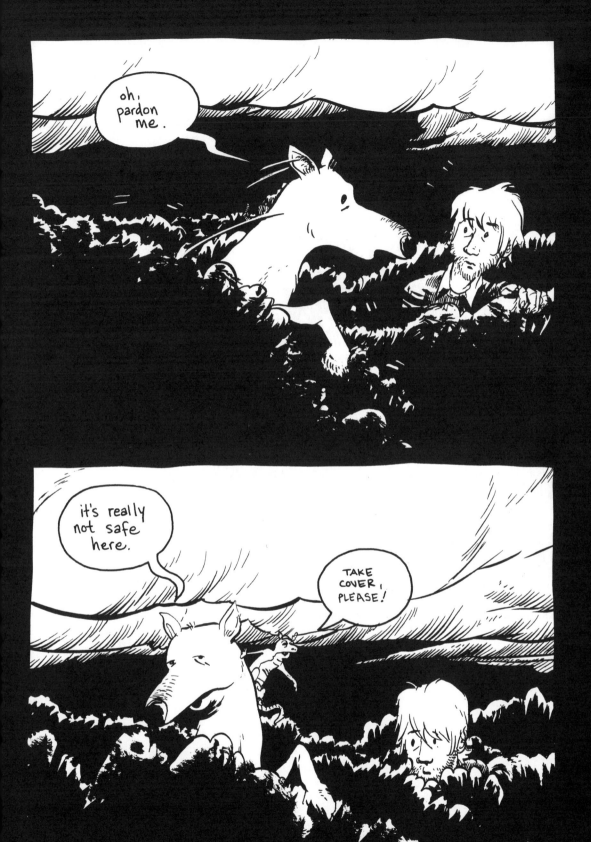

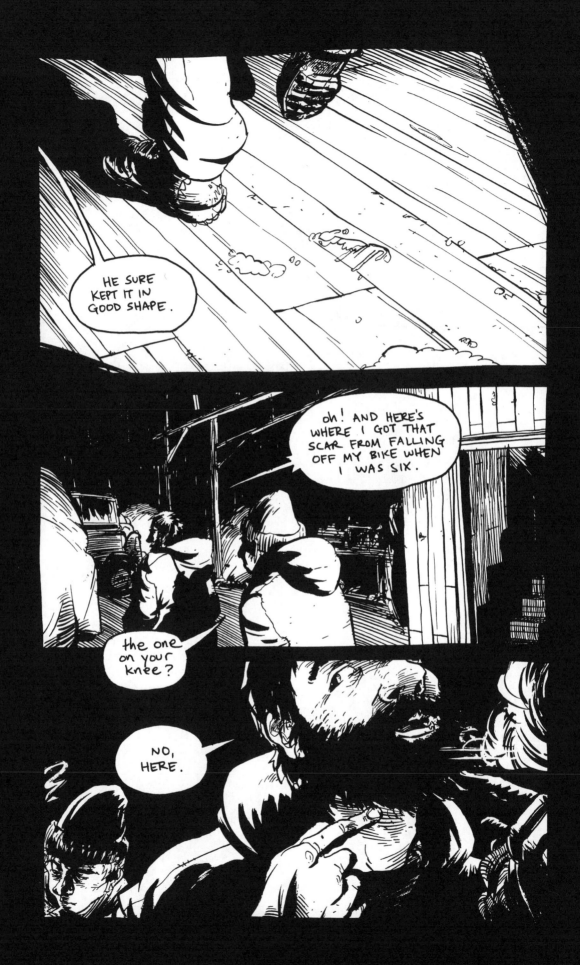

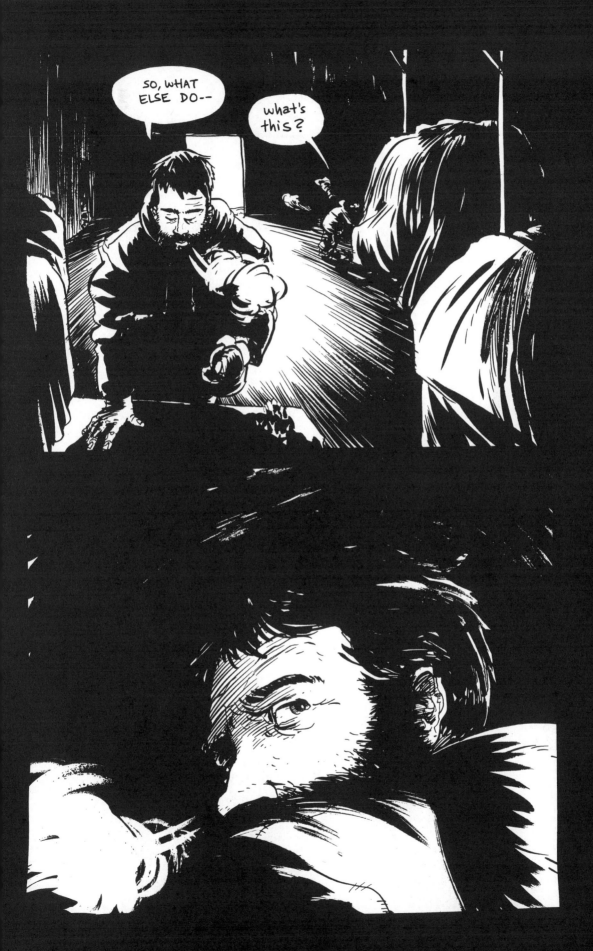

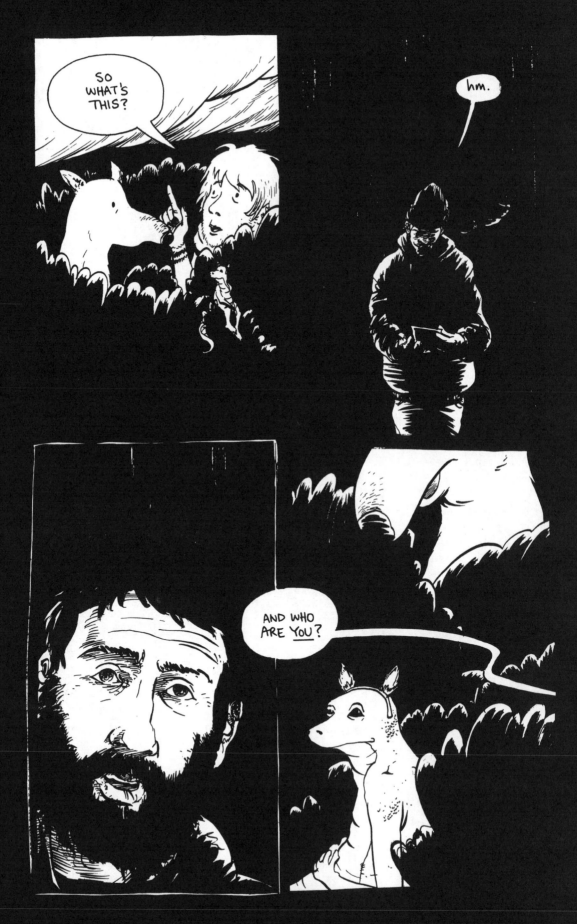

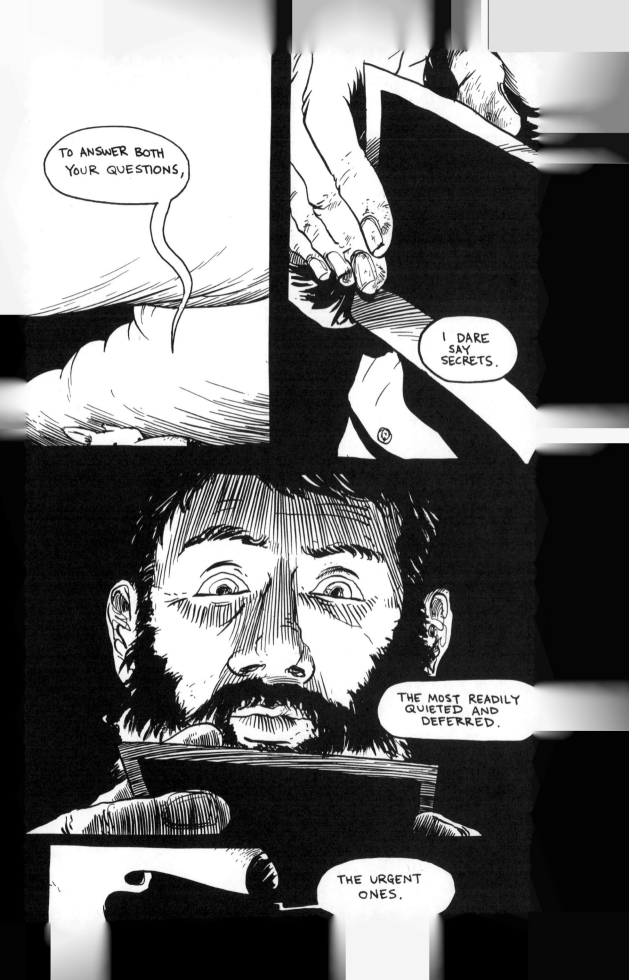

OKAY, SO TELL ME ABOUT IT.

i love this land so much--

the way you can feel evidence of the tectonic plates' pushing masses into rough, steep little hills.

the great lakes filled in the gaps, and this land was covered by some lush green mat to hide the violence of its conception.

the sky's so full of saturation here, pregnant with the possibilities that come with stormy weeknights.

AHEM!

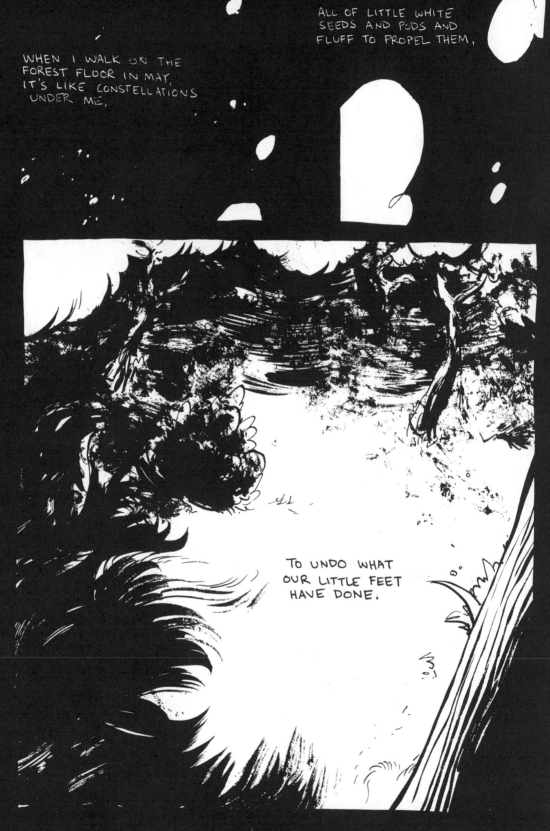

WHEN I WALK ON THE
FOREST FLOOR IN MAY,
IT'S LIKE CONSTELLATIONS
UNDER ME,

ALL OF LITTLE WHITE
SEEDS AND PODS AND
FLUFF TO PROPEL THEM,

TO UNDO WHAT
OUR LITTLE FEET
HAVE DONE.

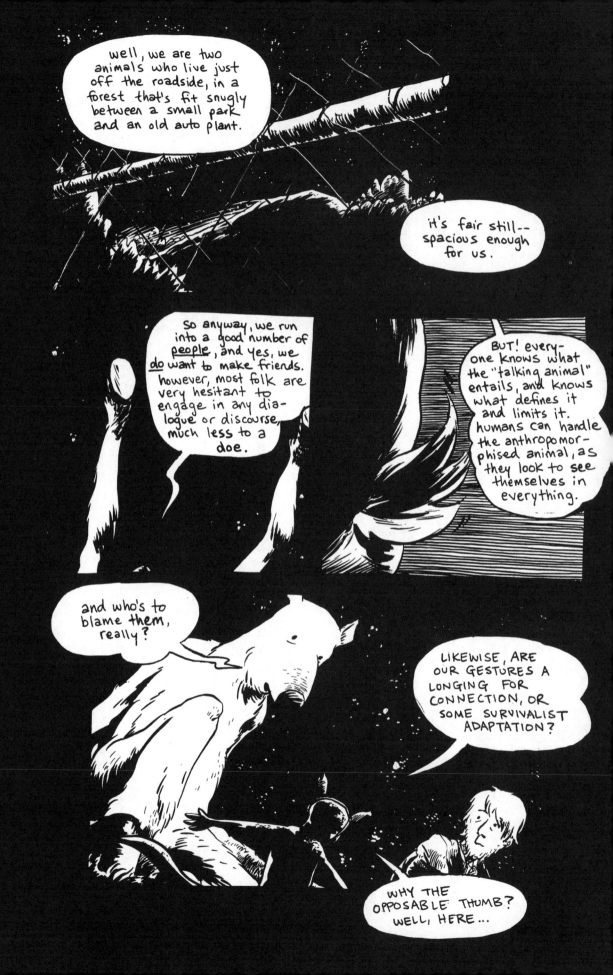

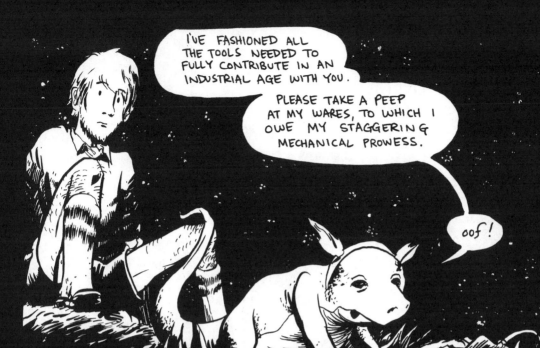

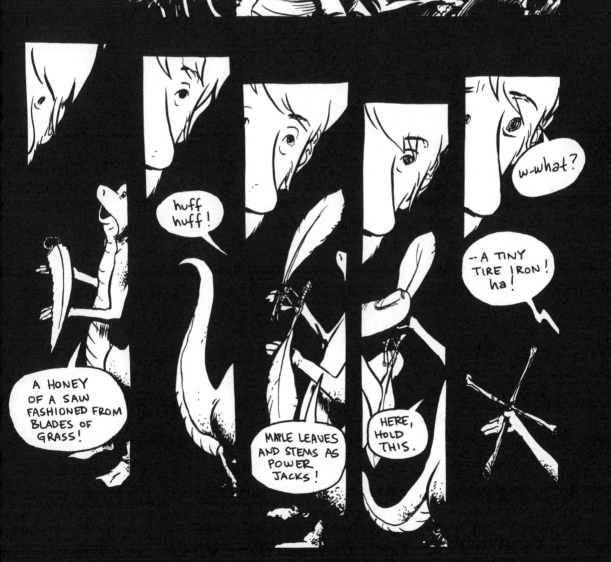

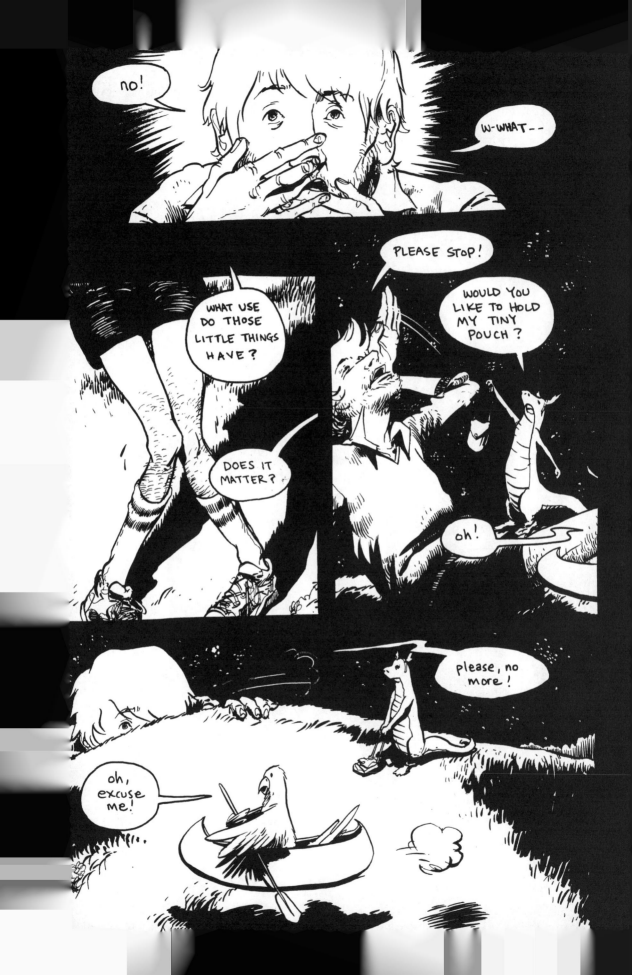

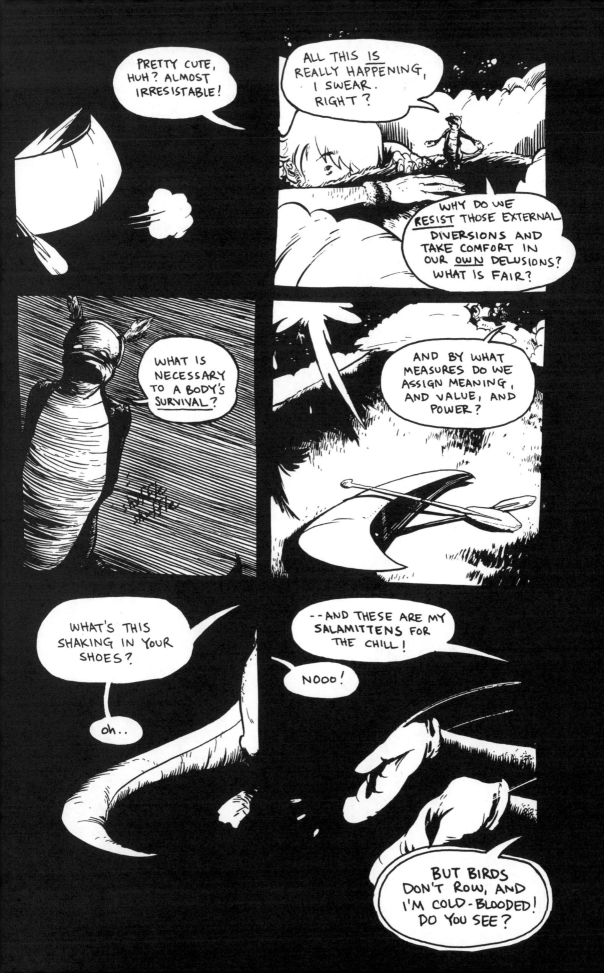

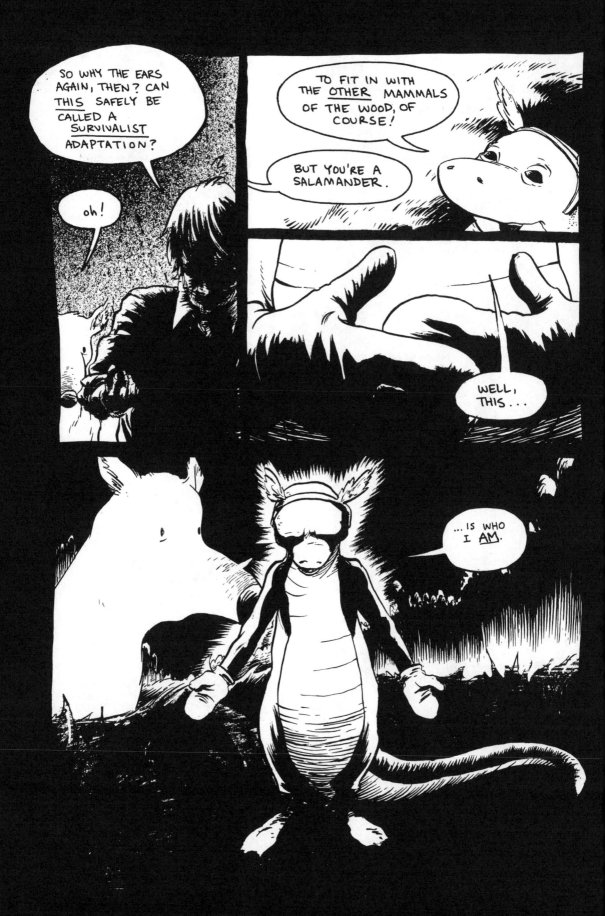

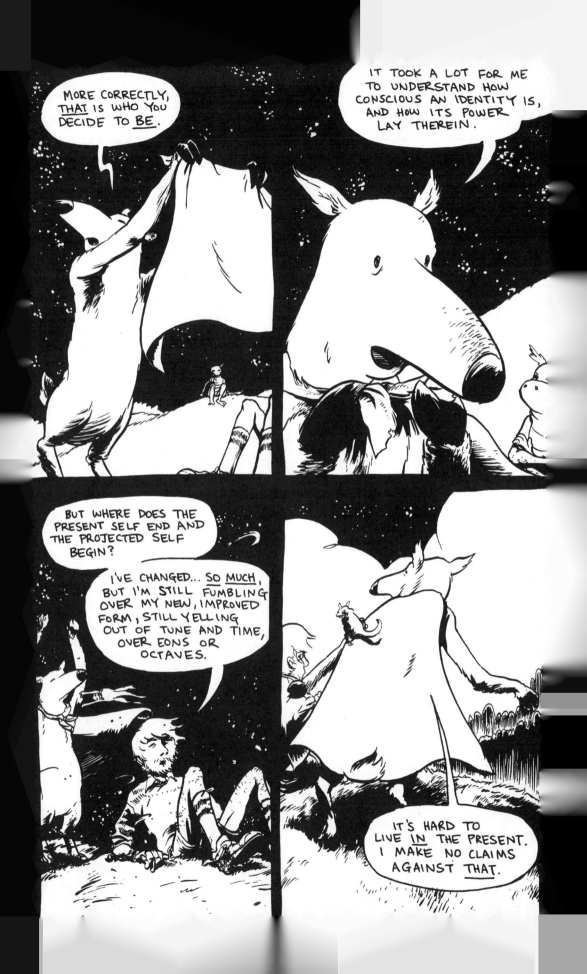

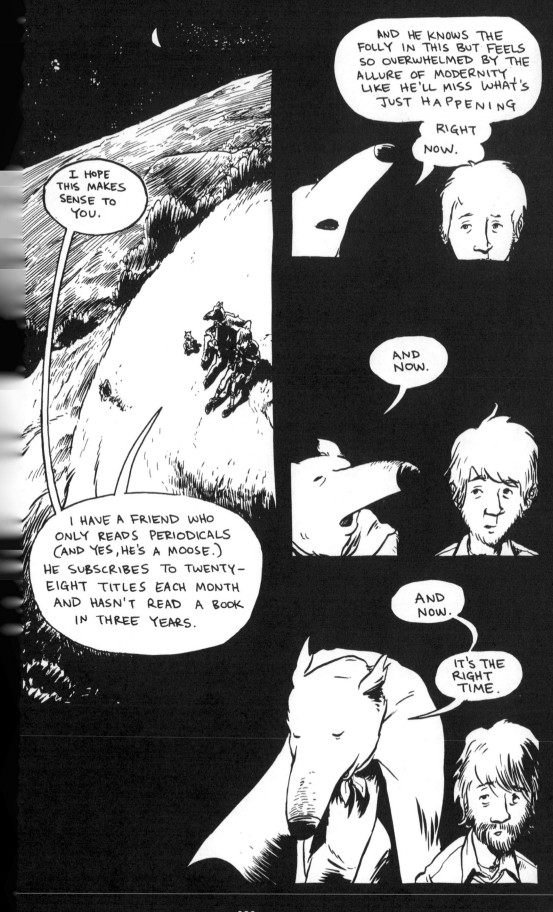

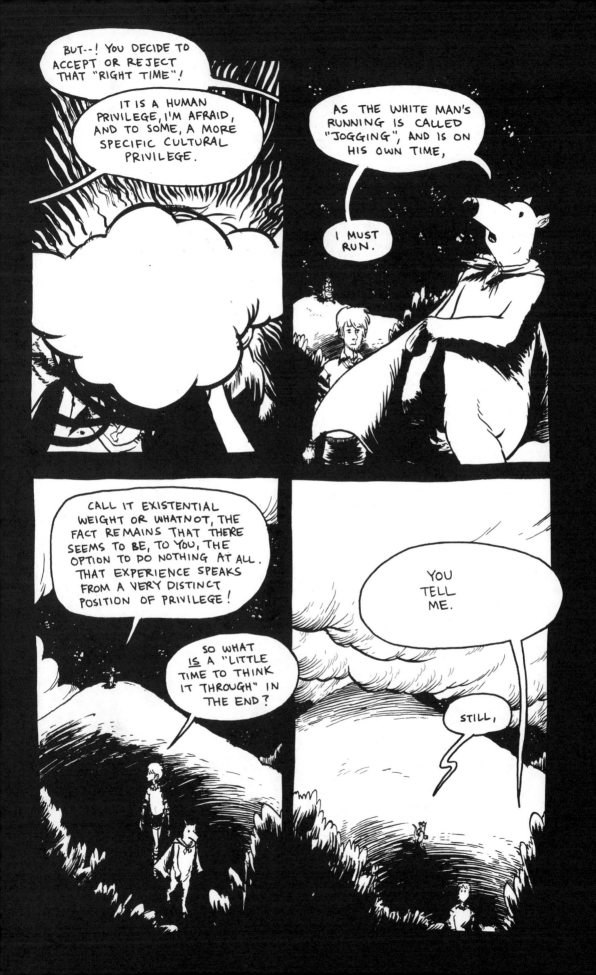

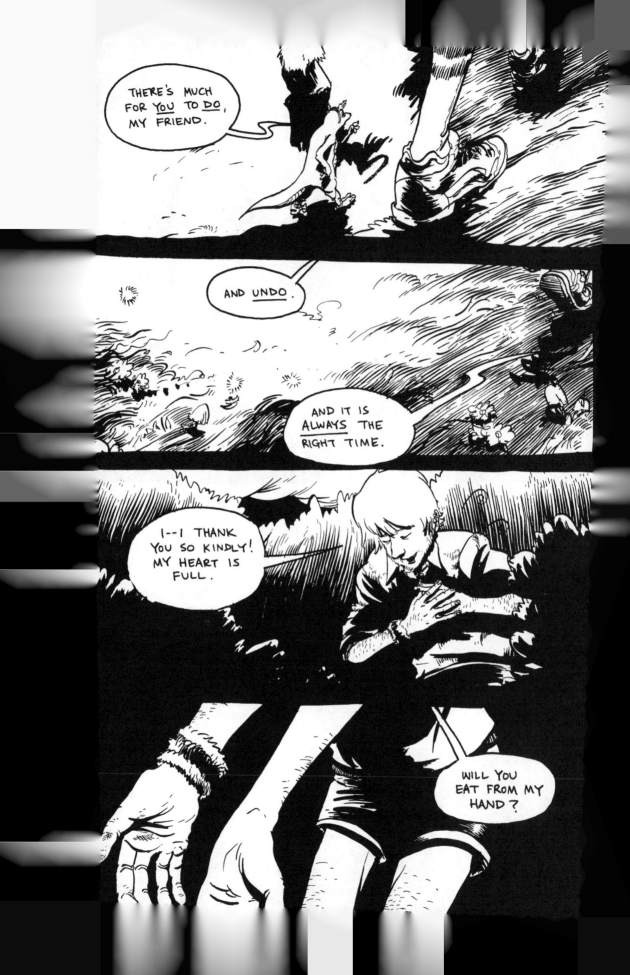

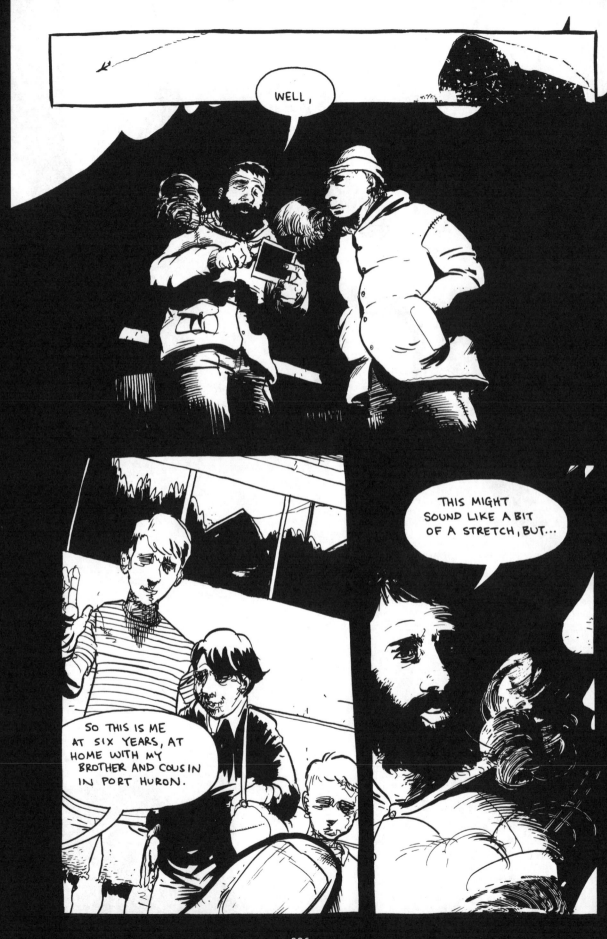

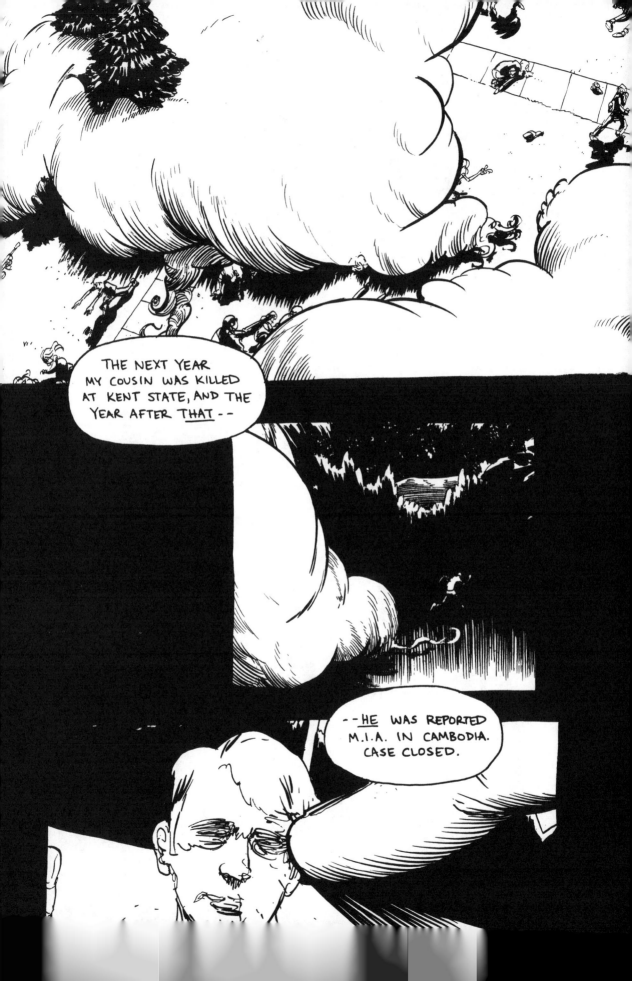

I WENT TO WORK IN FALL 1977 WITH MY FATHER AT A PARTS PROCESSING PLANT FOR OLDSMOBILE.

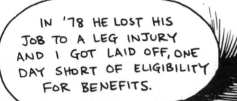

IN '78 HE LOST HIS JOB TO A LEG INJURY AND I GOT LAID OFF, ONE DAY SHORT OF ELIGIBILITY FOR BENEFITS.

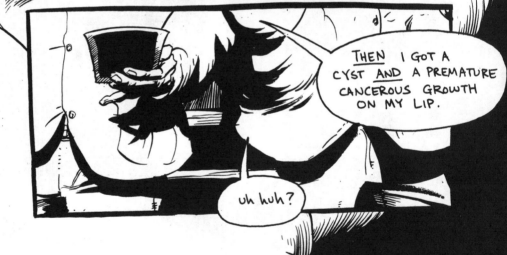

<u>THEN</u> I GOT A CYST <u>AND</u> A PREMATURE CANCEROUS GROWTH ON MY LIP.

uh huh?

NOW I DON'T KNOW HOW I GOT THERE,

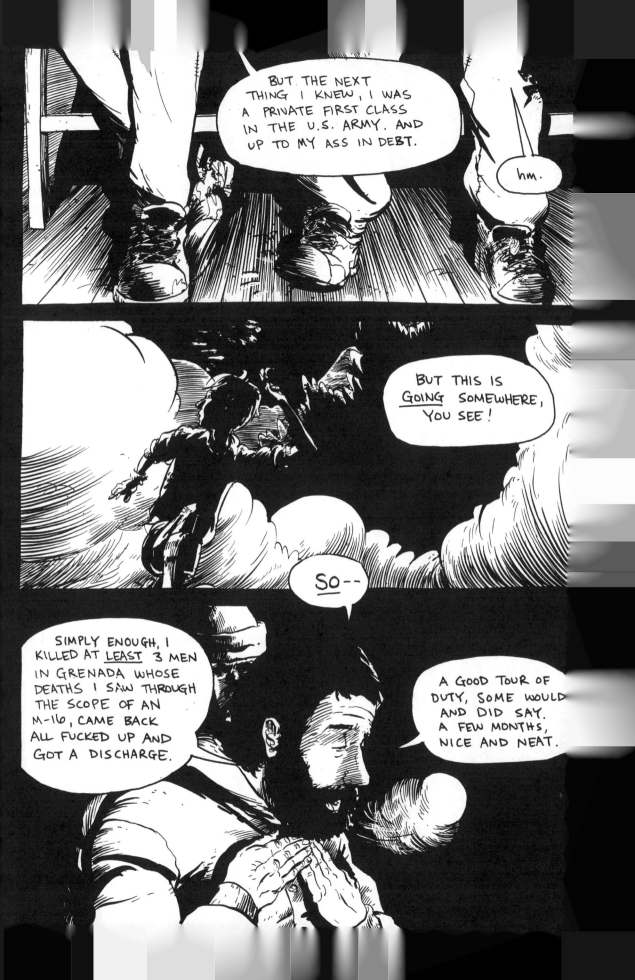

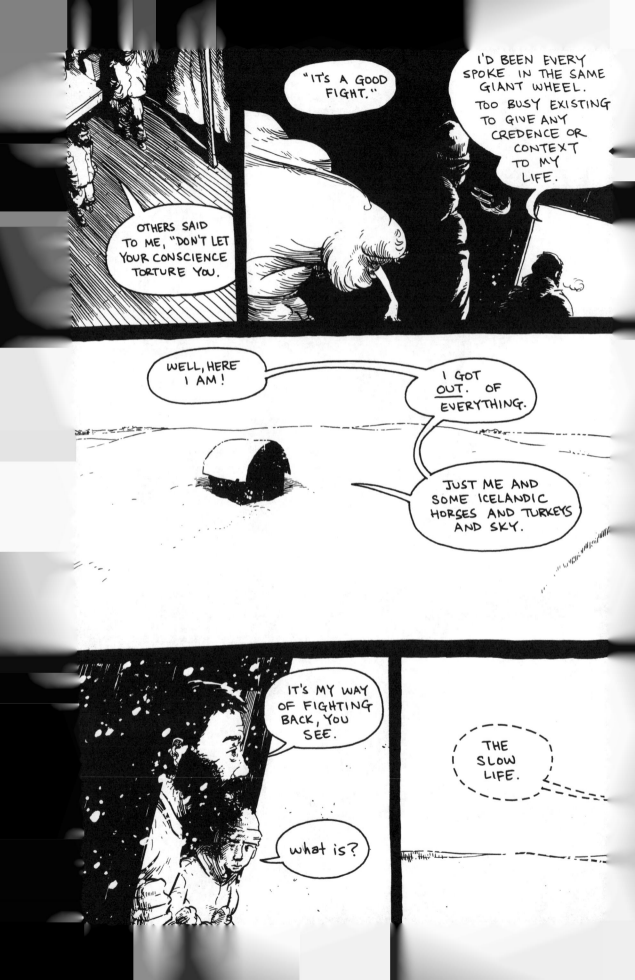

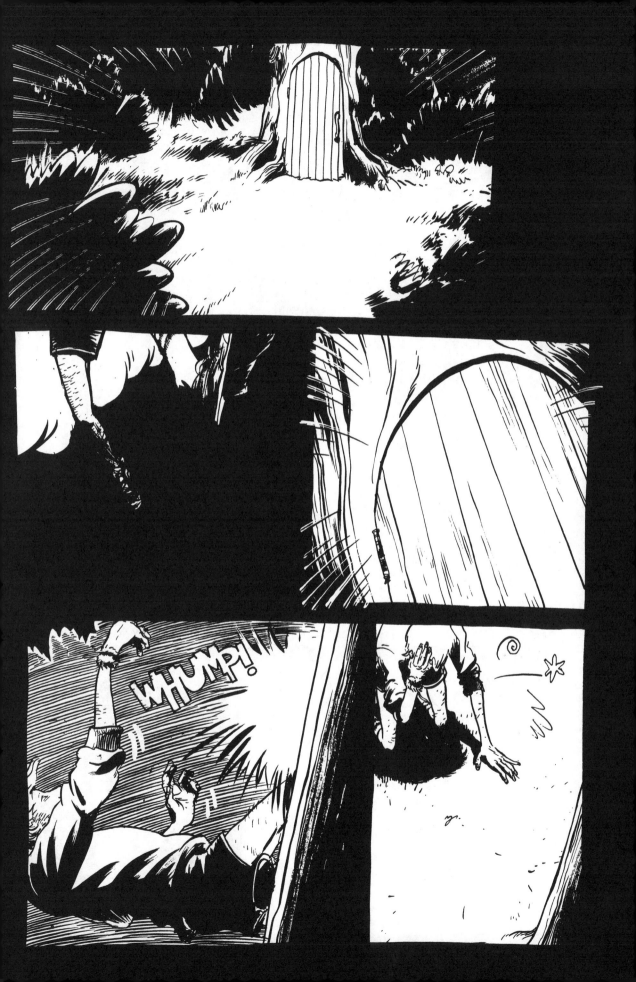

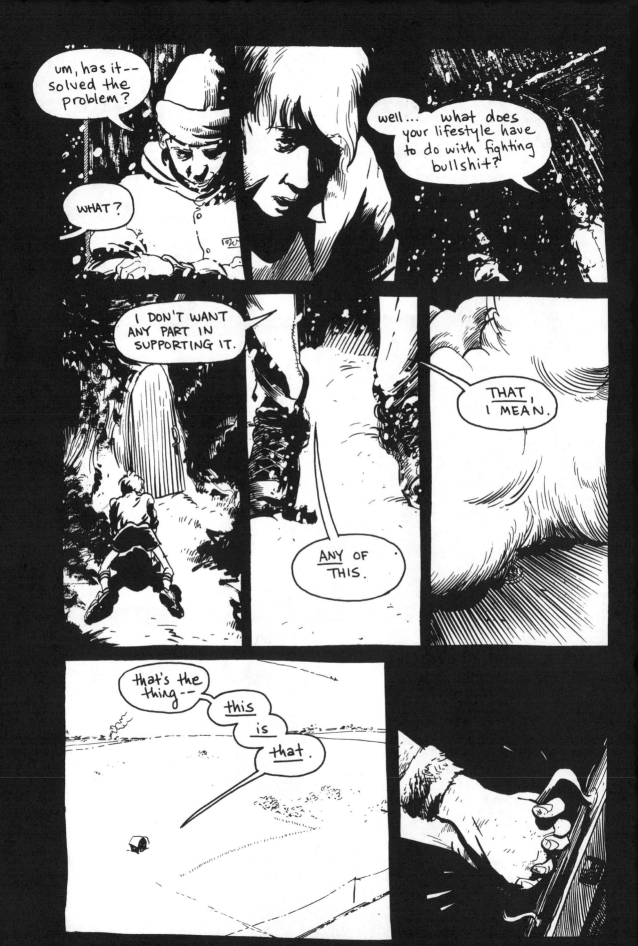

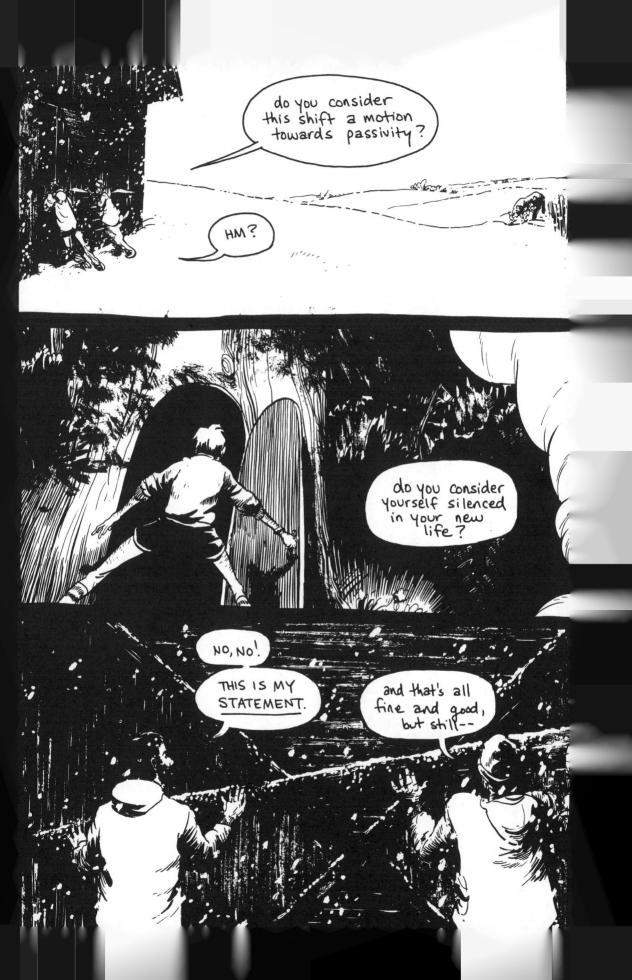

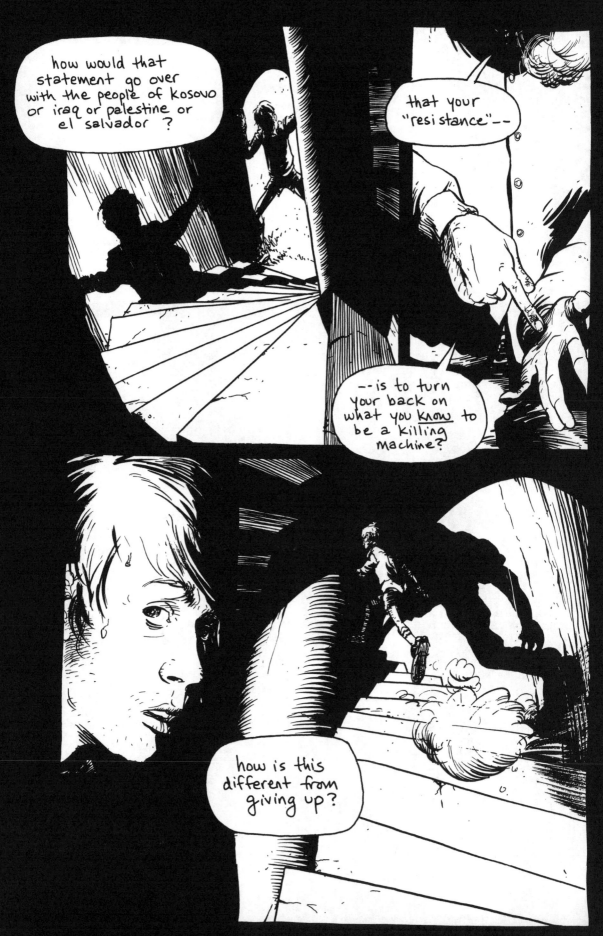

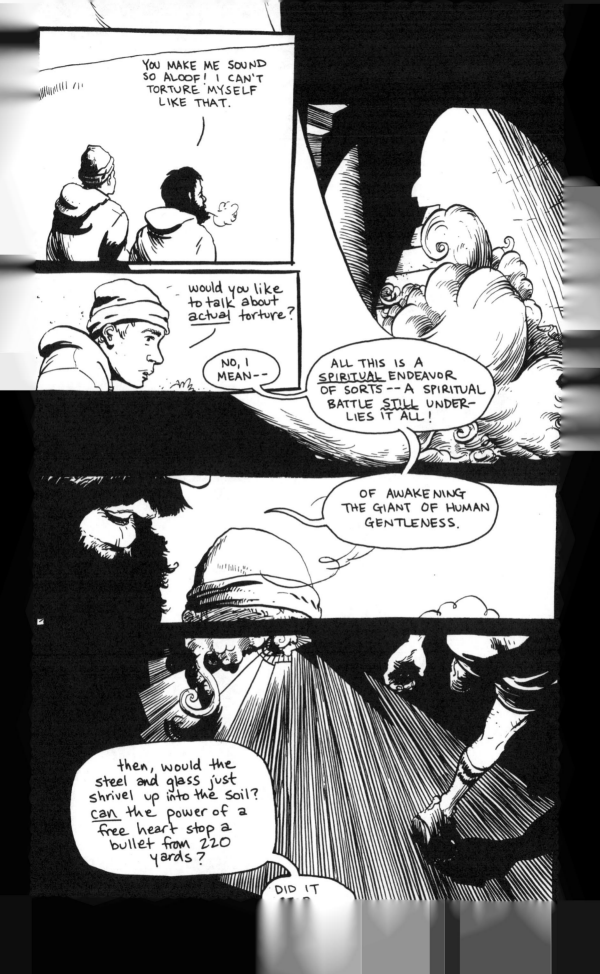

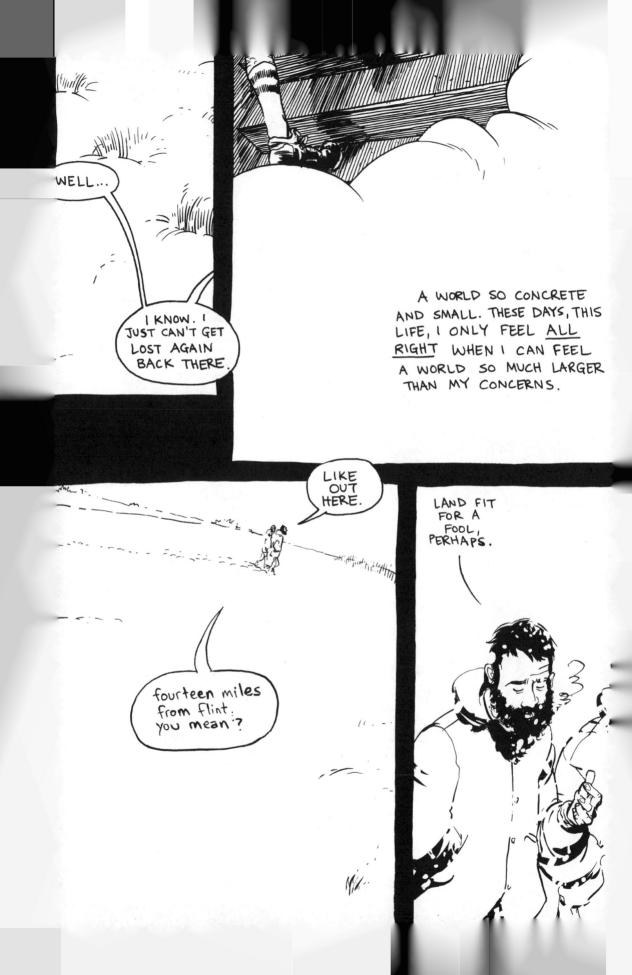

MUST THIS <u>ALWAYS</u> BE A FOOL'S
LIFE, THOUGH, HERE AMONG THE
STABLES AND GRAIN, THE PINK
CLOUDS ON A MICHIGAN EVE, FULL
OF GODLESS LITTLE TIES?

so ask yourself this:
why do i fear this
peace to be both truthful
and foolish?

lightning strikes,

creeks swell high,

the frost kills a hen
in her sleep.

death swallows us whole
each night.

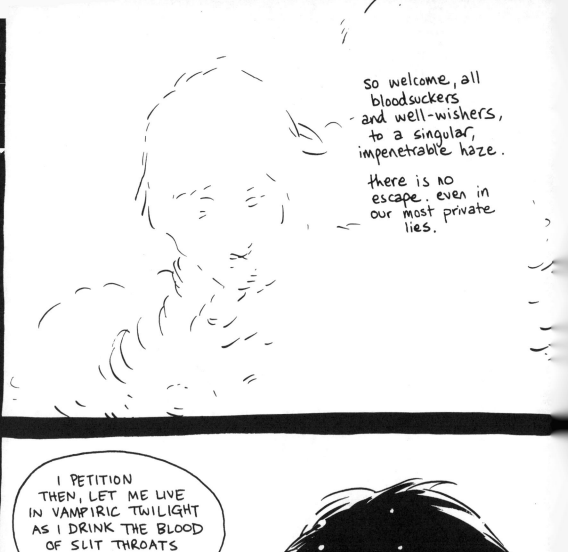

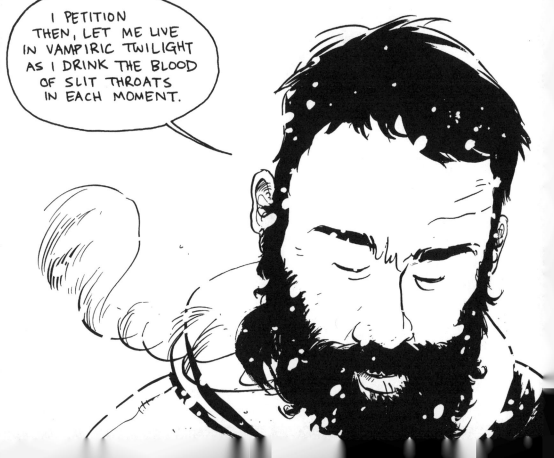

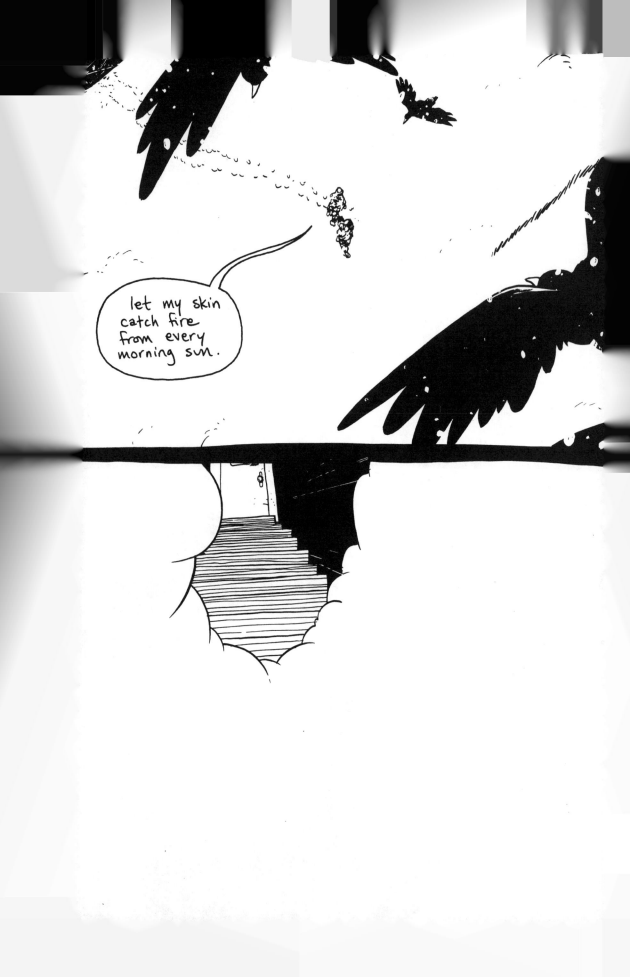

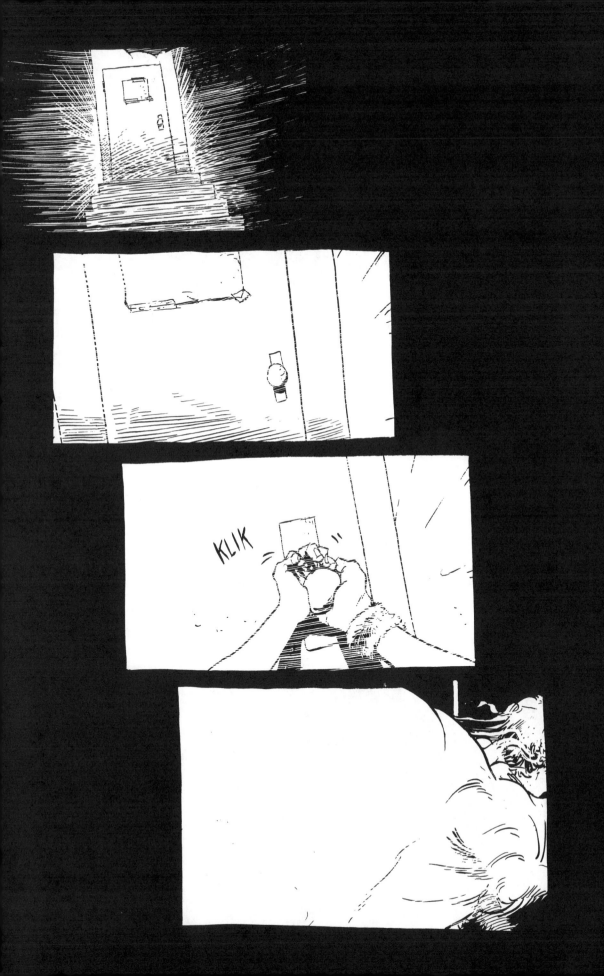

KOFF
KOFF
HACK

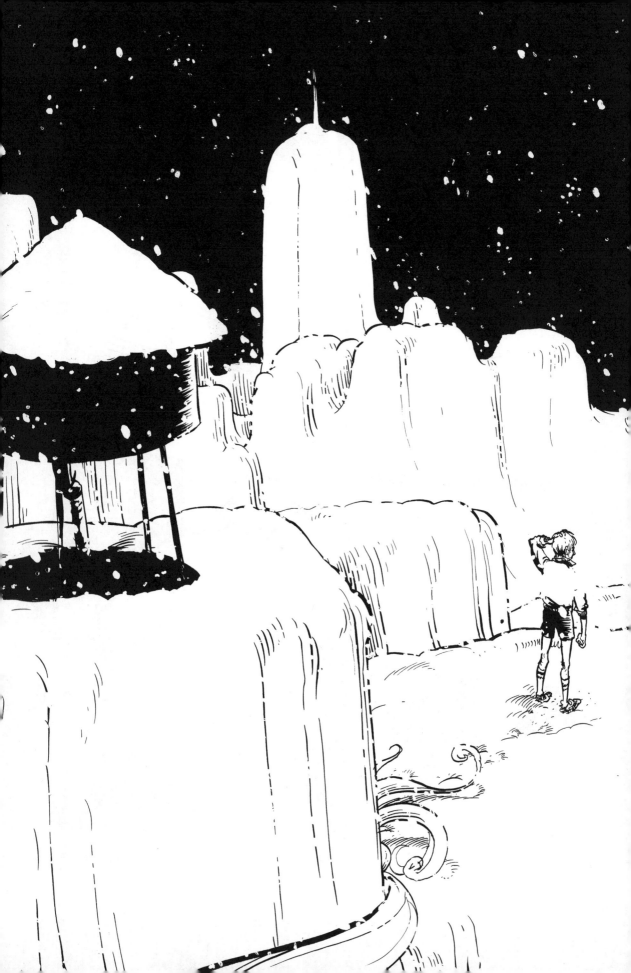

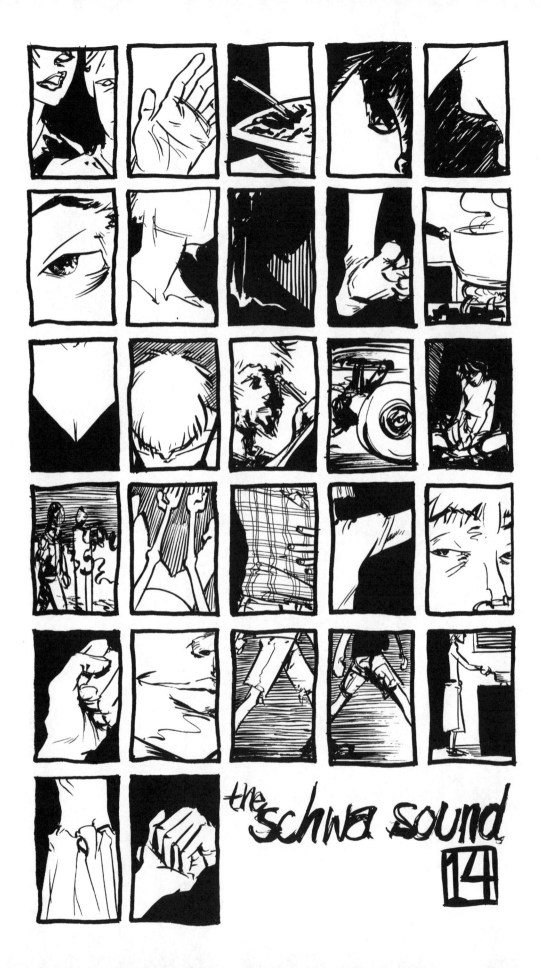

the schwa sound
14

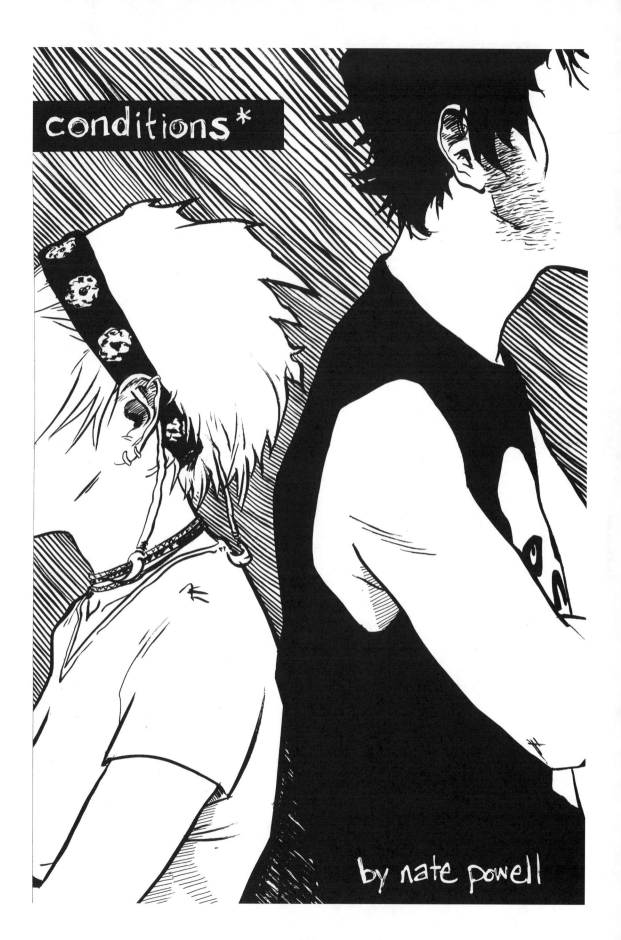

conditions*

by nate powell

frankenbones

emil heiple nate powell

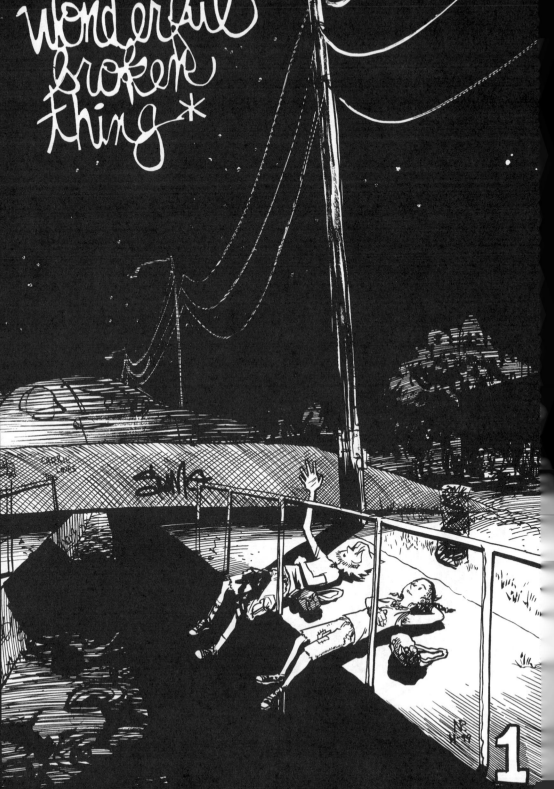

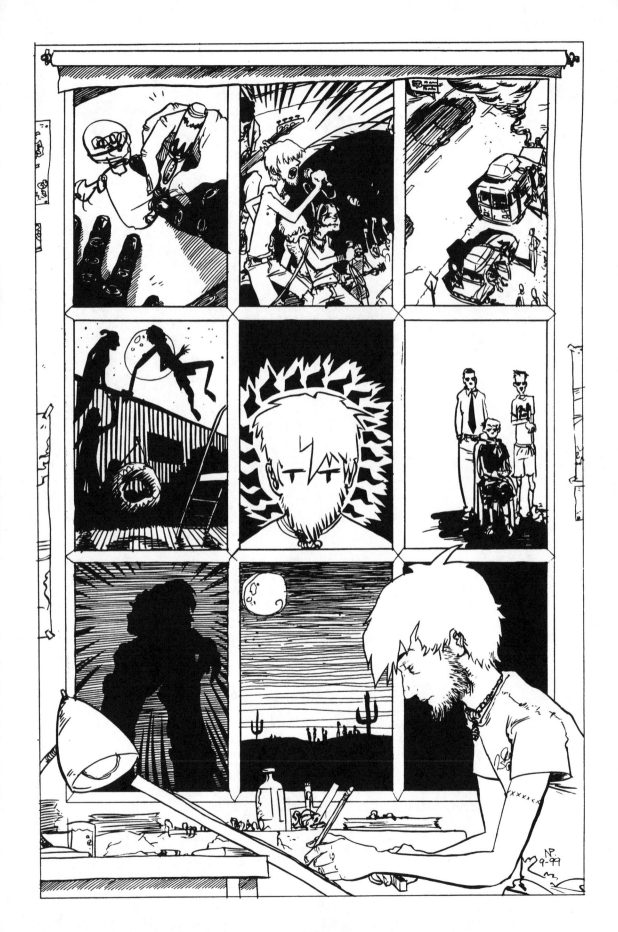

312

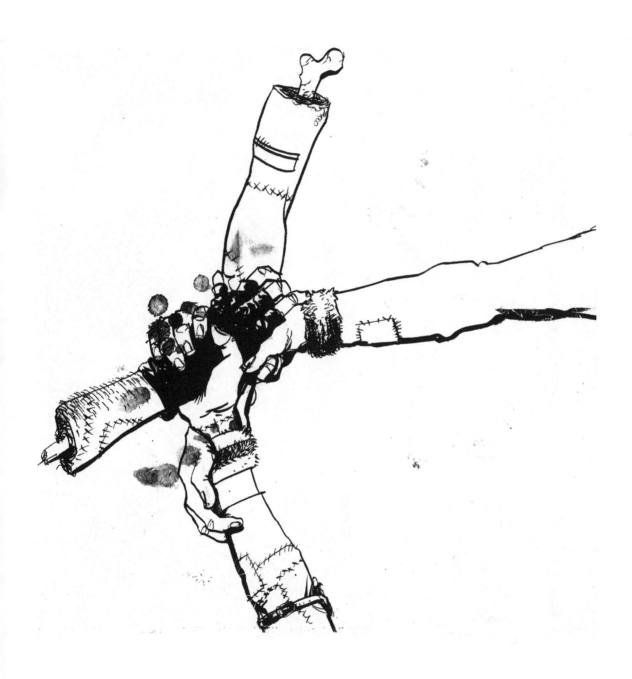

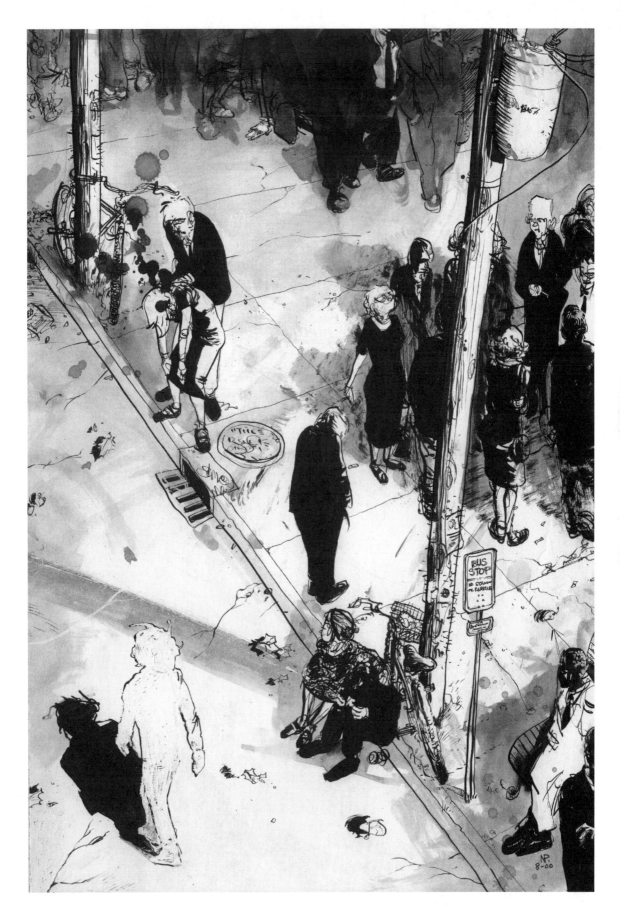

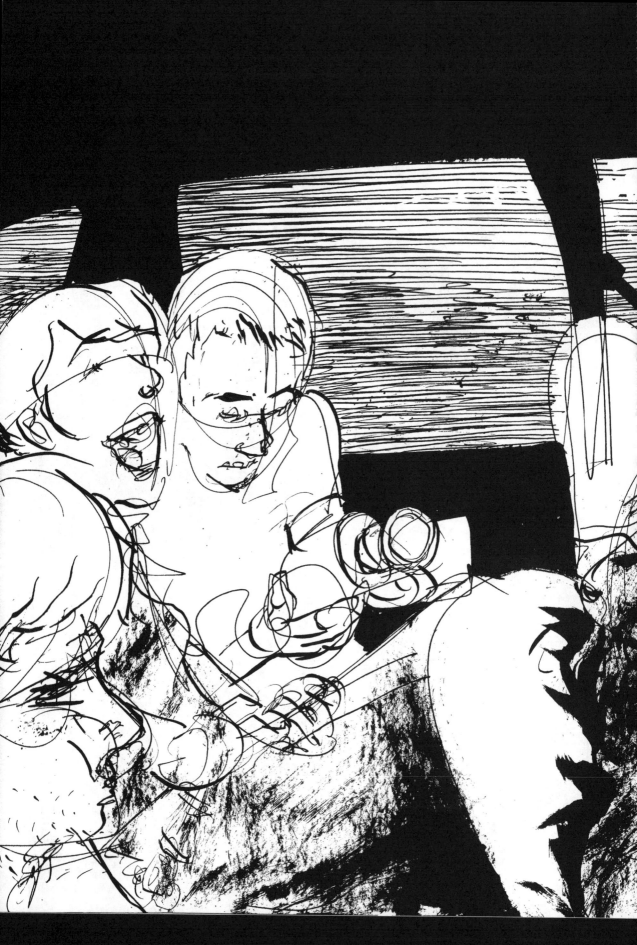

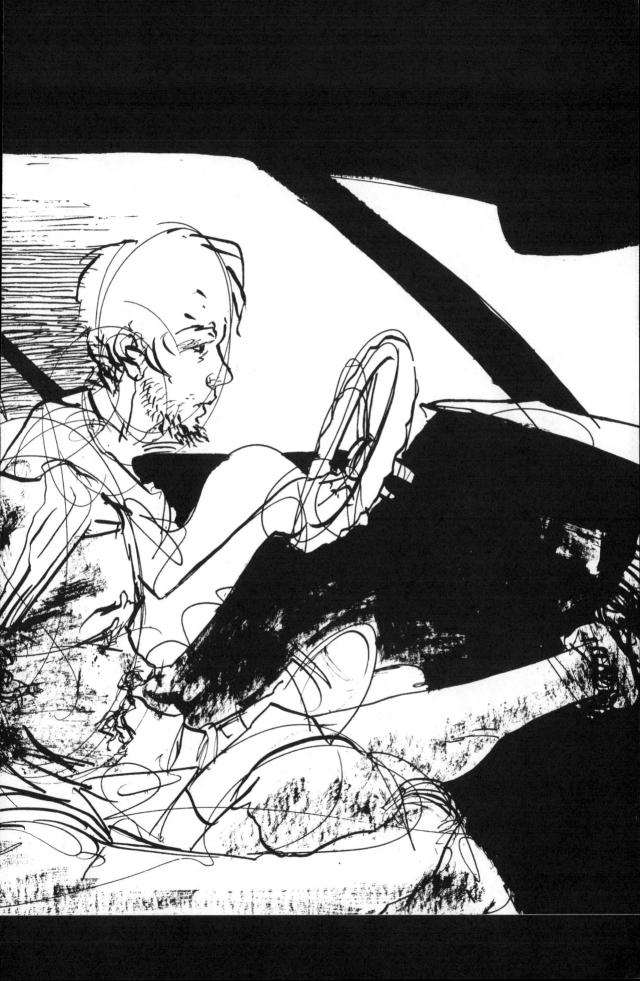

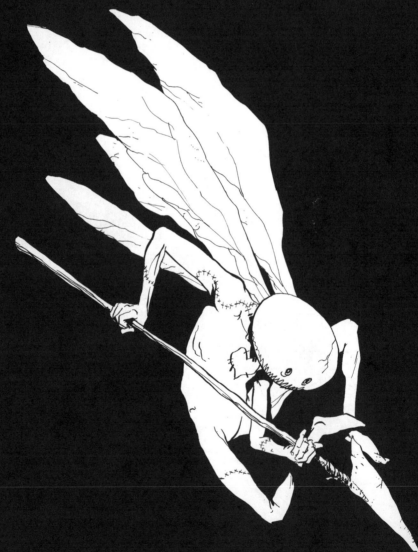

2

$2.95 in comic shops
$2.50 from the kids

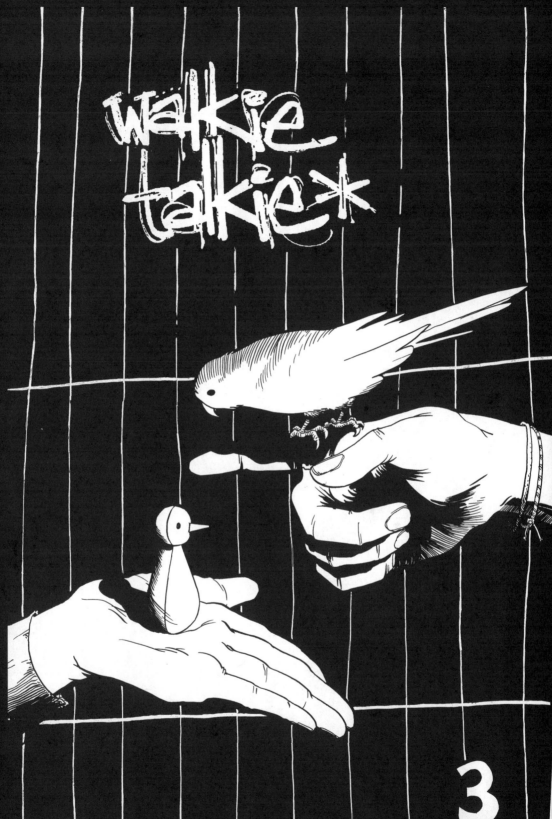

walkie
talkie*

3

$2.95 in comic shops
$2.00 from the kids

walkie talkie*

4

$2.95 in comic shops
$2.25 from the kids

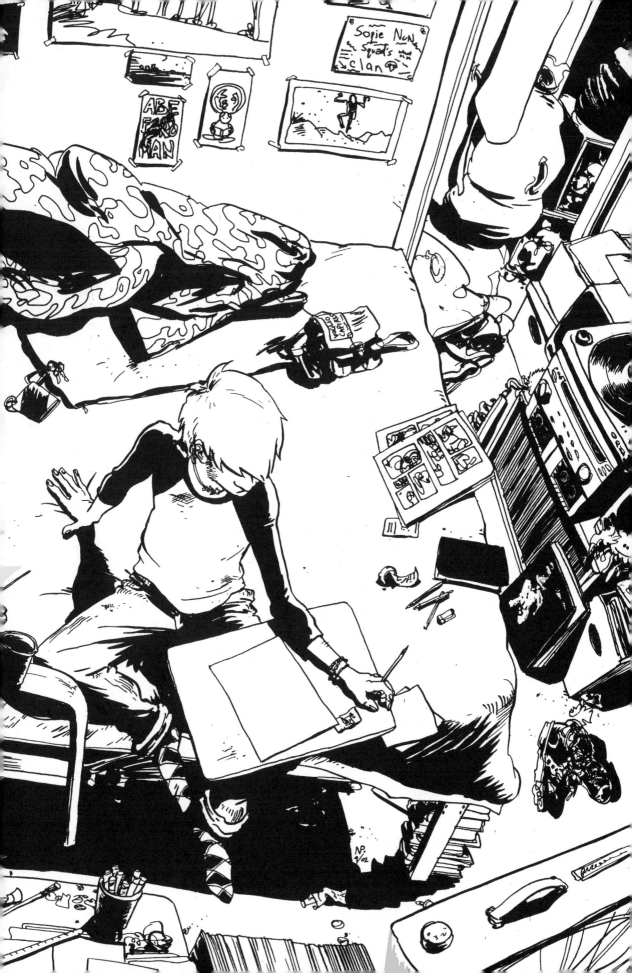

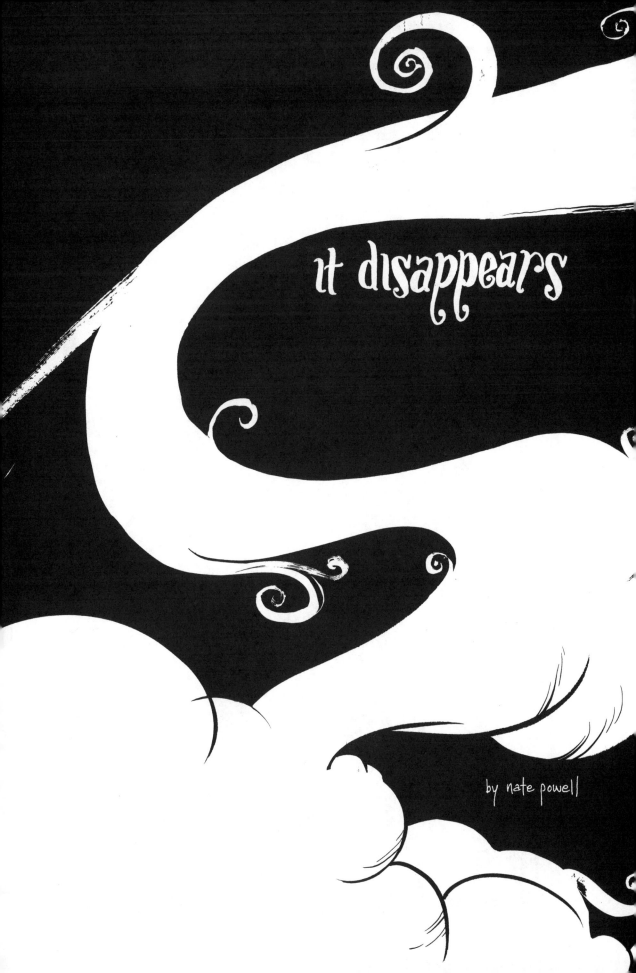

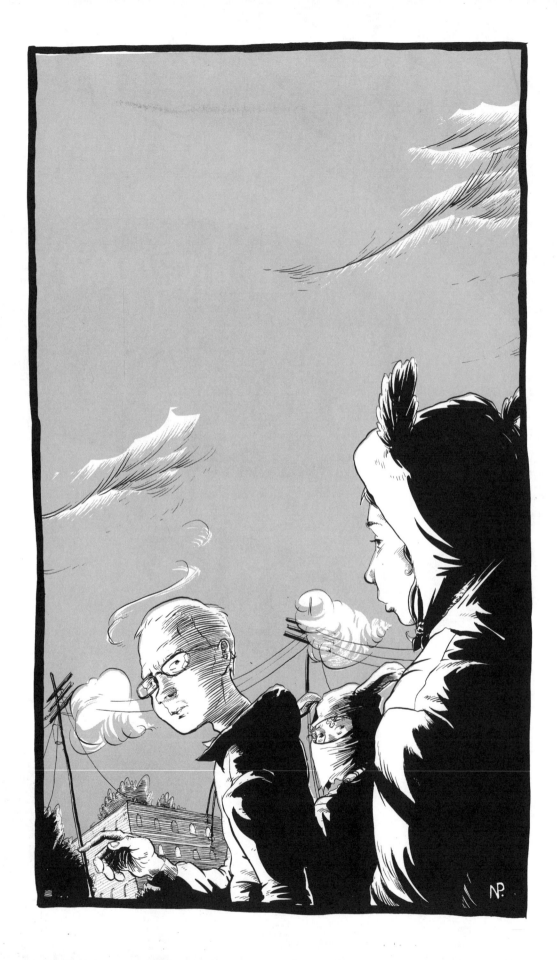